Narrative Theory in Conservation

Narrative Theory in Conservation engages with conservation, heritage studies, and architectural approaches to historic buildings, offering a synthesis of the best of each, and demonstrating that conservation is capable of developing a complementary, but distinct, theoretical position of its own.

Tracing the ideas behind the development of modern conservation in the West, and considering the challenges presented by non-Western practice, the book engages with the premodern understanding of innovation within tradition, and frames historic buildings as intergenerational, communal, ongoing narratives. Redefining the appropriate object of conservation, it suggests a practice of conserving the questions that animate and energize local cultures, rather than only those instantiated answers that expert opinion has declared canonical. Proposing a narrative approach to historic buildings, the book provides a distinctive new theoretical foundation for conservation, and a basis for a more equal dialogue with other disciplines concerned with the historic environment.

Narrative Theory in Conservation articulates a coherent theoretical position for conservation that addresses the urgent question of how historic buildings that remain in use should respond to change. As such, the book should be of great interest to academics, researchers, and postgraduate students from the fields of conservation, heritage studies, and architecture.

Nigel Walter is a Specialist Conservation Architect based in Cambridge, UK, a Fellow of the Royal Institute of British Architects, and a member of two ICOMOS International Scientific Committees. He specializes in living heritage, combining practice with research, and holds a PhD in the conservation of historic buildings.

Narrative Theory in Conservation

Change and Living Buildings

Nigel Walter

LONDON AND NEW YORK

First published 2020 by Routledge

2 Park Square, Milton Park, Abingdon, Oxon OX14 4RN
605 Third Avenue, New York, NY 10017

*Routledge is an imprint of the Taylor & Francis Group, an
informa business*

First issued in paperback 2021

Publisher's Note

The publisher has gone to great lengths to ensure the quality
of this reprint but points out that some imperfections in the
original copies may be apparent.

British Library Cataloguing-in-Publication Data
A catalogue record for this book is available from the British Library

Library of Congress Cataloging-in-Publication Data
Names: Walter, Nigel, author.
Title: Narrative theory in conservation: change and living buildings / Nigel Walter.
Description: Abingdon, Oxon; New York, NY: Routledge, 2020. |
Includes bibliographical references and index.
Identifiers: LCCN 2019051585 (print) | LCCN 2019051586 (ebook) |
ISBN 9781138385276 (hardback) | ISBN 9780429427183 (ebook)
Subjects: LCSH: Historic buildings–Conservation and restoration. |
Architecture and society. | Historic preservation–Social aspects. |
Historic preservation–Philosophy.
Classification: LCC NA105 .W35 2020 (print) |
LCC NA105 (ebook) | DDC 720.1/03–dc23
LC record available at https://lccn.loc.gov/2019051585
LC ebook record available at https://lccn.loc.gov/2019051586

ISBN: 978-1-138-38527-6 (hbk)
ISBN: 978-1-03-217312-2 (pbk)
DOI: 10.4324/9780429427183

Typeset in Sabon
by Newgen Publishing UK

Contents

Figures

All images by author, except where noted.

Preface and acknowledgements

Question: How many conservation professionals
does it take to change a light bulb?
Answer: Change???!!!

<div align="right">Anon</div>

For many people, myself included, historic buildings play an important role in constructing our sense of who we are and where we come from; they help to 'place' us. While seeming fixed and immemorial, most historic buildings will have changed multiple times during their lives, and often it is precisely this visible story of movement and change that gives them their character. Conservation is commonly defined as the management of change, and yet modern conservation processes typically treat these buildings as completed objects, negatively characterizing further change as harm. There is a fundamental contradiction at the heart of much of modern conservation: that being thoroughly modern in its assumptions and thinking the intellectual apparatus of modern conservation is particularly ill-suited to dealing with the premodern buildings in its care. These buildings were once a source and site of creativity that premodernity well understood; this book argues that, handled well, they *continue* to be so, and suggests that we must rethink our approach to conservation on the basis of that continuity.

This argument begins from a concern with historic buildings which continue in use, particularly those in use for the purposes for which they were originally built. In England, where I am based, perhaps the most plentiful example is the parish church; of a total of some 16,000, approximately half are medieval, at least in substantial part. The scope of the argument, however, is much wider, not restricted to buildings of a particular type, or a particular age. Instead of living buildings representing the awkward exception, the argument is reversed to suggest that living buildings present the norm that conservation must address head on, and that other forms of

historic building can be accommodated within the proposed narrative-based framework.

I have never been convinced by the modern paradigm of pure, abstracted forms of knowledge that are unencumbered by context or 'prejudice'. This book takes the contrary view, that knowledge – at least knowledge relating to the historic buildings that are its subject – is intimately bound up with context, that it is 'impure' and embodied. It seems important, therefore, to give some preliminary indication of my own context and commitments. I am an architect by profession, what could be described as 'a merchant of change'. I would also be classed as an entrepreneur, in that I founded and continue to lead Archangel, a UK-based architectural practice; the principal focus of the practice is historic buildings, particularly churches, many of them medieval and under high levels of statutory protection. All of this has helped shape the argument presented here.

Entrepreneurial activity is typically attended by disruption to existing organizational structures and patterns of behaviour, and this applies not only in the business world but in any cultural arena. These existing structures, for those invested in them, have an air of permanence, and the prospect of change to them may seem threatening. Conservation and entrepreneurship might seem strange bedfellows, but I would argue that each is essential to the other, and that it is only in holding them in dialogue that a culture can endure. If the contingent nature of the existing structures of conservation goes unrecognized then, as in any other realm, those structures will rapidly outlive their usefulness and become an obstacle to cultural growth and human flourishing. My approach to conservation is, in this sense, broadly entrepreneurial and 'disruptive'.

By questioning the existing structures of conservation, the argument of this book may to some appear unthinkable, wilfully destructive even – I hope not. The aim from the outset has been more than simply to critique the status quo of modern conservation; accordingly the book goes on to propose an alternative theoretical framework in the form of a narrative approach to historic buildings, and then in a third stage to explore some practical applications of that approach. I argue that this approach offers the basis for a more equal dialogue with other disciplines concerned with the historic environment such as heritage studies, art history and architecture. It also opens up new and exciting means for the public to engage more fully in deciding the future of their built heritage, without sidelining the expertise of heritage professionals. The book is therefore as much concerned with its applicability to questions of professional practice as it is with its impact on academic discourse. In this way the critique of the old is accompanied by the

proposal of something new in its place, reflecting the 'creative-destructive' paradigm familiar to both the entrepreneur and the designer. While for some this may appear heretical, if it leads us to question our assumptions, then that is all to the good, and no less than should be expected of any discipline in good health.

Modern conservation, having developed from a series of localized campaigns, is now well and truly international, both through World Heritage and through bodies such as ICOMOS and ICCROM. One challenge faced by international conservation is that the vocabulary it uses still reflects its more localized origins, such that in different locations the same word can be used to mean strikingly different things. The classic example of this is the American use of the word 'preservation', where Europe and much of the rest of the world uses 'conservation'. One benefit of the non-American usage, which is followed in this book, is the greater scope to differentiate between two contrasting approaches to old buildings – the positive management of change (conservation) and the attempt merely to keep things the same (preservation); this distinction is central to the argument of the book. In an attempt to reduce confusion, the term 'preservation' is used sparingly.

The core of this argument has been developed in dialogue with numerous other people – friends, clients, professionals, and academics – both in informal conversation and in the more formal settings of seminars and workshops. The original research project from which this book grew was funded by the Arts and Humanities Research Council through the White Rose College of Arts and Humanities; I am particularly grateful to Gill Chitty and Kate Giles, for their support and encouragement in the development of these ideas. Material from presentations at the meetings of ICOMOS International Scientific Committees in Jeju, South Korea on 18 October 2018 (joint meeting of PRERICO and ICLAFI) and in Florence on 28 February 2019 (PRERICO and TheoPhilos) has been included in the case study after Chapter 3, and in Chapters 4 and 5, respectively; some of this material is due for publication in the respective proceedings of those groups.

Whether the argument of this book is reactionary or revolutionary (or both, or neither) will be for others to judge. Whatever the verdict, it could not have been imagined in the first place, nor brought to publication, except against the specific background of the commitments discussed above. It is therefore dedicated to four groups of people: first, to my colleagues at Archangel, whose diligent application has allowed me the imaginative space to pursue this research; second, to the clients of the practice who have entrusted us to help them write the next chapter of their respective

narratives, and from whom we continue to learn so much; third, to my late mother Stella, who knew the value of a strong narrative, and the importance of passing it on; and, finally, to my wife Louise, for journeying with me. Without each of these, this book would indeed, quite literally, have been *unthinkable*.

Abbreviations

AHD	Authorized Heritage Discourse
CBC	Church Buildings Council
CDA	Critical Discourse Analysis
CHS	Critical Heritage Studies
CIAM	International Congresses of Modern Architecture
CSICH	Convention for the Safeguarding of the Intangible Cultural Heritage
DAC	Diocesan Advisory Committee
DCMS	Department for Digital, Culture, Media and Sport
ICCROM	International Centre for the Study of the Preservation and Restoration of Cultural Property
ICLAFI	ICOMOS International Scientific Committee on Legal, Administrative and Financial Issues
ICOMOS	International Council on Monuments and Sites
INTACH	Indian National Trust for Art and Cultural Heritage
NPPF	*National Planning Policy Framework*
OUV	outstanding universal value
PRERICO	ICOMOS International Scientific Committee on Places of Religion and Ritual
RIBA	Royal Institute of British Architects
SCARAB	Society for the Continuity and Renewal of Ancient Buildings
SMC	scheduled monument consent
SPAB	Society for the Protection of Ancient Buildings
TheoPhilos	ICOMOS International Scientific Committee for Theory and Philosophy of Conservation and Restoration
UNESCO	United Nations Educational, Scientific and Cultural Organization

Context

People and change in conservation

In a higher world it is otherwise,
but here below to live is to change,
and to be perfect is to have changed often.

John Henry Newman ([1845] 1909)

The conservation of historic buildings is just one of many disciplines with an interest in history; an interest, that is, not only in the minimal sense of intellectual curiosity, but also in the fuller sense that its outcomes are strongly influenced – or arguably determined – by the particular understanding of history adopted. Yet conservation rarely takes the time to reflect on that underlying theoretical understanding, and it is much the poorer for it. While modern conservation deals with buildings going back to antiquity, its processes are the product of modernity and come laden with modernity's particular ideological commitments. This book aims to take a fresh look at conservation theory, and in the process to suggest possible means of resolving some of the inherent and persistent contradictions that flow from those commitments. The approach taken is to bring the undeniable modernity of conservation into dialogue with resources from beyond the confines of Western modernity, and hopefully to promote a more fruitful exchange with adjacent disciplines such as archaeology, architecture and history of art.

E. F. Schumacher is best known for his book *Small Is Beautiful* (1973) which was highly critical of conventional Western economics and championed 'appropriate' technology as a means of empowering individuals and communities; the book had the subtitle 'economics as if people mattered'. His last book, *A Guide for the Perplexed* (Schumacher 1978), was published posthumously and set out the philosophical approach underlying his earlier work. Central to this was a critique of what he saw as the dominant 'materialistic scientism', particularly the misapplication of the methodology of the 'instructive sciences' to other fields such as the social sciences. The opening paragraph of the first chapter, 'On Philosophical Maps', reads:

On a visit to Leningrad some years ago I consulted a map to find out where I was, but I could not make it out. I could see several enormous churches, yet there was no trace of them on my map. When finally an interpreter came to help me, he said: 'We don't show churches on our maps'. Contradicting him, I pointed to one that was very clearly marked. 'This is a museum', he said, 'not what we call a "living church". It is only the "living churches" we don't show'.

(Schumacher 1978: 9)

In my experience as a practising conservation architect, those non-professionals responsible for historic buildings – including in England those who care for our parish churches – often face a similar perplexity. Conservation offers an official procedural and theoretical 'map', based on a series of largely unstated commitments, which similarly seems to ignore many of the salient features of the cultural landscape. Perhaps the most obvious of those missing features is a coherent account of the relation between a historic building and those groups of people that gather around or within it, and whose identity is often in turn formed by it. For Schumacher, his perplexity 'remained complete until I ceased to suspect the sanity of my perceptions and began, instead, to suspect the soundness of the maps' (ibid.). This book adopts a similarly critical approach to the maps provided by Western conservation for navigating the heritage landscape.

1.1 Beating the bounds: the scope of the argument

Despite a handful of valiant exceptions, conservation has typically shied away from locating its commitments in any wider theoretical landscape that might produce better maps, greatly to its detriment. Symptomatic of this is John Earl's otherwise excellent *Building Conservation Philosophy* (2003) which, despite its title, contains not a single reference to acknowledged philosophers of any kind. Earl himself warns of the danger that practitioners who ignore philosophical questions 'will find themselves in a rudderless ship' (2003: 3) but, since philosophy is understood in the weakest sense – merely as 'approaches' – he does nothing to locate the discipline with respect to other philosophical landmarks. Leaving aside the irony of a discipline that champions physical context while ignoring the theoretical hinterland beyond its narrowly defined borders, this substantial omission is downright dangerous; practice must connect with theory if practitioners are to know whether their intervention will be for the long term good, or not. In any case, even if we wished to, we cannot avoid theory; we either engage with it deliberately, or we find ourselves animated by a philosophy not of our choosing.

Since modernity is founded on the flight from tradition and towards dreams of progress and emancipation from the past, the implications for historic buildings of ignoring the wider philosophical landscape are both substantial and urgent.

The approach taken in this book is therefore not only to critique the operation of contemporary conservation practice, but also to propose an appropriate theoretical foundation and to explore its implications, both for professionals and community interests. Its central concern, in terms both of practice and theory, is the question of how people and physical heritage interrelate. This first section starts by considering what is meant by the evocative term 'living buildings', which often stands as a marker of these concerns, but is seldom defined, and then looks at our understanding of change to historic places, a frequent point of contention between experts and non-professionals. It then considers some more direct parallels between buildings and people, and how conservation can be located within an ethical framework.

The question of living buildings

The term 'living building' describes buildings that remain in use, particularly those in use for the purposes for which they were first created. This is a primary distinction for conservation, but one that is insufficiently acknowledged, either in theory or practice. In turn this raises the central questions of who makes heritage, and of who gets to decide what matters and how; these have been a central concern of heritage studies since its inception. The issue of living buildings therefore stands as representative of a rich set of questions concerning how we engage with the past and with the material world.

The evocative first sentence of the preamble to the *Venice Charter* (ICOMOS 1964) positions historic buildings, termed 'monuments', as 'living witnesses' of 'age-old traditions' (plural), but makes no acknowledgement of the creative workings of tradition (singular). These 'witnesses' are 'living' in the minimal sense of having survived, but they lack any sense of agency. Meanwhile, Article 3 of the *Charter* states that 'the intention in conserving and restoring monuments is to safeguard them no less as works of art than as historical evidence'. This in turn has profound implications for the question of change to historic buildings. After all, to change evidence is to falsify it, and to change a work of art is to destroy its integrity; clearly the approach of the *Venice Charter* is not one that addresses heritage that changes. By contrast, the twentieth-century philosopher Hans-Georg Gadamer declared that 'works of architecture do not stand motionless on

the shore of the stream of history, but are borne along by it' (Gadamer [1960] 1989: 157). While this holds in the minimal sense that history will inevitably leave its mark on any building, Gadamer is making the bolder claim that change is in the very nature of historic buildings, since they are not only the products of but also actors in the ongoing cultural life of a living tradition.

In England, official conservation guidance mentions living buildings primarily in the context of places of worship. Churches are described as 'living buildings at the heart of their communities' in the very first sentence of *New Work in Historic Places of Worship* (Historic England 2012: 1). The phrase is also used for the enticingly titled guidance *Living Buildings in a Living Landscape* (Historic England & Countryside Agency 2006) on the future of traditional farm buildings; however, neither document provides a definition. Elsewhere, the leading conservation architect Sir Donald Insall (2008) chose *Living Buildings* as the title for his monograph celebrating 50 years of practice. While he too offers no definition, for Insall all buildings are living; they are our interlocutors, and it is important that we know our place in that dialogue, allowing the building to address us before we ourselves speak (2008: 7). Perhaps the term 'living building' is assumed to be self-explanatory, but a thorough exploration of its implications for the practice of conservation is long overdue.

The main international focus for work on living heritage in conservation has been the International Centre for the Study of the Preservation and Restoration of Cultural Property (ICCROM); a brief paper, *Living Heritage: A Summary* (Wijesuriya 2015), outlines their approach. Living heritage is understood in terms of four interrelated forms of continuity: of function, of relation between a core community and the tangible heritage, of expressions (entailing a recognition that heritage places will continue to change), and of care. An explicit link is made to change, recognizing it as part of the living nature of a heritage place. In 2003 ICCROM convened a forum on living religious heritage, with the resulting publication (Stovel et al. 2005) providing case studies from across the world and from a variety of religious and cultural traditions. Ioannis Poulios (2014) has developed a detailed application of a living heritage approach – based on the same four forms of continuity – to the monastic sites at Meteora in Greece.[1]

The need for a living heritage approach within conservation arises in response to a disconnect between the life of living buildings and their material fabric, but it important to note that this is a problem of modernity's own making. The pre-Cartesian view is of a material world that is animated, mutable and protean. The seriousness with which alchemy was taken in Western culture into the seventeenth and even eighteenth centuries, despite

its later caricature as primitive chemistry, provides one trace of this; architectural examples of this include the Hortus Palatinus at Heidelberg castle, which was entirely structured around an alchemical understanding of light and water, or the use of progressively darker materials to structure degrees of holiness in some South German Baroque churches (Walter 1991). Against the standard Western view of physical objects as inert compounds of matter and form, known as 'hylomorphism' (Deleuze & Guattari 1987: 408), Tim Ingold also draws on alchemy to propose a 'morphogenetic' view. Rather than seeing the process of making as the imposition of an internal mental form on an external material world, for Ingold it is instead 'a process of *growth*' (2013: 21, emphasis original):

> Making, then, is a process of correspondence: not the imposition of preconceived form on raw material substance, but the drawing out or bringing forth of potentials immanent in a world of becoming.
>
> (Ingold 2013: 31)

Such a 'bringing forth' calls for a non-modern approach. John Ruskin, so important to the development of conservation, could speak of a 'living architecture' and insist that in the surface of ancient stones 'There was yet in the old *some* life' (Ruskin [1849] 1903: 243, emphasis original); yet Ruskin's adoption of the idea is partial and selective, and is employed to argue for the prevention of the sort of elective change that living heritage entails.

The preliminary definition of a living building as one that remains in beneficial use establishes the fundamental distinction between living buildings and 'dead' monuments. This distinction is not a new one. In 1904, William Locke reported the recommendations from the Sixth International Congress of Architects held in Madrid to the Royal Institute of British Architects (RIBA); the first of the six agreed principles was:

> Monuments may be divided into two classes, *dead monuments*, i.e. those belonging to a past civilization or serving obsolete purposes, and *living monuments*, i.e. those which continue to serve the purposes for which they were originally intended.
>
> (Locke 1904, emphasis original)

Principles 2 and 3 then state that dead monuments should be preserved with minimal intervention, while living monuments should 'be *restored* so that they may continue to be of use' (emphasis original). It was the Belgian Louis Cloquet who seems first to have developed this distinction in the 1890s; dead monuments such as pyramids, temples, and ruins should be preserved while

restoration was more appropriate for living monuments such as churches, castles, and manor houses (Tschudi-Madsen 1976: 98–99). Locke articulates the rationale for preservation: 'the importance of such a [dead] monument consists in its historical and technical value, which disappears with the monument itself'; this is noteworthy for the early use of the language of value(s), the investment of that importance (in the case of 'dead monuments' only) exclusively in the material fabric, and the tacit understanding that the importance of 'living monuments' is not similarly constrained. It should also be remarked that this understanding of living buildings was articulated by an international gathering of architects, whereas art historian Alois Riegl's almost contemporaneous 'Modern cult of monuments' ([1903] 1996) makes no such distinction.

The use aspect positions an active community or group of people as essential to the vitality described by the word 'living'. Continued beneficial use has long been recognized as important for sustaining built heritage, and the current understanding in England is explicitly that this 'is likely to require continual adaptation and change' (Historic England 2008: 42). But this immediately begs the question of use *for what*, and the further distinction between buildings that remain in use for the purposes for which they were built, as Locke envisages, from those whose continued existence is thanks to conversion to another use. Many historic buildings have been successfully adapted for new uses: mills converted into housing, banks into restaurants, churches into libraries (e.g. Lincoln College, Oxford), or bars (e.g. The Parish, Micklegate, York), hotel lobbies into museums (the Neon Museum, Las Vegas), and so forth. Here we must distinguish *continuity of usefulness* in the latter case, from *continuity of use* in the former; each raises quite distinct issues. In terms of the permissions process, change of use is typically argued on the basis of the very survival of the building. The concern is often to retain its external form in the landscape (urban or rural), and the challenge for heritage professionals in approving such proposals is the impact on the fabric – often in the form of insertions and perhaps subdivisions of the interior – to make the proposed use viable. In the case of continuity of use the issues are different and may, at first sight, appear more straightforward. The classic example here is the English parish church, in which the ongoing life of the building provokes demands for change which many conservation professionals find unacceptable, even though change and multiple uses were integral to their development in the first place (Davies 1968; French 2001). Change of use examples are often argued in life and death terms; the threat in continuity of use examples often appears less credible to permission-givers, though it may be just as real.

This distinction is mirrored in the conservation literature. While the question of adaptive reuse has received considerable coverage, the specific concerns and challenges of elective change to facilitate continuity of use in living buildings are under-theorized. For example, the claims made by religious communities for their buildings are typically theological in nature, and therefore difficult to take seriously – or comprehend at all – in a secular context. And while there is much talk of community ownership, it is rarely acknowledged that communities are not monolithic but highly differentiated, or indeed how the communities responsible for historic buildings are themselves often fragile. Living buildings with continuity of use thus provide an excellent basis for considering the relations between historic buildings and the communities that care for them and, by extension, how our culture as a whole regards historic fabric and its connection to people. The structure of this book's argument is therefore to develop an approach that addresses the particular concerns of living buildings, and then to consider its broader applicability and usefulness.

Fixity, fluidity, and the problem of change

Anything that is living is almost by definition growing and changing. It follows that if a building is to be termed 'living', then we should expect growth and change to be part of its nature. The question, therefore, for 'living' historic buildings should not be how to manage change *down* to an acceptable minimum – as though growth and change were a sickness – but how to change *well*. For this, an understanding of how heritage is created and renewed is needed; for as Jokilehto (2010: 30) observes, 'Compared to the habitual definition of monuments and sites as static objects, living heritage is continuously recreated'. Alongside this, rather than treating living buildings as a special case, this book proposes the reversal of that assumption, starting from the view that all historic buildings should be presumed living until proven otherwise. By grappling with the substantial practical and theoretical issues raised by change to living buildings, it is hoped to draw lessons of relevance to conservation as a whole.

In a buildings-related echo of Newman's epigraph, Stewart Brand (1994: 11) suggests that 'more than any other human artifact, buildings excel at improving with time, if they are given the chance'. His book *How Buildings Learn* argues that buildings are, of their nature, fluid, and from the title onwards he draws attention to their agency, with a particular concern for how buildings change *with use*. He likens buildings to architectural historian Rina Swentzel's description of her Pueblo Indian culture and home

village: 'Flow, continual flow, continual change, continual transformation' (1994: 2). He praises conservationists/preservationists for (uniquely) having a pragmatic interest in the impact of history on buildings and frames the conservation movement as a rebellion against professionalized design and commercial development in a bid to safeguard continuity. He holds strong views on particular professions; for example:

> Architectural historians, [...] a subset of art historians, they are interested only in the history of intention and influence of buildings, never in their use. Like architects, they are pained by what happens later to buildings. Building historians are the opposite. They are the ingenious detectives who deduce how specific buildings have changed through the years ...
>
> (Brand 1994: 90)

Brand is not interested in history as an end in itself: in the same passage he praises preservationists for 'their philosophy of time and responsibility that includes the future'. While this may be somewhat idealized, Brand's analysis suggests two divergent approaches to historic buildings open to conservation professionals: one predominantly concerned with the past, the other able to embrace both past and future in a coherent whole; adaptive reuse draws these two tendencies into sharpest contrast.

Central to preservation guidance in the United States, *The Secretary of the Interior's Standards for the Treatment of Historic Properties* includes a list of ten 'Standards for Rehabilitation'. The fourth of these standards, first published in the 1970s, states that: 'Changes to a property that have acquired historic significance in their own right will be retained and preserved' (Grimmer 2017: 76). While this helpfully acknowledges the temporal layering of historic buildings, it lacks an understanding of temporal continuity, that history continues to be made; it has also been criticized for the implication that it is possible to divide 'good' historic change from 'bad' non-historic change (e.g. Brand 1994: 98, n19). The ten standards are derived from an earlier document specifically on rehabilitation, which prefixes that sentence with the important acknowledgement that 'Most properties change over time' (Morton et al. 1992: vi–vii). The 2017 document does retain this acknowledgement, but demotes it from this statement of principles, placing it elsewhere entirely in the context of a discussion of restoration and the removal of existing features of other periods (Grimmer 2017: 166). Perhaps this illustrates Brand's insistence that, while '*All buildings grow*', this universal rule is 'never acknowledged because its action is embarrassing or illegal' (Brand 1994: 10, emphasis original).

Opposition to change to historic buildings almost invariably interprets proposed change as loss, and this is a strong theme is some forms of conservation literature where the words 'change' and 'harm' are used interchangeably. This conflation is not accidental, but nor is it inevitable. In *Loss and Change*, an exploration of the parallels between bereavement and broader societal change, Peter Marris (1986) teases change apart into three distinct aspects or modes of interpretation – loss, substitution, and growth. He argues that our response to a given experience of change – into which of those categories we place it – will be determined by the extent to which it threatens our sense of continuity. Marris himself applies this in passing to conservation, favouring the rehabilitation of historic buildings on the basis of their familiarity, regardless of whether they are beautiful or of historical importance; he suggests that 'the townscape ought to reflect our need for continuity, and the more rapidly society changes, the less readily should we abandon anything familiar which can still be made to serve a purpose' (Marris 1986: 150).

For Marris, attachment formation plays a fundamental role in the generation of meaning, and it is only once the anxieties that surround loss are properly understood that we can account for the tenacity of the conservative impulse. He argues that even innovators – those who propose change – experience the same strains of change but tolerate them because they wish to avoid some more fundamental threat. For example a community might tolerate a degree of disruptive change to its historic building from an urge to preserve a more fundamental form of continuity, such as safeguarding the overall health of that community. Whether an individual or group supports or opposes change is therefore determined, in part at least, by the broader context into which that change is placed. It is also clear that the physical status quo of the historic building is meaningful to opponents of change in ways quite different to those who first created or subsequently shaped it. This raises the obvious issue of whether the heritage we seek to conserve can be limited to its physical manifestation only, or whether it must always be placed in its broader social and temporal contexts, a theme explored further in Chapters 3 and 4.

At the preparatory workshop for the Nara Conference on Authenticity, David Lowenthal (1994: 40–41) used Plutarch's philosophical puzzle of the ship of Theseus, and subsequent variations on it, to explore the question of authenticity. Authenticity, of course, was a key issue for twentieth-century conservation, and the Nara conference was to challenge the modern Western assumption that the authenticity of historic buildings lies in the fixity of their physical fabric; the point of the puzzle is to explore the conflict between object identity (in this case as a ship) and material authenticity

(as a collection of timbers). It is important to note that Plutarch frames his example with the observation that 'this ship became a standing example among the philosophers, for the logical question of *things that grow*' (Plutarch n.d., emphasis mine); it is absolutely pertinent, therefore, to the question of living buildings.

John Henry Newman's epigraph to this chapter ('...to live is to change...') can be read in the minimal sense that change is part of life. But Newman meant considerably more, for he adds that '...to be perfect is to have changed often' ([1845] 1909: 40), implying that change should be welcomed, even rejoiced in, as a sign of life. The context of Newman's comment was the development of doctrine in the Christian Church, but he highlights two quite different notions of change of far broader application, one passive, the other active. In the passive sense, change is predominantly negative; even when romanticized by Ruskin as 'that golden stain of time' ([1849] 1903: 234) it is a form of decay. By contrast, change in Newman's active sense is positive, enriching, generative, and not only indicative of growth but essential for it.

Donald Insall (2008: 11) uses a similar distinction in differentiating conservation from preservation, seeing 'the latter as negative, obstructing all change, while the former encapsulates life'. For Insall, historic buildings are

> alive and constantly changing. For every building is a product not only of its original generator – whether architect or builder, caravanist or monk – but of the continuing effects upon its materials of time and weather, and of generations of successive occupants, each with his own set of values and requirements. Each building carries, and clearly demonstrates, the impact and influence of all its changing and unforeseeable circumstances.
>
> (Insall 2008: 10)

He illustrates this with a church, St Anne's at Kew (2008: 43), which has grown through nine separate stages from 1714 to 1979. For those historic buildings formed by these 'generations of successive occupants', this aspect of their character surely cannot be ignored when considering what should happen next. If *every* building is alive in this way, as Insall claims, then the fundamental aim of conservation cannot simply be to keep things the same; that is the preservationist approach, which he rejects.

In the context of urban design informed by post-war reconstruction, the town planner Thomas Sharp (1968: 20) criticized preservation, which 'opposes change of almost any kind' due to its failure to understand that towns are 'living organisms', alongside a *laissez faire* commercial utilitarianism;

these approaches we could characterize respectively as 'change nothing' and 'change everything'. Restricting ourselves to these as the only possibilities results in a sterile opposition of heritage versus people and contemporary need, and indeed many arguments over change to historic buildings reduce to this polarity of opinion. But the dichotomy is a false one: Sharp identified a middle way for conservation, which accepts change but whose focus is the 'maintenance of character'; this we can characterize as 'changing well'.

Buildings as people

While conservation processes can place the competing needs of buildings and people in conflict, it might be productive to extend the idea of living buildings and see them *as* people. In the context of arguing against whole-sale urban re-planning and for piecemeal renewal, Lionel Esher warned the 1964 RIBA conference that 'we must beware of contempt for old buildings just because, like old people, they can be frail, muddled and squalid' (Esher 1981: 73). As already noted, the *Venice Charter* presents historic buildings as witnesses without any agency, in something of the same way as the passive life of the contemporary old people's home contrasts with the vitality of a multi-generational community. In many modern Western societies, old people and old buildings are both accorded a special status which removes them from the stream of life in order better to meet their material needs, with less thought to the creative cultural contribution they might yet make; we tell ourselves that it is for the best, that they are too fragile to survive in the world. However, the 'care home' parallel is not exact, in that human life has a sharply delimited horizon of 120 years at most, while old buildings do not. Ruskin had counselled that 'A building cannot be considered as in its prime until four or five centuries has passed over it ...' ([1849] 1903: 241); where a human life passes through its seven ages in relatively short order, the narrative approach sees a living building as perennially 'in its prime' – and thus still capable of creative development.

Newman's adage offers a counterpoint to Marris's focus on anxiety and loss, restating the common observation that a full human life is marked not merely by surviving change, but by being formed by it, by growth of character and strengthening of identity, often in adversity. A similar idea was articulated in the 2016 BBC Reith Lectures by the philosopher Kwame Anthony Appiah, who suggested (in the context of the cultural challenge facing Muslims in the West) that:

the recognition that identity endures through change – indeed, *that it only endures by change* – will be a useful touchstone for everyone

involved. Religious identities, like all identities [...] are transformed through history: *that is how they survive*.

<div style="text-align: right">(Appiah 2016: 10, emphasis added)</div>

Likening buildings to orally transmitted stories, Edward Hollis has similarly suggested that:

incremental change has been the paradoxical mechanism of their preservation. Not one of [these] buildings [...] has lost anything by having been transformed. Instead, they have endured in a way that they would never have done if no-one had ever altered them. Architecture is all too often imagined as if buildings do not – and should not – change. But change they do, and have always done. Buildings are gifts, and because they are, we must pass them on.

<div style="text-align: right">(Hollis 2010: 14)</div>

The Mosque-Cathedral at Cordoba (Figure 1.1) presents an example of a historic building with a layered history and a complex identity that developed as it has been 'passed on'. The current building was started by the Muslim ruler Abd al-Rahman I in 786, and then successively enlarged

Figure 1.1 Cordoba, Mosque-Cathedral: external view, from south-west

to the south and then east until the late tenth century; this was on the site of the mid-sixth century Visigoth Basilica of San Vicente, remains of which are now visible through a section of glass floor. After the conquest of Cordoba by Ferdinand III in 1236, the site once again became a church, with only minor modifications, until in the sixteenth century a cruciform choir and presbytery was built within the existing structure. The effect, at least for the casual visitor, is stunning, with the height and light of the sixteenth-century work erupting from within the reused classical columns and polychrome ogee arches of the hypostyle mosque (Figures 1.2 and 1.3).

But how should a composite building like this be described? One reading of this developmental history is of purity (the mosque) contaminated by (Christian) additions; this approach informs the original evaluation for World Heritage status, in which the sixteenth-century work is presented as irreparable damage which emperor Charles V, 'deceived by the chapter, arrived too late to prevent' (ICOMOS 1984). Representing the clerics as the destroyers of what even then was supposedly 'considered as one of the essential properties of the heritage of mankind' is simplistic, anachronistic and partisan; critiquing the reception of the emperor's intervention, Heather Ecker observes that 'monarchs and clerics, Christians and Muslims alike, were protective, destructive, and transformative agents in the "later history" of the mosque' (Ecker 2003: 114). Furthermore, while UNESCO's current description for the site acknowledges that 'Its continued religious use has ensured in large part its preservation' – including, clearly, use as Cathedral – it still refers to the building as the 'Great Mosque' (UNESCO n.d.) into which the church was 'installed'. This is indicative of a fundamental clash of understandings, and that reading the development of such buildings in art historical terms leads to the discounting of later changes and ongoing uses. Ecker (2003: 113) questions whether a 'monolinear' approach that 'reduces buildings to a catalogue of foundational events' can possibly offer 'an adequate framework for studying any building with a complex, continuous history, particularly if that building has lost its morphological and ideological purity'.

In our descriptions of historic buildings – most of which are 'impure' in these terms– much therefore rests on whether we see the physical world as essentially fixed or as having a degree of fluidity. If our understanding of an old building is primarily one of fixity, then our approach will be antiquarian or art historical, and any change will then be loss; after all, we do not alter a Rembrandt and believe we have improved it. This very much seems to be the approach of the Cordoba nomination discussed earlier. But if our understanding of a building is primarily one of fluidity and communal authorship over time, then both our descriptions and the role of conservation

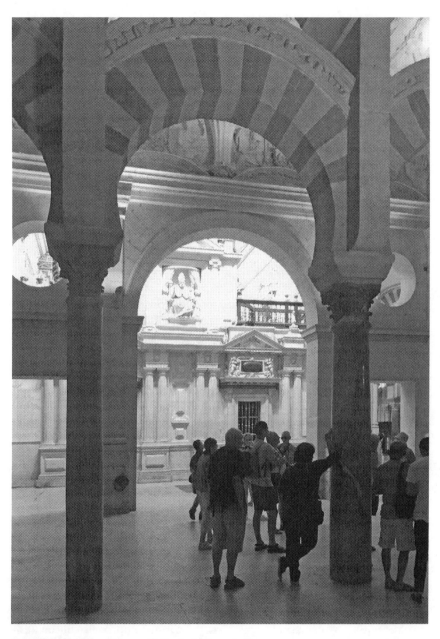

Figure 1.2 Cordoba, Mosque-Cathedral: internal view

Figure 1.3 Cordoba, Mosque-Cathedral: ceiling to west end of choir

will be radically different. Hence Gill Chitty (2017: 2) quotes Jukka Jokilehto suggesting that in conservation there should be 'less emphasis on managing change, more on managing continuity through change'.

Clearly not all change is good. But if old buildings are 'living' they are fixed neither physiologically (due to the effects of the elements, conflict etc.) nor culturally (because of their ongoing use). The continuity of the life of these buildings depends on their connection with people, their embedded-ness in community. While change should not be at anyone's whim, neither should the prevention of change. On this view, preservation is a very blunt instrument which threatens to destroy the balanced holism of the physical and the communal that is a 'living building' through the very processes adopted for its care.

Framing conservation as applied ethics

Part of the appeal of conservation is that it is gloriously practical, whether at the policy or campaigning level of saving buildings, or at the hands-on level of deciding how best to intervene for the health of the 'patient' in question. Conservation practitioners constantly encounter new situations

and challenges, and must ask themselves 'what should I do?'; framed in this way, conservation is a branch of applied ethics, a theme going back at least as far as John Ruskin (Chitty 2003: 43). For the philosopher Erich Matthes, rather than this being a question merely of professional ethics, that is, the internal debate over the ethical constraints on a profession's activities, 'historic preservation [conservation] is *essentially* concerned with ethical issues. How we relate to the past is an important dimension of our ethical lives and relationships more broadly' (Matthes 2016: 787, emphasis added). Similarly, in their edited volume *The Ethics of Cultural Heritage*, Tracy Ireland and John Schofield note that ethics in heritage has conventionally focused on responsibilities to external domains such as the 'archaeological record', stakeholders, or the professions; instead they consider heritage to be a future-focused domain of social action (2015: 2). Aylin Orbaşli makes a similar point in the context of a recent article critiquing contemporary conservation processes as 'woefully ill-equipped' to respond to current realities (2017: 1, 8). Just as medical practitioners cannot limit themselves to narrow professional boundaries in their engagement with medical ethics, so conservation must also situate itself in the broader landscape of moral philosophy.

Ethics is conventionally divided into three major approaches: deontological (concerned with duty and the rightness of actions themselves), consequentialist (where the moral worth of actions derives from their anticipated outcomes or consequences) and virtue (rooted in Plato and Aristotle and looking beyond the individual action to questions of moral character) (Hursthouse & Pettigrove 2016). The ethicist Samuel Wells (2004: 33–35) offers an alternative tripartite division between universal, subversive and virtue ethics. Wells's two innovations are to combine deontological and consequentialist together under the heading of universal, and to introduce a second category of subversive ethics. Whether concerned with duty or consequences, universal ethics considers 'what is right for anyone and everyone [whereas] subversive ethics points out the particular perspective of the marginalized and excluded' (Wells & Quash 2017: 200).

This Wellsian division maps well onto the ethical landscape of conservation. The universal approach describes modern conservation in its first stage of development, embracing the authority claims of the antiquarian and the strong universalizing tendency of the early international charters and of the World Heritage Committee. Subversive ethics then describes the growing consciousness of power relations in the development of the brokered notion of significance from the *Burra Charter* (Australia ICOMOS 2013)

onwards together with the application of Critical Discourse Analysis (CDA), for example in Laurajane Smith's (2006) notion of Authorized Heritage Discourse (AHD). The following two chapters explore ways in which these first two forms of ethics are applied 'from above' and 'from below', respectively; the potential of virtue ethics as an appropriate model for an inclusive and historically literate conservation becomes a major theme from Chapter 4 onwards. The question of how people and buildings interrelate is central to conservation, and it is clear that none of these three 'heritage ethics' can claim to be uniquely associated with either 'people' or 'buildings'. Rather, each different approach to conservation conceals a different anthropology, the key issue being what place each accords to people in general, and to local communities in particular.

1.2 Conservation as 'making' and 'keeping'

The divergent responses to change touched on earlier are reflected in the tension at the heart of modern conservation, present from its inception, between preserving historic fabric and allowing it to change. Conservation is often now defined, in opposition to preservation, as the management of change (e.g. Historic England 2008: 71; Japan ICOMOS 2014); the phrase dates from the mid-1980s, when Sir Bernard Feilden defined conservation as 'the dynamic management of change in order to reduce the rate of decay' (cited in Stiefel & Wells 2014: 23) at a conference on the impact of air pollution. Donald Insall introduces his section on 'Philosophy in Action' under the heading 'To make or to keep; to change or to save?' and puts this tension in the following terms:

> Our philosophy of conservation is based upon resolving a simple dichotomy. The life of places and of buildings is conditioned largely by two contrasting human motives. These two instincts, somewhat akin to the philosophical Chinese male and female energy factors, can be isolated and identified as 'making' – the aggressive principle that implies change (sometimes indeed, domination), and 'keeping' – protecting and saving things unchanged. These two notions run very deep in human nature and they do conflict.
>
> Virtually all we set out to do involves change.
>
> (Insall 2008: 93)

This section considers the ebb and flow of that tension through the legislative frameworks and polemic that created and continue to shape conservation.

Conservation, preservation, and monuments

The meaning of the terms preservation and conservation have shifted over time. John Earl notes the development of a mid-1960s 'propagandist' distinction:

> drawn (especially by architectural writers) between the museum preservation of buildings in supposedly 'frozen-in-time' states and the enlightened conservation of imaginatively adapted buildings 'in the environment'. The former was represented as a sterile, negative process and the latter as a creative, forward-looking activity.
>
> (Earl 2003: 5)

Earl favours the more neutral dictionary definition of preservation as keeping safe from harm, with conservation 'embracing not only physical preservation but also all those other activities, which the practitioner must engage in to be successful in "preserving, retaining and keeping entire"' (2003: 6). Historic England, in defining 'preserve' in the self-same way, references a 1991 legal definition (2008: 72). Earl thus defines conservation as preservation with other aspects added to it, a view we might label 'preservation plus'.

Such a definition is consistent with William Morris's *Manifesto* ([1877] 2017) for the Society for the Protection of Ancient Buildings (SPAB), a central pillar in the development of modern conservation in England and with influence much further afield. Morris adapted Ruskin's earlier argument against restoration and his metaphor of living architecture, defining the life of a building as its history. The *Manifesto* specifically aimed to counter changes to church buildings, with Morris pleading that 'Protection [be put] in the place of Restoration'. The SPAB approach, at least as seen in the early annual reports, was to treat historic buildings as fragile historic documents which should not be changed either by addition or subtraction. Thus, for example, after noting that 'The custodians of Tewkesbury Abbey appear to be possessed by a spirit of restlessness', the 1891 SPAB annual report laments that

> If people really saw the true worth of our medieval churches they would realise how dangerous it is to introduce new work into old buildings. It is like putting new wine into old bottles, for both are destroyed.
>
> (SPAB 1891: 35)

SPAB won that particular argument, and nineteenth-century restoration is now typically represented as a desecration, the cavalier indulgence of

historical fancy, with St Albans Cathedral standing as the totemic example, condemned by Morris as 'an architectural freak' (SPAB 1884: 8–9; Fawcett 1976: 97–99). Since nineteenth-century restoration furnished the most prominent and obvious examples of change to historic buildings, the construction of a pejorative account of restoration cannot help but colour the contemporary view of change within the conservation community.

In a famous passage from the *Seven Lamps of Architecture*, Ruskin describes restoration as 'the most total destruction which a building can suffer [...] a destruction accompanied with false description of the thing destroyed. [...] it is *impossible*, as impossible as to raise the dead ...' (Ruskin [1849] 1903: 242, emphasis original). What Ruskin was reacting against was the practice of refinishing decayed stone, in the process losing all the signs of the building's age, including the tool marks of the original craftsman's hand which gave the building spirit, 'the life of the whole'. Of all the restoration architects of the age it was the prominent and accomplished George Gilbert Scott who was the foremost target of the preservationists, and it was his restoration proposals for Tewkesbury Abbey which precipitated the founding of SPAB. Scott took this opposition very personally and went into print to counter it. In a paper entitled 'The Anti-Restoration Movement' of October 1877 he notes his long resistance to 'the extreme views of Mr. Ruskin against any form of restoration' (Scott 1879: 358). To illustrate his case, he used the thirteenth-century St. Etheldreda's Church in Holborn, where newly discovered historic tracery provided a model for other windows whose tracery had been replaced by 'execrable' wooden window-frames. Scott uses this to illustrate 'the lengths to which this new society [SPAB] will go', praising instead the good sense of 'the architects employed, who are replacing the lost traceries, while avoiding the reparation of features which have only suffered from decay' (Scott 1879: 363). Scott is candid about his own shortcomings, but as he says was engaged in a 'double battle', criticized as much for doing too little, as too much. Scott's death in early 1878, less than a year after SPAB was founded, deprived conservation of what might have become an instructive debate.

Current definitions of restoration focus on avoiding the conjectural. For example, the *Burra Charter* restricts the practice to where 'there is sufficient evidence of an earlier state of the fabric' (Art. 19), and the US Standards for Restoration stipulate that 'A false sense of history will not be created by adding conjectural features, features from other properties, or by combining features that never existed together historically' (Grimmer 2017: 164). The intervention Scott describes at St. Etheldreda would be acceptable under both the above. The portrayal of nineteenth-century restoration as entirely

destructive has subsequently been challenged, for example in Geoffrey Brandwood's (1984) review of restoration in Leicestershire churches, and Dav Smith (2014) has more recently demonstrated through close archaeological analysis of completed schemes that restorations could be both archaeologically literate and painstakingly executed. This partial rehabilitation is pertinent, since the division between 'living' and 'dead' monuments discussed above was used in the original legitimization of restoration. As Jukka Jokilehto (2010: 29) observes, the debate resolved into the view that living buildings 'such as old churches that were still used [...] should be restored taking into account the present-day needs', whereas restoration should be avoided for the material remains of an ancient civilization. The distinction was still being made in the early twentieth century by Professor C Weber (Jokilehto 1999: 196), and as already noted at the Madrid Conference of 1904.

Françoise Choay (2001) examines the idea of the historic monument, describing how it was an invention born in the immediate aftermath of the French Revolution as a necessary response to the confiscation of historic property from both the Church and the aristocracy. Whatever one's view of the French Revolution, implicit in this initial definition of the historic monument is the building's removal from its original cultural context; it is partly against that background that it became necessary to distinguish the 'living' from the 'dead'. It is interesting to note that heritage law in England has from its inception differentiated between buildings on the one hand and monuments on the other (Mynors 2006: 13). This distinction is reinforced in the specific case of church buildings: referring to the Ancient Monuments and Archaeological Areas Act 1979, s.61(7), Charles Mynors (2006: 567) notes that 'Even today the definition of monument specifically excludes "an ecclesiastical building in use for ecclesiastical purposes"'. While international conservation makes broader use of the word 'monument' – for example in Article 1 of the World Heritage Convention (UNESCO 1972) – this distinction is nevertheless useful.

Clearly some historic structures are overtly 'monumental' in the narrow sense, as recognized by Alois Riegl in his category of 'deliberate commemorative value'. But these are in the minority. Much conservation theory ignores this critical distinction, for example by failing to distinguish between the conservation of historic monuments and artworks such as paintings and sculpture, on the one hand, and historic buildings that remain in beneficial use, on the other. It is interesting to note that Morris ([1877] 2017) explicitly uses the analogy of the artwork, complaining that even the best 'of the Restorations yet undertaken [...] have their exact analogy in the Restoration of an old picture'. Cesare Brandi ([1963] 2005) and Salvador Muñoz Viñas

(2005) present examples of the same blurring of categories in more recent conservation theory. Paul Eggert (2009) adopts a more nuanced approach, comparing the work of conservators of both historic buildings and artworks together with his own work as an academic editor of historic texts. Eggert distinguishes between treating buildings as mere objects of historical study, or as 'works'. The meanings of a work cannot be fully determined in the act of its creation; rather, both time and the agency of successive generations are central to the ongoing development of its meaning, such that the work is 'constituted by an unrolling semiosis across time, necessarily interwoven in the lives of all who create it, gaze at it or read it' (Eggert 2009: 237). Similarly, Stephen Prickett sees the works of Shakespeare as having been progressively enriched by subsequent readers; thus 'Shakespeare' is 'not a fixed object, but a still-flowing conduit of ideas and emotions, a moving, inexhaustible tradition' (Prickett 2009: 230). For Prickett, likening literature to a palimpsest, fixity of meaning is replaced not with anarchy but with 'the dynamic of the ongoing debate'. And if a work – in our case a historic building – is an 'ongoing debate' then it must therefore be unfinished.

Significance and values in the contemporary conservation framework

The notion of cultural significance was introduced into international conservation with the *Venice Charter* (ICOMOS 1964), but it was only in the *Burra Charter* (Australia ICOMOS 2013) – whose full name is the *Australia ICOMOS Charter for Places of Cultural Significance* – that this was elaborated. First created in 1979 as a local application of the principles of the *Venice Charter*, the *Burra Charter* addressed the specific need for a common framework that could address the claims of both colonial and Indigenous forms of heritage. Subsequently it has achieved much wider application, and in retrospect marked a significant shift from the original Western focus on tangible forms of heritage towards an increasing acknowledgement of intangible aspects. It takes the previous passing reference to 'cultural significance' and makes it central to the conservation process, defining this in terms of 'aesthetic, historic, scientific, social or [subsequently] spiritual value for past, present or future generations' (Art. 1). Unlike the *Venice Charter*, its concern is not 'historic monuments' but the much broader category of 'places', and it defines the purpose of conservation as the retention of the cultural significance of those places (Art. 1.4). It is acknowledged that 'cultural significance may change over time and with use' (Art. 1.2 note) and that the range of cultural values may vary between people, and indeed conflict (Arts 1.2, 13).

The policy framework within which conservation in England operates is set by Historic England, the government's expert advisor on heritage, and offers another example of local practice in dialogue with international charters. The foundational policy document is *Conservation Principles* (Historic England 2008), alongside which stand numerous publications dealing with particular areas of heritage by issue or sector. Central to *Conservation Principles* is the notion of significance, which is defined as 'the sum of the cultural and natural heritage values of a place, often set out in a statement of significance'; in turn a value is defined as 'an aspect of worth or importance, here attached by people to qualities of places' (Historic England 2008: 72). In this and much else, the framework draws heavily on the *Burra Charter*.

Conservation Principles defines conservation as:

> The process of managing change to a significant place in its setting in ways that will best sustain its heritage values, while recognising opportunities to reveal or reinforce those values for present and future generations.
>
> (Historic England 2008: 71)

This definition, while very helpful, begs the question of what sort of change is envisaged. As already touched upon, the word 'change' can be used both in the passive sense for processes associated with the effects of weather and the passage of time – broadly the context in which Bernard Feilden coined the term – and in the more active sense for alterations arising from creative responses to the pressures of use. Where elective change is concerned, and in the absence of a theoretical framework for living buildings, 'managing change' very easily becomes 'managing (to avoid) change', with the bracketed words rarely spoken but always understood. Conservation professionals may present themselves as, and indeed honestly believe themselves to be, engaged in the former activity, but without an adequate theory of change may unknowingly stray into the latter, which more closely matches the common perception of many communities that engage with conservation, as becomes apparent when the views of those groups are sought.

The current version of *Conservation Principles* was written in anticipation of revised heritage legislation that never progressed through Parliament, leaving some obvious discrepancies with the prevailing legislation. In late 2017 a draft of a fully revised document was issued for consultation which attempted to address those discrepancies, but in doing so moved decisively away from the consensus in international conservation, for example replacing the familiar framework of values with a reduced set of 'interests', and demoting the communal/social to an aspect of historic interest. The

consultation produced a great deal of negative comment, and at the time of writing a more fundamental revision is understood to be in preparation.

Conservation Principles also draws on the *Nara Document* (UNESCO 1994), which positions itself as another elaboration of the *Venice Charter*, in the context of the 'expanding scope of cultural heritage concerns' (Art. 3). Michael Falser outlines the discussions behind its development, and quotes Marc Laenen's description of heritage as a living 'expression in its continuity of social and cultural functions' (2010: 122). Heritage is thus dynamic in character, and constantly 'builds up layers of social and cultural stratigraphy'; by implication, 'heritage qualities' must remain renegotiable (ibid.). This is a quite different approach to the *Venice Charter*, whose opening sentence famously proclaims that:

> Imbued with a message from the past, the historic monuments of generations of people remain to the present day as living witnesses of their age-old traditions.

Ongoing use, while desirable, 'must not change the lay-out or decoration of the building' (ICOMOS 1964 Art. 5). The clear implication of the *Venice Charter* is that these monuments are the remnants of a by-gone age and are 'living' only in the minimal sense of having survived as witnesses to the passage of time.

Both of these approaches – of fluidity and stasis, or in Insall's terms 'making' and 'keeping' – retain currency; the key difference between them is the extent to which the contemporary culture is seen to be in continuity with, or discontinuity from, what came before. Rodney Harrison similarly notes that 'official' forms of heritage adopt a clear distinction between the past and the present, while 'unofficial' models of heritage are characterized 'as "continuous", in the sense in which they emphasise the connection between the past and the quotidian present' (2013: 18). This tension is evident through all the above documents in the extent to which significance, and heritage more generally, is seen on the one hand as a finite resource that can only be depleted – in which case elective change can only be seen as harm – or on the other as a renewable one. For example, the *Venice Charter* asserts our duty to hand 'historic monuments' on 'in the full richness of their authenticity'. In an English context, the more recent *National Planning Policy Framework* ('NPPF'; Ministry of Housing, Communities and Local Government 2019: 184) describes heritage assets as 'irreplaceable', while in cases of 'less than substantial harm to the significance of a designated heritage asset, this harm should be weighed against the public benefits of the proposal' (2019: 196). Once again, the judgement of how 'substantial'

is the degree of 'harm' will vary widely depending on one's understanding of significance, of what it is that is being conserved, and of the nature of change; to frame it as a question of degree masks what is a question of principle.

For Kate Clark, values-based conservation enables communities to connect to the historic environment in ways that previously were not possible; Clark was herself involved in the drafting of *Conservation Principles* and argued strongly for the values system. In her subsequent review of values-based heritage management in the United Kingdom, she notes the significant change in methodology stemming from the *Burra Charter*'s emphasis on significance:

> Values-based management involved a fundamental intellectual shift from heritage decisions based purely on the individual expertise of the heritage professional to a more transparent process of analysis and diagnosis. Ultimately, values-based management was more than a process; it was a different way of thinking about cultural heritage.
>
> (Clark 2014: 65–66)

Clark notes with regret the reluctance of many within Historic England to engage with what we could call this 'values agenda', preferring instead to focus on significance (pers. comm.); in her view, since the determination of significance remains the province of the expert, this has the effect of keeping heritage out of the hands of the communities to which it belongs. The *Burra Charter* calls for the *participation* of people in the conservation, interpretation and management of heritage (Art. 12), but there is nothing beyond this about local *ownership* of that heritage, and the *Charter* has been criticized for doing nothing to challenge the assumption of authority by experts (Waterton et al. 2006). A focus on significance provides no guarantee against the co-option of the process to more ideologically conservative ends.

If Clark can be described as a 'values-optimist', the position taken in this book is that of the 'values-sceptic'. A coherent values system in conservation was first articulated by Alois Riegl ([1903] 1996) in a resolutely neo-Kantian philosophical context in which values were *the* central philosophical idea (Schnädelbach 1984). Values were first deployed to account for meaning within a positivist philosophical outlook; on this view material things have meaning through people 'attaching' values to them. This language of attachment has endured and is seen throughout the literature; for example, *Conservation Principles* makes constant reference to 'attachment', including in its definition of a value, as noted above. As I have argued elsewhere (Walter

2014), this is a flawed foundation for conservation, with the result that a values-based methodology cannot deliver on its promises. Aside from being philosophically suspect, the implication of treating meaning as assembled from discrete 'gobbets of significance' is that any values that might be added, particularly an intangible class such as communal value, can just as readily be bracketed or entirely detached. In this way the interests of the local and communal are easily marginalized, and the values system collapses back into Laurajane Smith's (2006) AHD. Chapters 4 and 5 attempt to address this deficit in the exploration of an alternative philosophical foundation.

A new heritage paradigm?

When Gustavo Araoz became ICOMOS president in 2008, he called for a new heritage paradigm, in the context of significant changes in government and public sector perceptions of heritage:

> Everywhere the heritage conservation community is increasingly finding that the professional toolkit and the doctrinal foundation on which it has relied for decades [...] for an ethical practice are insufficient to effectively deal with these new demands which are often perceived as threats.
>
> (Araoz 2011: 56)

Araoz's intervention came in the form of a paper delivered to the ICOMOS Advisory Committee in Valletta in October 2009, central to which is the notion of the historic environment's 'tolerance for change'. This paper subsequently formed the focus of two meetings of the ICOMOS International Scientific Committee for Theory and Philosophy of Conservation and Restoration (TheoPhilos) (Lipp et al. 2012). The previous ICOMOS President, Michael Petzet, was vociferous in his opposition. He characterized conservation as the management of change as an 'inconsiderate [unconsidered?] general proposal', and suggested that:

> the core ideology of our organization is being counteracted. After all, conservation does not mean "managing change" but preserving, – preserving, not altering and destroying: ICOMOS [...] is certainly not an International Council on Managing Change.
>
> (Petzet 2009: 9)

In the TheoPhilos volume, Petzet complains bitterly that his 2009 publication was blacklisted 'because of a few harmless remarks' (Petzet 2012: 53);

in challenging Araoz's paper, he had complained that it 'somehow seems to be based on an "Australian" heritage philosophy [which] is quite confusing and suitable for damaging the traditional objectives of monument conservation' (Petzet 2009: 10–11). In the subsequent version the key phrase was revised to a no less damning 'very strange heritage philosophy' (Petzet 2012: 54). Petzet's preservationism is evident; the title of both versions of his paper is 'Conservation *or* managing change?' (emphasis added).

Stepping away from individual buildings, historic urban landscape is a subdiscipline in which conservation is forced to address a living form of heritage that is subject to change: the *Valletta Principles* acknowledge that 'Historic towns and urban areas, as living organisms, are subject to continual change' (ICOMOS 2011: 4). For Araoz, this is an area of conservation:

> where values have also expanded from being assumed to rest entirely in its urban fabric and its building morphologies toward the dynamic nature of the city and its inherent role in providing a vibrant setting for communal life and an incubator for creativity. In other words, an important cultural value of the historic city rests precisely upon its ability to be in a constant evolution, where forms, space and uses are always adapting to replace obsolescence with functionality. This gives rise to the paradox – or perhaps the oxymoron – of the concept of preserving the ability to change.
>
> (Araoz 2011: 58)[2]

Petzet ends his attack on Araoz's proposal by engaging with the same issue, but seeking to draw a distinction between past and contemporary forms of change:

> given the dramatic changes in our cities, villages and cultural landscapes, which cannot be compared with the gradual changes in past centuries, the common reasoning that there has always been change and that the quasi natural process of demolition and new building has time and again generated an attractive urban development, becomes obsolete given the uniformity of modern mass-production dictated almost exclusively by economic considerations. Therefore, instead of an a priori 'tolerance for change' based on whatever standards, which would condemn our colleagues working in conservation practice merely to act as supernumeraries (only watching change?), we should stick to our fundamental principles and fight for cultural heritage in a dramatically changing world.
>
> (Petzet 2009: 12)

Petzet is arguing against *unconstrained* change, and he is surely right to be concerned in that regard. But not all change is unconstrained, and this book argues that what Araoz says of historic urban areas is equally true of historic living buildings; the issue for conservation is how change should be constrained.

The difference can be summed up by distinguishing two views of continuity. Petzet adopts an 'either/or' view, that change stands in opposition to continuity, for example, declaring that 'To maintain continuity needs a serious controlling of change' (Petzet 2009: 101). For Petzet, continuity is another word for preservation – he explicitly makes the link in a commentary on the *Venice Charter* (Petzet 2009: 15) – for keeping things the same, for freezing historic buildings in time. Contrast this with Araoz, for whom change and continuity must co-exist. The latter approach is far more compatible with living heritage, where the concern is for the continuity of the totality of building and people (Poulios 2014; Wijesuriya 2015). It is unsurprising that Petzet does not engage at all with the concerns of living heritage.

1.3 Wider heritage concerns

As signalled at the outset, context is a central concern of this book; it is appropriate, therefore, to set the above discussion of people and change in conservation in the wider context of some adjacent disciplines. This section briefly considers some themes from heritage studies and anthropology, including the social construction of reality, the perennial interest in agency and the specific notion of material vitality. The aim of this engagement is to point towards distinct but related areas of theory that might have application to conservation.

Heritage studies

Alongside the development of a values-based conservation, the 1980s also saw the emergence of heritage studies within the disciplines of history and archaeology, dealing with the same material remains that are the concern of conservation, but within a quite different theoretical framework. Where the groundwork for conservation was laid in the nineteenth century when experts and public each 'knew their station', heritage studies emerged in a postmodern and postcolonial context. Central themes from the outset were the lack of a single approved version of history and thus the contestability of authority claims. This led to an inevitable unsettling of prevailing assumptions:

For heritage this meant a challenge, for example, to established views about how importance (and thus the status of preservation) is granted. The result was that not only established practices, but also their epistemological basis, were questioned and challenged.

(Carman & Sørensen 2009: 17)

Conservation, for whatever reasons, has been slow to follow this lead, and the familiar focus on material authenticity and the art historical, sometimes clothed in the language of significance, has largely endured, as seen earlier in Petzet's vehement opposition to Araoz's suggestion of a 'new heritage paradigm'.

The late geographer Denis Cosgrove addressed this same contrast when he criticized the preliminary paper of the 1992 Dahlem Workshop on Durability and Change, which had proclaimed:

an urgent need to sustain our cultural heritage through preserving 'irreplaceable artefacts' of 'cultural value'. This phrasing already reifies culture, relating it through an art object to a set of shared, apparently authentic meanings whose canonical values and ideological significance are not so much taken for granted as simply unexamined. [...] Culture and identity cannot be captured within an unproblematic concept of heritage, rather they are constantly invented and reinvented; they are mobile and subversive.

(Cosgrove 1994: 260)

This 'mobility' of heritage is consistent with, and a constituent part of, the idea of living buildings discussed in this chapter. That heritage might also be capable of 'subversion' will appear thrilling for some and profoundly unsettling for others, depending perhaps on how much one has invested in heritage 'staying still' and 'doing what it's told', that is, the extent to which heritage remains 'obedient' to the norms and processes imposed upon it.

Another prevalent theme in heritage studies is the social construction of reality, for example implied in the view that 'all heritage [is] inherently intangible' (Smith 2006: 56). Social constructionism comes in a variety of forms, but all hold that knowledge is in some sense constructed rather than discovered; it follows that it is not disinterested or inert, but political, and therefore contested. This is highly relevant to the reaction to change in the historic environment: if the significance of a historic building is socially constructed today, then why should it not be reconstructed tomorrow? Under this view, in principle everything is contestable and therefore changeable, and culture is 'hypermutable'. For those from a conventional conservation

background this is deeply suspect, and enough of a concern for some to dismiss heritage studies in its entirety. Mapping this onto the tripartite division of ethics outlined in Section 1.1 above, this is the meeting (and mutual incomprehension) of the universal and subversive approaches.

Furthermore, the social construction of reality is an activity that, by implication, happens only in the here and now. It is not that the past is unacknowledged; in the context of discussing the social construction of cultural landscapes, Denis Byrne (2008: 155) notes that 'we in the present landscape are thus always in a form of contact with those who occupied it before us. Their presence interacts with our presence'. For Byrne, the present generation are not merely passive recipients of culture, but its owners and modifiers; thus, 'the significance or meaning of heritage places is simultaneously inherited and reinvented by the living' (2008: 162). This intergenerational dimension, specifically a historical understanding of how the preceding generations shaped our heritage, can perhaps provide a degree of boundedness to the fluidity of a socially constructed heritage. We used to call this boundedness 'tradition', yet the prevailing understanding would lump tradition into Smith's AHD as a form of top-down, universal ethics, such that the relevance of tradition will either be missed or ruled inadmissible. G.K. Chesterton (1908) declared that 'Tradition is only democracy extended through time', suggesting an intergenerational dialogue between the present and the past. This book follows Chesterton's lead in treating tradition as itself discursive, an active conversation between the present and earlier generations, reaching back to antiquity. The nature of tradition and the role of hermeneutics is explored further in Chapter 4.

Agency and material vitality

To regard the material world as inanimate is a commonplace of modernity and a natural corollary of the privileging of the human subject over against a supposedly 'objective' material world. These are perhaps the most basic of classifications for the modern mind, and ones we mostly take for granted. Nevertheless, they are being questioned: for example Arjun Appadurai's exploration of the 'social life of things' (1986) marked for him the beginning of a continuing engagement 'with the idea that persons and things are not radically distinct categories' (2006: 15). The notion that objects mediate social agency has been developed further in anthropology and archaeology (e.g. Kopytoff 1986; Olsen 2003; Hodder 2007). The remainder of this section samples some alternative readings of the material world – alluded to above as 'disobedient' and by Jane Bennett (2010) as 'recalcitrant' – that might fruitfully inform our approach to historic buildings.

Agency is widely acknowledged to be a fundamental theme for archae-ology, but one by which different authors can mean quite different things. In describing the disputed relationship between people and material cul-ture, Dobres and Robb (2000: 12) sketch out a theoretical spectrum from a view of agency as a question of intentionality in which 'the material world is created and manipulated by more or less freely acting individ-uals', to another in which 'meanings and values, histories and biographies, even personhood and agency can be attributed to material things' and our material culture therefore actively constructs us. Stewart Brand's approach discussed above grants buildings agency in this latter sense – they 'learn', act', 'are mortified', and so forth. Archaeologist Chris Gosden argues that houses are the 'containers, shapers and complex products of human action all at once' (Gosden 2010: 41). In a very different context Winston Churchill captured the poles of possibility with the simple for-mulation, delivered during a debate on how to rebuild the bomb-damaged House of Commons, that 'We shape our buildings, and afterwards our buildings shape us' (UK Parliament 1943). The first approach – agency as intentionality – operates within a modern paradigm and is concerned with individuality and the Marxian interplay of agency and structure; the second approach transgresses the limits of modernity and reflects a broader concern to challenge the watertight division between subject and object. Each, therefore, flows from a very different anthropology; it is the second pole that is of greater relevance to the themes of this book, and it is anthropologists who will be our guides.

The philosopher and anthropologist Bruno Latour suggests in his book *We Have Never Been Modern* (1993) that one founding characteristic of modernity is a dichotomy between the natural and social worlds, using Robert Boyle and his contemporary Thomas Hobbes as exemplars. This 'separation of powers' is part of what Latour terms the 'modern constitu-tion'. Much is invested in clearing the ground between the social and natural poles, enforcing the separation through a work of 'purification'; in our con-text, ideas of living buildings and personification discussed above involve an unconstitutional 'deployment of networks' (Latour 1993: 49). In rewriting the constitution, Latour suggests retaining from the premoderns:

> their obsessive interest in thinking about the production of hybrids of Nature and Society, of things and signs, their certainty that transcendences abound, their capacity for conceiving of past and future in many ways other than progress and decadence, the multiplication of types of nonhumans different from those of the moderns.
>
> (Latour 1993: 133)

In Latour's terms, the living buildings that are a central concern of this book are just the sort of hybrid 'quasi-objects' (1993: 51) that defy the modern dualism of Nature and Society.

Drawing on Latour, Lambros Malafouris and Colin Renfrew (2010) speak of 'the cognitive life of things', arguing that archaeology is particularly well placed to reconsider our understanding of the relation of people to things. Noting that merely linking the material with the social has the result that things 'very often become a mere passive substratum for the social to project or imprint itself upon', they propose a more ambitious 'Material Engagement Theory' to account for the interrelation of mind and matter (2010: 2). In a close parallel to the understanding of buildings argued for here, they conclude, 'The cognitive life of things *is about things in motion*; it is about hybridity, fluidity and genuinely interactive relationships between brains, bodies and things' (2010: 9, emphasis original). Amongst the identified implications of this approach is that material culture must be taken much more seriously as a cognitive extension; that our understanding of the temporality of human thought is changed; that the conventional focus on objects as end products should be balanced with a concern for the processes of their formation; and ultimately that the cognitive life of things challenges what it means to be human (ibid.).

The anthropologist Alfred Gell framed the importance of a work of art not as a question of aesthetics or visual communication, but as what it *does* in the context of social relations. Like Latour, he explores 'a domain in which "objects" merge with "people" by virtue of the existence of social relations between persons and things' (1998: 12). For Gell, this is not agency of the sort we enjoy as human agents, but 'the kind of second-class agency which artefacts acquire once they become enmeshed in a texture of social relationships' (1998: 17). Gell describes both the *oeuvre* of an artist and entire classes of art as 'distributed objects' which extend the agency of those who created them through time. Daniel Miller (2005: 13) registers this difference of approach, observing that:

> while Latour is looking for the nonhumans below the level of human agency, Gell is looking through objects to the embedded human agency we infer that they contain.

The particular case of the historic building produced over multiple generations is not considered by any of these authors but combines these notions of hybridity and the distributed object. In this light, the treatment of objects as mere carriers for meanings attached by humans in the present – as envisaged by the *Burra Charter, Conservation Principles*, and so

forth – appears grossly simplistic. It is also wholly inappropriate to the subject matter, since it demands that the middle ground between people and objects is cleared of the hybridity that seems essential to the full understanding of living buildings.

The medieval world would have found modernity's sharp distinction between people and things both strange and artificial. Caroline Walker Bynum (2001) has explored the prominence of hybridity and metamorphosis across the breadth of medieval culture; both, of course, involve change and were matched by a complementary concern with identity, all of which are of relevance to this discussion. In her later *Christian Materiality*, she describes the medieval understanding of matter as 'by definition labile, changeable and capable of act' (2011: 283). It is this *lability* – a liability to change – that best sums up the difference between the medieval and modern assumptions about matter. Since the medieval world laid the foundation for the modern, this sharply different view is of relevance not only to its medieval context, but potentially to the full range of contemporary discourse on material culture. While Bynum makes clear that she is not proposing a general theory of materiality, she does acknowledge the parallels with Latour, Gell, Miller, and others (2011: 31). Similarly, a comprehensive theory of material culture is beyond the scope of this book; it is, however, important to acknowledge that modernity's approach to the material world as a passive resource, an understanding that contemporary conservation practice takes for granted, is particularly ill-suited to dealing with the question of change to historic buildings, medieval or otherwise.

1.4 Structure of the book

The narrative approach set out in these pages aims to address the central question of change in historic settings, starting from the experience of current conservation processes often dealing badly with the particular concerns of living historic buildings. The book firstly surveys the current state of conservation, starting with the forces that shape the conservation process and the often unacknowledged theoretical understanding that undergirds it, and then looking at the role assigned within conservation processes to the communities most closely related to historic buildings. It then attempts to build an alternative framework that addresses some of the identified contradictions, from an alternative philosophical foundation. Finally, in a return to the practical, the implications of this alternative foundation are explored.

Concealed beneath the surface of the conservation process is a framework of interpretation which demands excavation and critique. Chapter 2

takes a critical look at the development of modern conservation in the West, including its response to two traumatic episodes of unnecessary loss of historic fabric, the first resulting from the nineteenth-century passion for the restoration of historic buildings, already touched on, and the second from the wave of reconstruction following World War II. Both of these were seen in terms of national crisis, both were met with a vigorous response, and both remain central to the self-understanding of the conservation movement. They mark out the intellectual territory within which conservation currently operates and establish the character of contemporary conservation discourse. Since conservation is as much a cultural as a technical phenomenon, Chapter 3 considers the experience of the conservation process by non-professionals and provides the 'bottom up' view of the current system.

Like any other cultural area, conservation practice cannot fail to reflect the theoretical commitments on which it is built. Since conservation is concerned with the well-being of the material production of 'traditional' cultures, an understanding of tradition is central. From its roots in the Enlightenment, a central tenet of modernity has been the overthrow of tradition, presenting a profound irony at the heart of conservation – itself the product of modernity – that requires theoretical exploration. (The particular case of the conservation of non-traditional buildings such as modernist architecture is, I suggest, the exception that proves the rule.) The philosopher Alasdair MacIntyre (1985, 1988, 1990) provides one of the most cogent reflections on the contemporary relevance of tradition, exploring some of the resources offered by premodernity that may be of use to us today, and connecting tradition to practices and narrative. Writing at a similar time, Paul Ricoeur (1984, 1985, 1988) explores the relation of temporality and narrative. These two linked themes of tradition and narrative form the focus of Chapters 4 and 5, respectively. Given this overarching concern with the interrelation of theory and practice, the approach taken is an unapologetically hermeneutic one. This focus on interpretation, far from marking a retreat into philosophical abstraction, represents an insistence that practice and theory should be mutually engaged and constantly informing one another.

As well as tracing an alternative theoretical foundation for conservation, it is essential also to consider what impact such an alternative foundation would have on the practice of conservation. Chapter 6 therefore reconsiders three sets of questions of relevance to conservation professionals in light of the narrative approach that is taken, including issues both of principle and practice, and some that are more general in nature. The argument is therefore circular in structure, moving from a practical question encountered in professional life, via the current methodology, to theoretical concerns, and

back via a proposed theoretical foundation to the outlines of an alternative praxis. Taken as a whole, therefore, this research reflects Hans-Georg Gadamer's ([1960] 1989: 324) view – in the context of ethics as a 'model of the problem of hermeneutics' – that 'application is neither a subsequent nor merely an occasional part of the phenomenon of understanding, but co-determines it as a whole from the beginning'. Finally, while living buildings form the basis of this investigation, Chapter 7 concludes that the approach has much broader application to conservation as a whole.

Notes

1 Poulios was previously a consultant with ICCROM's Living Heritage Sites Programme, where he was supervised by Gamini Wijesuriya and Joe King.
2 It is instructive to compare the two versions of this paragraph, which show Araoz strengthening his argument.

References

Appadurai, A. (1986). Introduction: Commodities and the Politics of Value. In: A. Appadurai (ed.) *The Social Life of Things: Commodities in Cultural Perspective*. Cambridge and New York: Cambridge University Press. pp. 3–63.

Appadurai, A. (2006). The Thing Itself. *Public Culture*, 18 (1): 15–22.

Appiah, K.A. (2016). *Reith Lectures 2016: Lecture 1: Creed*. [Online]. Available at: http://downloads.bbc.co.uk/radio4/transcripts/2016_reith1_Appiah_Mistaken_Identies_Creed.pdf.

Araoz, G.F. (2011). Preserving Heritage Places under a New Paradigm. *Journal of Cultural Heritage Management and Sustainable Development*, 1 (1): 55–60.

Australia ICOMOS (2013). *The Burra Charter: The Australia ICOMOS Charter for Places of Cultural Significance, 2013*. Burwood: Australia ICOMOS.

Bennett, J. (2010). *Vibrant Matter: A Political Ecology of Things*. Durham, NC, and London: Duke University Press.

Brand, S. (1994). *How Buildings Learn: What Happens after They're Built*. New York and London: Viking.

Brandi, C. ([1963] 2005). Theory of Restoration. (C. Rockwell, trans.). In: G. Basile (ed.) *Theory of Restoration*. Firenze: Nardini Editore. pp. 43–170.

Brandwood, G.K. (1984). *Church Building and Restoration in Leicestershire, 1800–1914*. Leicester: University of Leicester. PhD thesis.

Bynum, C.W. (2001). *Metamorphosis and Identity*. New York: Zone Books.

Bynum, C.W. (2011). *Christian Materiality: An Essay on Religion in Late Medieval Europe*. New York: Zone Books.

Byrne, D. (2008). Heritage as Social Action. In: G.J. Fairclough, R. Harrison, J.H. Jameson, & J. Schofield (eds.) *The Heritage Reader*. Abingdon and New York: Routledge. pp. 149–173.

Carman, J. & Sørensen, M.L.S. (2009). *Heritage Studies: Methods and Approaches*. Abingdon and New York: Routledge.

Chesterton, G.K. (1908). *Orthodoxy*. New York: Dodd, Mead & Co.

Chitty, G. (2003). Ruskin's Architectural Heritage: The Seven Lamps of Architecture – Reception and Legacy. In: R. Daniels & G.K. Brandwood (eds.) *Ruskin and Architecture*. Reading: Spire Books. pp. 25–54.

Chitty, G. (2017). Introduction: Engaging Conservation – Practising Conservation in Communities. In: G. Chitty (ed.) *Heritage, Conservation and Communities: Engagement, Participation and Capacity Building*. Abingdon and New York: Routledge. pp. 1–14.

Choay, F. (2001). *The Invention of the Historic Monument*. (L.M. O'Connell, trans.). Cambridge: Cambridge University Press.

Clark, K. (2014). Values-Based Heritage Management and the Heritage Lottery Fund in the UK. *APT Bulletin*, 45 (2/3): 65–71.

Cosgrove, D.E. (1994). Should We Take It All So Seriously? Culture, Conservation, and Meaning in the Contemporary World. In: W.E. Krumbein, P. Brimblecombe, D.E. Cosgrove, & S. Staniforth (eds.) *Durability and Change: The Science, Responsibility, and Cost of Sustaining Cultural Heritage*. Chichester: Wiley. pp. 259–268.

Davies, J.G. (1968). *The Secular Use of Church Buildings*. London: S.C.M. Press.

Deleuze, G. & Guattari, F. (1987). *A Thousand Plateaus: Capitalism and Schizophrenia*. (B. Massumi, trans.). Minneapolis: University of Minnesota Press.

Dobres, M.-A. & Robb, J.E. (2000). Editors' Introduction. In: M.-A. Dobres & J.E. Robb (eds.) *Agency in Archaeology*. Abingdon and New York: Routledge. pp. 3–17.

Earl, J. (2003). *Building Conservation Philosophy*. 3rd ed. Shaftesbury: Donhead.

Ecker, H. (2003). The Great Mosque of Córdoba in the Twelfth and Thirteenth Centuries. *Muqarnas*, 20: 113–141.

Eggert, P. (2009). *Securing the Past: Conservation in Art, Architecture and Literature*. Cambridge: Cambridge University Press.

Esher, L. (1981). *A Broken Wave: The Rebuilding of England 1940–1980.* London: Allen Lane.

Falser, M.S. (2010). From Venice 1964 to Nara 1994 – Changing Concepts of Authenticity? In: M.S. Falser, W. Lipp, & A. Tomaszewski (eds.) *Conservation and Preservation: Interactions between Theory and Practice: In Memoriam Alois Riegl (1858–1905)*. Firenze: Edizioni Polistampa. pp. 115–132.

Fawcett, J. (1976). A Restoration Tragedy: Cathedrals in the Eighteenth and Nineteenth Centuries. In: J. Fawcett (ed.) *The Future of the Past: Attitudes to Conservation 1174–1974*. London: Thames and Hudson. pp. 74–115.

French, K.L. (2001). *The People of the Parish: Community Life in a Late Medieval English Diocese*. Philadelphia: University of Pennsylvania Press.

Gadamer, H.-G. ([1960] 1989). *Truth and Method*. (J. Weinsheimer & D.G. Marshall, trans.). 2nd rev. ed. London: Sheed and Ward.

Gell, A. (1998). *Art and Agency: An Anthropological Theory*. Oxford: Clarendon Press.

Gosden, C. (2010). The Death of the Mind. In: L. Malafouris & C. Renfrew (eds.) *The Cognitive Life of Things: Recasting the Boundaries of the Mind*. Cambridge: McDonald Institute for Archaeological Research. pp. 39–46.

Grimmer, A.E. (2017). *The Secretary of the Interior's Standards for the Treatment of Historic Properties: With Guidelines for Preserving, Rehabilitating, Restoring & Reconstructing Historic Buildings*. Washington, DC: National Park Service.

Harrison, R. (2013). *Heritage: Critical Approaches*. Abingdon and New York: Routledge.

Historic England (2008). *Conservation Principles: Policies and Guidance for the Sustainable Management of the Historic Environment*. London: English Heritage.

Historic England (2012). *New Work in Historic Places of Worship*. 2nd ed. London: English Heritage.

Historic England & Countryside Agency (2006). *Living Buildings in a Living Landscape: Finding a Future for Traditional Farm Buildings*. London: English Heritage.

Hodder, I. (2007). The 'Social' in Archaeological Theory: An Historical and Contemporary Perspective. In: L. Meskell & R.W. Preucel (eds.) *A Companion to Social Archaeology*. Oxford: Blackwell. pp. 23–42.

Hollis, E. (2010). *The Secret Lives of Buildings: From the Parthenon to the Vegas Strip in Thirteen Stories*. London: Portobello.

Hursthouse, R. & Pettigrove, G. (2016). Virtue Ethics. In: E.N. Zalta (ed.) *The Stanford Encyclopedia of Philosophy*. Metaphysics Research Lab, Stanford University. [Online]. Available at: https://plato.stanford.edu/archives/win2016/entries/ethics-virtue/.

ICOMOS (1964). *International Charter on the Conservation and Restoration of Monuments and Sites*. Paris: ICOMOS.

ICOMOS (1984). *Advisory Body Evaluation: The Mosque of Cordoba*. [Online]. Available at: https://whc.unesco.org/document/153175.

ICOMOS (2011). *The Valletta Principles for the Safeguarding and Management of Historic Cities, Towns and Urban Areas*. [Online]. Available at: www.icomos.org/Paris2011/GA2011_CIVVIH_text_EN_FR_final_20120110.pdf.

Ingold, T. (2013). *Making: Anthropology, Archaeology, Art and Architecture*. Abingdon and New York: Routledge.

Insall, D.W. (2008). *Living Buildings: Architectural Conservation: Philosophy, Principles and Practice*. Mulgrave, Victoria: Images.

Ireland, T. & Schofield, J. (2015). The Ethics of Cultural Heritage. In: *The Ethics of Cultural Heritage*. New York: Springer. pp. 1–10.

Japan ICOMOS (2014). *Nara + 20: On Heritage Practices, Cultural Values, and the Concept of Authenticity*. [Online]. Available at: www.japan-icomos.org/pdf/nara20_final_eng.pdf.

Jokilehto, J. (1999). *A History of Architectural Conservation*. Oxford: Butterworth-Heinemann.

Jokilehto, J. (2010). The Idea of Conservation – an Overview. In: M.S. Falser, W. Lipp, & A. Tomaszewski (eds.) *Conservation and Preservation: Interactions between Theory and Practice: In Memoriam Alois Riegl (1858–1905)*. Firenze: Edizioni Polistampa. pp. 21–36.

Kopytoff, I. (1986). The Cultural Biography of Things: Commoditization as Process. In: A. Appadurai (ed.) *The Social Life of Things: Commodities in Cultural Perspective*. Cambridge: Cambridge University Press. pp. 64–91.

Latour, B. (1993). *We Have Never Been Modern*. (C. Porter, trans.). Cambridge, MA: Harvard University Press.

Lipp, W., Štulc, J., Szmygin, B. & Giometti, S. (eds.) (2012). *Conservation Turn – Return to Conservation: Tolerance for Change, Limits of Change*. Firenze: Edizioni Polistampa.

Locke, W.J. (1904). Recommendations of the Madrid Conference. *The Architectural Journal, being the Journal of the Royal Institute of British Architects*, 9: 343–346.

Lowenthal, D. (1994). Criteria of Authenticity. In: K.E. Larsen & N. Marstein (eds.) *Conference on Authenticity in Relation to the World Heritage Convention – Preparatory Workshop*. Oslo: Tapir Forlag. pp. 35–64.

MacIntyre, A.C. (1985). *After Virtue: A Study in Moral Theory*. 3rd ed. London: Duckworth.

MacIntyre, A.C. (1988). *Whose Justice? Which Rationality?* London: Duckworth.

MacIntyre, A.C. (1990). *Three Rival Versions of Moral Enquiry: Encyclopaedia, Genealogy, and Tradition: Being Gifford Lectures Delivered in the University of Edinburgh in 1988*. London: Duckworth.

Malafouris, L. & Renfrew, C. (2010). The Cognitive Life of Things: Archaeology, Material Engagement and the Extended Mind. In: L. Malafouris & C. Renfrew (eds.) *The Cognitive Life of Things: Recasting the Boundaries of the Mind*. Cambridge: McDonald Institute for Archaeological Research. pp. 1–12.

Marris, P. (1986). *Loss and Change*. Rev. ed. London: Routledge & Kegan Paul.

Matthes, E.H. (2016). The Ethics of Historic Preservation. *Philosophy Compass*, 11 (12): 786–794.

Miller, D. (2005). Materiality: An Introduction. In: D. Miller (ed.) *Materiality*. Durham, NC and London: Duke University Press. pp. 1–50.

Ministry of Housing, Communities and Local Government (2019). *National Planning Policy Framework*. [Online]. Available at: https://assets.publishing.service.gov.uk/government/uploads/system/uploads/attachment_data/file/810197/NPPF_Feb_2019_revised.pdf.

Morris, W. ([1877] 2017). *The Society for the Protection of Ancient Buildings Manifesto*. [Online]. Available at: www.spab.org.uk/about-us/spab-manifesto.

Morton, W.B.I., Hume, G.L., Weeks, K.D. & Jandl, H.W. (1992). *The Secretary of the Interior's Standards for Rehabilitation & Illustrated Guidelines for Rehabilitating Historic Buildings*. Washington, DC: US Dept. of the Interior.

Muñoz Viñas, S. (2005). *Contemporary Theory of Conservation*. Oxford: Butterworth Heinemann.

Mynors, C. (2006). *Listed Buildings, Conservation Areas and Monuments*. Andover: Sweet & Maxwell.

Newman, J.H. ([1845] 1909). *An Essay on the Development of Christian Doctrine*. London: Longmans, Green.

Olsen, B. (2003). Material Culture after Text: Re-Membering Things. *Norwegian Archaeological Review*, 36 (2): 87–104.

Orbaşli, A. (2017). Conservation Theory in the Twenty-First Century: Slow Evolution or a Paradigm Shift? *Journal of Architectural Conservation*, 1–14.

Petzet, M. (2009). *International Principles of Preservation*. 20. Berlin: Hendrik Bäßler Verlag.

Petzet, M. (2012). Conservation or Managing Change? In: W. Lipp, J. Štulc, B. Szmygin, & S. Giometti (eds.) *Conservation Turn – Return to Conservation: Tolerance for Change, Limits of Change*. Firenze: Edizioni Polistampa. pp. 53–56.

Plutarch (n.d.). *Theseus*. [Online]. Available at: http://classics.mit.edu/Plutarch/theseus.html.

Poulios, I. (2014). *The Past in the Present: A Living Heritage Approach – Meteora, Greece*. London: Ubiquity Press.

Prickett, S. (2009). *Modernity and the Reinvention of Tradition: Backing into the Future*. Cambridge and New York: Cambridge University Press.

Ricoeur, P. (1984). *Time and Narrative, Vol. 1*. (K. McLaughlin & D. Pellauer, trans.). Chicago and London: University of Chicago Press.

Ricoeur, P. (1985). *Time and Narrative, Vol. 2*. (K. McLaughlin & D. Pellauer, trans.). Chicago and London: University of Chicago Press.

Ricoeur, P. (1988). *Time and Narrative, Vol. 3*. (K. Blamey & D. Pellauer, trans.). Chicago and London: University of Chicago Press.

Riegl, A. ([1903] 1996). The Modern Cult of Monuments: Its Character and Its Origin. (K. Bruckner & K. Williams, trans.). In: N.S. Price, M.K. Talley, & A. Melucco Vaccaro (eds.) *Historical and Philosophical Issues in the Conservation of Cultural Heritage*. Los Angeles, CA: Getty Conservation Institute. pp. 69–83.

Ruskin, J. ([1849] 1903). The Seven Lamps of Architecture. In: E.T. Cook & A.D.O. Wedderburn (eds.) *The Works of John Ruskin*. London: George Allen.

Schnädelbach, H. (1984). *Philosophy in Germany, 1831–1933*. (E. Matthews, trans.). Cambridge: Cambridge University Press.

Schumacher, E.F. (1973). *Small Is Beautiful: A Study of Economics as If People Mattered*. London: Blond and Briggs.

Schumacher, E.F. (1978). *A Guide for the Perplexed*. London: Abacus.

Scott, G.G. (1879). *Personal and Professional Recollections*. (G. Gilbert Scott, ed.). London: Sampson Low, Marston, Searle, & Rivington.

Sharp, T. (1968). *Town and Townscape*. London: Murray.

Smith, D.C. (2014). *Vandalism and Social Duty: The Victorian Rebuilding of the 'Street Parish' Churches, Ryedale, North Yorkshire*. York: University of York. PhD thesis.

Smith, L. (2006). *Uses of Heritage*. Abingdon and New York: Routledge.

Society for the Protection of Ancient Buildings (1884). *The Seventh Annual Meeting of the Society; Report of the Committee*.

Society for the Protection of Ancient Buildings (1891). *The Fourteenth Annual Meeting of the Society; Report of the Committee and Paper Read by W.B. Richmond*.

Stiefel, B.L. & Wells, J.C. (eds.) (2014). *Preservation Education: Sharing Best Practices and Finding Common Ground*. Hanover, NH: University Press of New England.

Stovel, H., Stanley-Price, N. & Killick, R.G. (eds.) (2005). *Conservation of Living Religious Heritage: Papers from the ICCROM 2003 Forum on Living Religious Heritage: Conserving the Sacred*. Rome: ICCROM.

Tschudi-Madsen, S. (1976). *Restoration and Anti-Restoration: A Study in English Restoration Philosophy*. Oslo: Universitetsforlaget.

UK Parliament (1943). *HC Deb 28/10/1943 Vol 393 C403*. [Online]. Available at: http://hansard.millbanksystems.com/commons/1943/oct/28/house-of-commons-rebuilding.

UNESCO (1972). *Convention Concerning the Protection of the World Cultural and Natural Heritage*. [Online]. Available at: http://whc.unesco.org/archive/convention-en.pdf.

UNESCO (1994). *The Nara Document on Authenticity*. [Online]. Available at: http://whc.unesco.org/document/9379.

UNESCO (n.d.). *Historic Centre of Cordoba*. [Online]. UNESCO World Heritage Centre. Available at: https://whc.unesco.org/en/list/313/.

Walter, N. (1991). *Proportion in Water: The Relation of Wisdom to the Aqueousness of Matter*. Cambridge: University of Cambridge, Dip. Arch. dissertation.

Walter, N. (2014). From Values to Narrative: A New Foundation for the Conservation of Historic Buildings. *International Journal of Heritage Studies*, 20 (6): 634–650.

Waterton, E., Smith, L. & Campbell, G. (2006). The Utility of Discourse Analysis to Heritage Studies: The Burra Charter and Social Inclusion. *International Journal of Heritage Studies*, 12 (4): 339–355.

Wells, S. (2004). *Improvisation: The Drama of Christian Ethics*. London: SPCK.

Wells, S. & Quash, B. (2017). *Introducing Christian Ethics*. 2nd ed. Oxford: Wiley-Blackwell.

Wijesuriya, G. (2015). *Annexe 1: Living Heritage: A Summary*. [Online]. Available at: www.iccrom.org/wp-content/uploads/PCA_Annexe-1.pdf.

Chapter 2

Modernity

Conservation, discontinuity, and the past

> The ancients, one would say, with their gorgons, sphinxes, satyrs, mantichora, etc., could imagine more than existed, while the moderns cannot imagine so much as exists.
>
> Henry David Thoreau ([1860] 1906)

The conservation of historic buildings is a modern project and cannot be rightly understood except through the concerns and commitments of modernity. Its development in the West can be seen as a response to two traumatic episodes of unnecessary loss of historic fabric: first, the nineteenth-century passion for the restoration of historic buildings and, second, the wave of reconstruction following World War II. While conservation has not generally been good at reflecting on the theoretical context of its processes and principles, in its more recent development it does at least consider physical context to be of relevance. This invites us to think in terms of the broader landscape within which a given building sits, and to focus not just on the building or the part of the building in question, but to consider its relation to the whole. This is helpful with respect to relating a building to its physical context, but it is equally necessary, and I argue more urgently needed, in terms of relating the practices of conservation to their cultural context.

2.1 The development of conservation

Restoration

The Society for the Protection of Ancient Buildings (SPAB) is an important and animating force for good in conservation in the United Kingdom, and with broader influence much further afield. Its founding *Manifesto* (Morris [1877] 2017) was William Morris's response to the first of the two traumas outlined here, and its importance extends far beyond its original nineteenth-century context, continuing to inform the self-understanding of modern

conservation. For the organization itself it remains a central point of reference, and one to which members are still required to assent; its influence is evident in the subsequent development of international policy, such as the *Venice Charter* (ICOMOS 1964), and it therefore merits some detailed consideration.

The *Manifesto* is an attack on the 'strange and most fatal idea' of restoration, particularly as applied to medieval church buildings. For Morris, historic buildings cannot now be altered without despoiling them: 'Our ancient buildings [are] monuments of a bygone art [...] that modern art cannot meddle with without destroying'. Where an ancient church ceases to meet a congregation's needs, he suggests it is better 'to raise another building rather than alter or enlarge the old one'. The novelist Thomas Hardy, himself a long-term member of SPAB, gave this prescription an additional twist with his subsequent suggestion that a ruinous church could be enclosed in a 'crystal palace' and a new church built alongside for parish use (Hardy [1906] 1967: 205). Whether literally or figuratively, placing an old building into a glass case is to turn it into a museum exhibit, radically altering its status. If, as will be argued, heritage lies precisely in the intimate interplay of people and material culture, then conservation on this model risks destroying heritage in the very act of its preservation, just as do the actions of the trophy hunter or the collector of rare eggs in the natural world.

Morris saw his contemporaries as abusers of the past, and drew a sharp distinction with the way in which ancient buildings had previously changed:

> a church of the eleventh century might be added to or altered in the twelfth, thirteenth, fourteenth, fifteenth, sixteenth, or even the seventeenth or eighteenth centuries; but every change, whatever history it destroyed, left history in the gap, and was alive with the spirit of the deeds done midst its fashioning.
>
> (Morris [1877] 2017)

And there was indeed a sharply observable difference in the way the nineteenth century typically dealt with historic buildings. But what does it mean to 'leave history in the gap'? And what is meant by 'the spirit of the deeds done midst its fashioning'? By setting up an opposition between a modern understanding of old buildings and an earlier one which it replaced, Morris raises the question of how we relate to the tradition that created these historic buildings whose care is conservation's concern. He urges architects in particular, and the public generally, 'to remember how much is gone of the religion, thought and manners of time past'. Morris emphasizes – declaring

that 'it cannot be too often repeated' – that the 'living spirit' of those buildings was 'an inseparable part' of that tradition. Because for him the tradition was as good as dead, so too was the physical manifestation of that tradition; and for this reason, 'leaving history in the gap' was no longer possible. For Morris, therefore, the only legitimate option for such buildings was preservation.

Precisely because Morris's *Manifesto* has endured from the nineteenth century, it is essential to read it in context: this is the work of interpretation that any historic text demands of us, and indeed a failure to do this work would be to make the very same hermeneutic mistake that so outraged Morris. His target is the nineteenth-century romantic approach which failed to recognize historical distance and imagined that a nineteenth-century modern could compose a sixteenth-century sonnet or build a thirteenth-century church just as authentically as his predecessors, provided he learned the appropriate style for its composition. There is no argument that architecture was one of the cultural disciplines most affected by this romanticism, and Morris had good grounds for opposing this naïve vision of effortless cultural continuity, which facilitated the worst excesses which SPAB was established to counter. Morris ([1877] 2017) writes that the restorers:

> have no guide but each his own individual whim to point out to them what is admirable and what contemptible; [which] compels them [...] to supply the gap by imagining what the earlier builders should or might have done.

The nineteenth-century French architect Eugène Viollet-le-Duc epitomizes what Morris opposed, with his oft-quoted assertion that 'To restore a building is not to preserve it, to repair, or rebuild it; it is to reinstate it in a condition of completeness that could never have existed at any given time' (Hearn 1990: 269).

But in avoiding the first trap of a simplistic cultural continuity Morris falls into the next, by positing a radical *discontinuity*. He has some sense of the role tradition might formerly have played in artistic production, but believes it is no longer capable of doing so, declaring it irretrievably lost: these buildings were 'created by bygone manners', architecture has 'died out', and constructive and historically literate change to historic buildings is therefore now impossible. The reference throughout the *Manifesto* is to *ancient* buildings. Current conservation usage in the United Kingdom, perhaps following Morris, generally attaches the word 'ancient' to monuments (that is, generally, ruins), while buildings are termed 'historic'. The former suggests otherness, while the latter perhaps allows some scope for temporal continuity, since it is possible to 'make history' but not to create age. This

is a distinction recognized in the United Kingdom in separate legislative systems for the care of ancient monuments and listed buildings.

Asking which buildings merit protection, Morris answers:

> anything which can be looked on as artistic, picturesque, historical, antique, or substantial: any work, in short, over which educated, artistic people would think it worth while to argue at all.

This places the focus exclusively on the architectural and the ancient, or in contemporary conservation terms on the aesthetic, historical, and evidential; what gets no mention at all is the communal. The omission is reinforced by the appeal to the taste of 'educated, artistic people', suggesting that only an elite minority is capable of understanding the importance of historic buildings. On this last point, it would be anachronistic to be too harsh in our criticism of Morris, who in this is only reflecting his times. Rather, it is worth noting how this nineteenth-century understanding retains its normative power, for example with 'architectural or historical interest' as the sole criteria for statutory listing in England (sn 7, Planning Act 1990). It is testament to the efficacy of the *Manifesto* that it continues to exert an influence over conservation to the present day.

Morris was, of course, not alone in his interest in medieval buildings; Gothic became the dominant style for the great majority of nineteenth-century public architecture. Pugin had argued in his books *Contrasts* ([1841] 2013) and *The True Principles of Pointed or Christian Architecture* that Gothic was the architecture of Christianity: 'Indeed, if we view pointed architecture in its true light as Christian art, as the faith itself *is perfect, so are the principles on which it is founded*' ([1841] 2014: 9, emphasis original). By contrast, Morris complained in the *Manifesto* that 'the nineteenth century has no style of its own', and later that the nineteenth century's architectural style 'is merely a habit of giving certain forms not worth noticing to an all-pervading ugliness and meanness' ([1888] 2012: 318). Rather, for Morris, the significance of ancient buildings was that they represented the product of freely given, pre-industrialized labour, for 'it is the harmony of the ordinary everyday work of the population which produces Gothic, that is, living architectural art, and mechanical drudgery cannot be harmonized into art' ([1888] 2012: 330). For all their evident differences, however, Chris Miele sees substantial common ground between Pugin and Morris, centred on the question of continuity:

> Pugin and Morris had described in their different ways historical rupture, a shattering of continuity and communal relations that could only

be healed by focusing, to the exclusion of all else, on medieval buildings, objects of contemplation, the architectural equivalent of a medieval reliquary or altarpiece. Theirs was a cultish view of antiquity and of historic buildings care. For both the goal of future history was a return to some imagined social order mystically encoded in medieval matter. Stylistic purity, Pugin's quest, and authenticity (Morris's) allowed them to commune with a utopian dream. Artefacts were a way into the vision, which is why they wrote so passionately and fought so fervently to protect them.

(Miele 2005: 27–28)

Miele posits two contrasting views of history, and thus two forms of conservation discourse, 'the one rejoicing in improvement, the other despising it' (2005: 13); Morris stands for the latter, while, for Miele, George Godwin, architect and editor through the middle of the nineteenth century of the influential *Builder Magazine*, represents the former. As a principled pragmatist, Godwin viewed Europe's medieval past 'as the first stage in a continuous, if dialectical, historical narrative with no rupture' (2005: 28). In Godwin, Miele identifies a vigorous alternative approach to conservation which subsequently faded from view but which merits closer examination. However, Godwin and 'this other Conservation Movement' are not presented as a model for contemporary practice but as marking one end of a spectrum, balancing Morris at the other; Miele argues for the incorporation of both ends of the spectrum as the prerequisite for the development of a progressive conservation culture.

The broader political context is also relevant. The SPAB *Manifesto* serves as an example of the defensive use of the past in the long aftermath of the French Revolution; in this way, belief in cultural discontinuity, formed in the context of both political and industrial revolution, became a characteristic of modern conservation. One manifestation of that discontinuity is the way the ancient is rendered sacred. In the context of Morris's later novel *News from Nowhere* ([1890] 2009), Miles Glendinning (2013: 123) notes that his utopianism 'elaborated the animistic stream of thought developed by Ruskin, sacralizing and attributing a quasi-eternal life to the monument'. Paul Ricoeur, in discussing the abuse of memory, emphasizes the excesses of commemoration 'which attempt to fix the memories in a kind of reverential relationship to the past' (Ricoeur 1999: 9). The language of reverence and mysticism was passed down, directly or indirectly, to later generations: for example the *Venice Charter* speaks almost mystically of historic monuments as 'imbued with a message from the past', continuing down to the present day, where it remains a feature of contemporary conservation discourse.

Once again, all of this testifies to the enduring influence of the nineteenth-century genesis of conservation – exemplified in the United Kingdom by Morris and Ruskin – on contemporary practice.

Reconstruction

The second episode of unnecessary loss of historic buildings highlighted earlier was the wave of reconstruction following World War II. The nineteenth century had been a time of competing nationalisms, with built (and other) forms of heritage deployed and indeed appropriated to further those nationalist projects. In the twentieth century, the disastrous consequences of that nationalistic phase were played out, with both huge loss of life and the systematic targeting of cultural property in the aerial bombing campaigns of World War II. Prior to that, pressure was already growing to address a series of problems resulting from nineteenth-century urbanization and industrialization, including often insanitary housing and increasingly inadequate transport infrastructure.

After the war, the urgent need for the reconstruction of many European cities was plain, but it was not uncommon for the destruction also to be seen as a positive opportunity; for example Donald Gibson, who led the redevelopment of Coventry wrote just days after the bombing of Coventry that it 'has given us a chance to rebuild a dignified and fitting city centre [...] like a forest fire the present evil may bring forth greater riches and beauty' (cited in Mason & Tiratsoo 1990: 97). Like many architects of the younger generation, Gibson was much influenced by the CIAM (International Congresses of Modern Architecture) doctrine of the 'Functional City'. First promulgated in the early 1930s and subsequently published by Le Corbusier as the *Athens Charter* ([1941] 1973), this favoured the radical replanning of cities on 'rational' principles that typically sought to sweep away existing urban infrastructure to start again from a *tabula rasa*. Yet within this approach, even Le Corbusier allowed for the retention of selected historic monuments which would be 'freed' from their context and presented as museum objects.

As we have seen, William Morris unfavourably contrasted nineteenth-century work to historic buildings with an earlier understanding which was capable of leaving 'history in the gap'. He vilified restoration for the belief 'that it is possible to strip from a building this, that, and the other part of its history – of its life that is – and then to stay the hand at some arbitrary point, and leave it still historical, living' (Morris [1877] 2017). But other, contrary voices make a very similar appeal to history, as when the critic and arch-modernist Reyner Banham dismissed the conservation movement as the 'preserve-at-all-costs' brigade, labelling them '*anti*-historians, trying

to deny or destroy history, like someone trying to make the good times last by nailing up the hands of the clock' (Banham 1963: 529; cited in Whiteley 2002: 266, emphasis original). Each of these voices not only lays the same charge of violating history at the door of their opponent but also does so in almost identical terms.

Or again there is a striking parallel between Thomas Hardy's proposed 'museumification' of historic buildings and their retention as isolated specimens in international modernist town planning. For example, the proposed alternative fates of the medieval Ford's Hospital in Gibson's initial plans for Coventry – either stranded on a roundabout or transplanted elsewhere to join a collection of other timber-framed survivals – illustrate the link. The vast difference in the overall thrust of their arguments makes the compatibility of the respective preservationist and modernist approaches to history all the more telling. But what can explain this seeming coherence between two approaches that stand in mutual opposition? Only that both see history as discontinuous, with the effect that in both cases old buildings become objects to be displayed as the retained relics of the past, that is, as monuments.

That two such divergent approaches – the preservationist and the international modernist – can be so similar in these regards indicates two things: first, that opposed views of this sort may be more intimately related and share more in common than at first seems possible; and, second, it questions the adequacy of the account of history, and behind that of temporality, which they apparently share. Banham continues thus: 'For history is about process; the objects the process creates are incidental ...'. Almost anyone in conservation would take issue with this further step in Banham's argument, and insist that the physical survival of historic buildings is of great importance. But the implication of his argument should be taken seriously: that is, that the conservation movement fundamentally misunderstands the objects of tradition which it seeks to safeguard, and that it does so because it refuses to question the modern understanding of history from which it grew.

2.2 Modernity and the past

Both of these episodes of trauma that shaped the development of conservation are characterized by a belief in a radical discontinuity between ourselves and the past which profoundly affects our understanding of historical objects. Bruno Latour, whose critique of modernity helped outline differences in its approach to the material world in Chapter 1, points out one of the implications of this belief in discontinuity:

As Nietzsche observed long ago, the moderns suffer from the illness of historicism. They want to keep everything, date everything, because they think they have definitively broken with their past. The more they accumulate revolutions, the more they save; the more they capitalize, the more they put on display in museums. Maniacal destruction is counterbalanced by an equally maniacal conservation.

(Latour 1993: 69)

Seen from the perspective of its development from antiquarianism in the wake of the trauma of the French Revolution, modern conservation has indeed at times had something of the maniacal about it, as can become evident when listening to the experiences of the communities most closely involved with historic buildings. This should not surprise us, however, as it flows naturally from conservation's status, at least as originally developed, as an integral aspect of modernity. Paul Philipott, writing in the 1970s, explicitly links conservation to the development of the modern historical consciousness [that] 'brought an end to the traditional link with the past', noting that 'since this rupture, the past has been considered by Western man as a completed development, which he now looks at from a distance' (Philippot [1972] 1996: 268).[1]

Rodney Harrison suggests in his treatment of the relationship between heritage and modernity:

This emphasis on progress, historical change and a break with tradition in modernity throws up unacknowledged tensions in terms of our relationship with time and its passage, tensions that are at the heart of contemporary understandings of the term 'heritage'.

(Harrison 2013: 25)

One characteristic of modernity, and a particular weakness, is to imagine it can stand outside of time and survey the past, like an autocrat surveying their dominions. The outrage at the abuses of modernity expressed by Ruskin and Morris, and the conservation movement that developed from them, must be seen in this context; their response, however, was *insufficiently* radical, accepting too much from their opponent, and most crucially adopting modernity's central assumption of a profound discontinuity between the present age and the past. The uncomfortable truth is that instead of rescuing the past from modernity's march of progress, preservationism becomes complicit in the fracturing of the past. This inability to stand apart from modernity accounts for the shape of modern conservation and many of its characteristics, such as the concern for classification by period, and

the fear that everything of worth is threatened with decline, decay, and destruction.

In his essay 'Modernity and Literary Tradition', Hans Robert Jauss ([1970] 2005) investigates the long history of the word 'modern' from its late-fifth-century use to describe the new Christian age in late antiquity, through the late-seventeenth-century *Querelle des anciens et des modernes*, to a condition in the nineteenth century in which it 'only ever repels itself' through a perpetual process of leaving behind, and accompanied by a new notion of the classical in the negative terms of pastness rather than, as formerly, of perfection (Jauss [1970] 2005: 361–362). Following Jauss, the later development of the term 'modern' thus entails a new relationship to antiquity as newly separated from the present. While the romantic modernists – represented in our context by Ruskin, Pugin, and Morris – idealized the medieval, a new understanding less encumbered by history began to emerge from the middle of the nineteenth century, exemplified in Charles Baudelaire's definition of modernity as 'the transient, the fleeting, the contingent; it is the one half of art, the other being the eternal and the immovable' (Baudelaire [1863] 1981: 403). Jürgen Habermas, in his 'Modernity versus Postmodernity', describes this as an 'aesthetic modernity' based on an 'abstract opposition between tradition and the present' and which in its 'very celebration of dynamism, discloses the longing for an undefiled, an immaculate and stable present' (Habermas 1981: 4, 5).

Another formative aspect in the development of conservation, and a central theme in Latour's characterization of modernity, is the search for purity. Nineteenth-century restoration was one expression of this modern hunger for purity – in this case of original stylistic form. The late Andrej Tomaszewski notes, subsequently, that 'Puristic restoration was rejected in favour of a mode of conservation that respected all phases of development of the historical monument' (Tomaszewski 2012: 44); but in so doing, twentieth-century conservation simply replaced purity of style with an alternative purity, of authenticity, such that change is now too readily interpreted as harm on the basis of a defilement of purity, of contamination of the past by the present. Against this ideal of purity, Latour characterizes premodernity as tolerant of, indeed fascinated by, the hybrid. There are many medieval buildings, including some of the most prominent churches and cathedrals, where different forms of Gothic architecture were cheerfully juxtaposed, much to the chagrin of the nineteenth-century restorers who often sought to iron out what they saw as the inconsistent and impure.

Very few historic buildings are pure in the sense of having been passed down to us in their original state; almost all, at least to some extent, are hybrid. This may be the cause of some regret: how wonderful it would be

to discover an unaltered medieval house or Greek temple, how much of value we could learn from such survivals! The historical sciences such as archaeology and anthropology were created by modernity precisely in order to categorize the past and impose order upon it. On this view, the historic building – no matter how prolific its experience of past change – 'needs' to be treated as completed and those tasked with its care should indeed pass this precious inheritance on as unaltered as possible. Hence, for example the *Venice Charter* opens by recognizing 'our duty to hand [historic monuments] on in the full richness of their authenticity' to future generations. Lacking an intergenerational understanding of heritage, such a view forfeits the hermeneutic equipment necessary to distinguish between change as destructive and change as constructive which, it is argued here, is essential in the conservation of living buildings; there is no scope for temporal continuity in the modern imagination, and the contemporary intervention in a historic building, on the modern view, necessarily equates to harm.

The aesthetic is a prominent category of significance in modern conservation, but it is also intimately bound up with the development of modernity itself – like conservation, it is itself a thoroughly modern construct. Originated by the German rationalist Alexander Baumgarten in 1735 as a term for a science of the beautiful, aesthetics became a widespread concept after it played so central a role in Immanuel Kant's *Critique of Judgement*, subsequently becoming synonymous with taste, a central idea for the eighteenth century. David Harvey, in his treatment of modernity and postmodernity, notes that aesthetics arose partly as a necessary abstraction to account for the growing diversity of art and culture that the old world discovered in encountering the new (1990: 19); we can observe much the same role played in the *Burra Charter* by significance as a bridge between Western and Indigenous Australian ideas of culture. Clearly beauty and meaning were important long before Baumgarten and Kant, and objects of beauty and significance have been produced by humanity from its earliest days. But to approach such objects – for example an ancient Greek temple or a medieval painting – through the modern apparatus of aesthetics is at best culturally loaded, and likely to result in a reinterpretation that pays scant regard to the cultural understanding that produced the object in the first place. The same issues apply to premodern historic buildings.

But if aesthetics does not do justice to premodern artistic creativity, then how are we to approach it? Premodern historic buildings, including the church buildings which so concerned both Ruskin and Morris, can be described as 'traditional', including in the literal sense that they are the products of a tradition. Alongside modernity's imagined discontinuity with the past goes a deep distrust of tradition; the Enlightenment appeal to

universal reason was precisely an attempt to escape what were seen to be the oppressive and stultifying effects of tradition. Bound up as it was with the aristocracy and the Church, tradition was easily portrayed in pejorative terms, and this attitude became foundational for the modernity that followed. Françoise Choay (2001) recounts how the idea of the historic monument first emerged in 1790 in the immediate aftermath of the French Revolution. The question arose of how properties confiscated from the Church and the nobility, recognized even then as of great historical and architectural importance, were to be cared for once they had been removed from their original ownership and cultural context. The invention of the term 'historical monument' effectively allowed a reclassification of these products of tradition to suit a radically changed cultural situation. Redefining historic buildings as sacred on account of their age, as noted above, is a continuation and heightening of this separation that Choay identified. In her *Fragile Monument*, Thordis Arrhenius extends Choay's analysis, but sees the development of conservation as a dialectic between preservation and restoration, with each stage 'resolved by a fuller and more complete understanding of authenticity' (Arrhenius 2012: 12). While there is much to admire in Arrhenius's account, the approach taken in this book is to see preservation, restoration, and authenticity all as part of the furniture of modernity, and that Arrhenius's dialectic of authenticity provides little help in addressing the particular issues of living buildings.

2.3　But is it art? – non-aesthetic interpretation

Few would suggest that the cultures from which historic buildings have emerged are irrelevant to the form that those buildings take. While the relevance of that earlier premodern understanding, and the distance that separates us from it, may be relatively uncontroversial, the question of how accessible that premodernity is to us is much less so. As we have seen, that most eloquent of the restorers, Viollet-le-Duc, saw no such obstruction, judging himself capable not only of reading the mind of his medieval forebears but also, where necessary, correcting their work. In the face of so clear a belief in the restorer's ability to engage directly with history, it is not surprising that Morris, in opposing restoration, should have been so forthright in asserting temporal discontinuity. How and on what terms that temporal and cultural divide might be bridged, and therefore the scope for that earlier understanding to address us and inform our present-day approach to historic buildings, are questions of hermeneutics, that is, of textual interpretation, broadly understood. From such a perspective, the suggestion that the

past is straightforwardly accessible using only the resources of our contemporary culture is hermeneutically naïve.

Hermeneutics is precisely the discipline which grapples with the question of historical distance. Differentiating between justifiable and unsupportable interpretations is a fundamental aspect of dealing with historical texts, and hermeneutics is the field of study that developed around this. Originally concerned with biblical exegesis and its methodology, in the early nineteenth century Friedrich Schleiermacher and others broadened its scope to the interpretation of texts of all kinds, before Wilhelm Dilthey extended this still further to the methodology for all understanding within the so-called 'human sciences'. It was Hans-Georg Gadamer in the later twentieth century who, building on his teacher Martin Heidegger's use of hermeneutics as fundamental to the structure of all understanding, developed a philosophical hermeneutics that sees understanding as 'a dialogic, practical, situated activity' grounded in tradition (Malpas 2018: sn 2.2).

In considering tradition in the context of conservation it is helpful that Gadamer explicitly discusses the role of architecture, regarding it as exemplary amongst other forms of art, since a building always points back to 'the contexts of purpose and life to which it originally belongs [and which it] somehow preserves' (Gadamer [1960] 1989: 156). This is in contrast to his contemporary, the art historian Cesare Brandi, more familiar within conservation as its pre-eminent theoretician of the post-war period and one of the founders of what is now ICCROM. Missing from Brandi's writings such as his *Teoria del Restauro* ([1963] 2005) is the critical acknowledgement that architecture differs in important respects from art in general. Brandi's engagement with the question of use relates to restoration, the point of which is precisely the recovery of function; yet for those works of art that

> do have a functional purpose (such as architecture [...]), the re-establishment of the property of use is, in the end, only a secondary or supplementary part of the restoration, and never the primary or fundamental aspect, that lies in having respect for a work of art as a work of art.
> (Brandi [1963] 2005: 47)

By contrast, for Gadamer the distinction is crucial:

> A building is never only a work of art. Its purpose, through which it belongs in the context of life, cannot be separated from it without its losing some of its reality. If it has become merely an object of aesthetic consciousness, then it has merely a shadowy reality and lives a distorted

life only in the degenerate form of a tourist attraction or a subject for photography. The 'work of art in itself' proves to be a pure abstraction.
(Gadamer [1960] 1989: 156)

Brandi's prioritization of the aesthetic and his assumption that architecture is reducible to a work of art ignores the functional and 'living' character of many historic buildings, and thus their progressive shaping at the hands of multiple 'authors'. To fail to differentiate this from art in general renders it an abstraction; asserting the 'living' character of historic buildings presents a challenge to the aesthetic-historical approach that is pivotal for the argument of this book. To follow the point to its conclusion, the aestheticization of historic buildings leads directly to the destruction of heritage.

Romantic and classical approaches to hermeneutics

While romanticism is notoriously difficult to tie down into a comprehensive definition, common to all its manifestations is that aesthetics – a concern with art and beauty – is more than just another form of knowledge, but rather is central to all that it means to be human. While it is often placed in opposition to the Enlightenment, for Gadamer romanticism merely involves the reversal of the Enlightenment's distrust of myth, implying acceptance of the fundamental assumption that myth and reason are incompatible. Both are based on a faith in perfection; for the Enlightenment it is the perfection of reason and freedom from superstition, and for romanticism the perfection of 'the "mythical" consciousness' and the promise of a 'paradisiacal primal state before the "fall" of thought' ([1960] 1989: 274). Gadamer explicitly suggests that romanticism results in 'the paradoxical tendency toward restoration – i.e., the tendency to reconstruct the old because it is old' (p. 273). This is an observation that resonates in the world of conservation, given its development, discussed above; but the same basic charge – the urge to keep the old 'because it is old' – is equally applicable to conservation as a whole.

While Gadamer acknowledges the 'great achievements of romanticism', he argues that where the Enlightenment 'measured the past by the standards of the present' (p. 275), romanticism brought about a revaluation of the past, ascribing to it a value of its own. This created the illusion of a historical science delivering an objective knowledge of the past achieved through entering the mind of the author of the text, and standing on a par with the 'grasp' of the natural world (as a detached object over against a knowing subject) achieved by modern science:

The fact that the restorative tendency of romanticism could combine with the fundamental concerns of the Enlightenment to create the historical sciences simply indicates that the same break with the continuity of meaning in tradition lies behind both.

<div align="right">(Gadamer [1960] 1989: 275)</div>

For Gadamer, then, the 'historical sciences' share with the Enlightenment the same misplaced orientation towards a supposedly objective knowledge, and a view of history as fundamentally *discontinuous*. If we accept Gadamer's analysis, we should see preservation and restoration not as polar opposites – as is argued, for example, in the SPAB *Manifesto* – but as sharing the same philosophical foundation, as two sides of the same coin. Following Gadamer's approach, by contrast, the focus of conservation would become our understanding of tradition and continuity.

The critical importance of the continuity of history is brought out in Gadamer's distinction between romantic and classical hermeneutics. Working from Hegel, he asserts that 'this is just what the word "classical" means: that the duration of a work's power to speak directly is fundamentally unlimited' (Gadamer [1960] 1989: 290). A romantic hermeneutic addresses the past by attempting to get inside the mind of the original author, and in so doing history is bracketed and separated, deprived of the ability to address us directly, and thereby forced to relinquish any claim to truth. By contrast, what Gadamer terms a 'classical hermeneutic' supposes a fundamental *continuity* between past and present. For Gadamer, one particularly relevant characteristic of a genuine work of art is its ability to address us *directly* in the present moment, no matter how old it might be. That is to say that the meaning that the work has is negotiated in dialogue with the present, and its significance is therefore in a sense iterative and never complete. Gadamer insists that the process of integrating the new or alien into the present understanding is not one of 'subsumption'. As Nicholas Davey (2016: sn 3) comments of Gadamer's position, 'integration implies a reciprocity: the integrated changes its character as well as the character of the whole within which integration occurs'. This reciprocity is a key aspect of what the premodern understanding of tradition can offer a revised conservation philosophy, and is strikingly similar to the approach adopted by T.S. Eliot in his well known essay 'Tradition and the Individual Talent' (1920), to be discussed in Chapter 4.

Genius and authorship

The romantic approach to the past is predicated on the ideal of the individual as a realm of inner meaning; in turn this is closely related to romanticism's

account of creativity as the working of inner genius. Romanticism's elevation of genius is in opposition to the role of reason, with the attendant implication that genius, and the creativity that is supposed to flow from it, is in some fundamental sense irrational. This is important in the context of developing an understanding of change. The current values-based conservation methodology lacks any theoretical foundation or shared rational basis for differentiating healthy from harmful change, or therefore any place for creativity, which is seen as the product of individual genius. On the other hand, if creativity operates within the bounds of tradition, it is not primarily individual at all, but (at least in part) communal and embodied.

Individual biography is one of the principal modes in which history has been written since Thomas Carlyle popularized the so-called 'Great Man theory' in his *On Heroes, Hero-Worship and The Heroic in History* (1840). It is similarly prevalent in architectural history, epitomized by Sir Howard Colvin's *Biographical Dictionary of British Architects 1600–1840* ([1954] 1995); one implication, as Dana Arnold (2002: 35) notes, is that 'buildings without architects are pushed to the sidelines of history'. That is clearly the effect in jurisdictions such as France where the designation of buildings for protection is the preserve of an elite. Hence the radical nature of Bernard Rudofsky's 1964 book *Architecture Without Architects*, published to accompany the exhibition of the same name at the Museum of Modern Art in New York, and which precisely sought to draw attention to this marginal zone of 'non-pedigreed' architecture. In his preface Rudofsky declares that

> architectural history as we know it [...] amounts to little more than a who's who of architects who commemorated power and wealth [...] with never a word about the houses of lesser people.
>
> (Rudofsky 1964: 1)

He quotes American architect Pietro Belluschi's definition of communal architecture as 'not produced by a few intellectuals or specialists but by the spontaneous and continuing activity of a whole people with a common heritage, acting under a community of experience'. The post-war listing of examples of vernacular architecture and the introduction of conservation area legislation are both responses to this within conservation (Walter 2017: 66, 68).

When it comes to proposed change to historic buildings, the romantic understanding implies that if that change is creative it must be in some sense arbitrary. Without the resources of communal architecture grounded in ongoing tradition and intergenerational, practical knowledge, there

are no shared criteria to evaluate the quality of proposed change; in such circumstances, the focus will be on loss and harm, and permission for such works will at best be given reluctantly, as the least worst option. In such cases, the name of the designer (as individual genius) becomes a principal determinant of value, whether from the past (in the United Kingdom, Pugin, Gilbert Scott, Comper et al.) or the present. The architectural historian John Harvey's *English Mediaeval Architects: A Biographical Dictionary* (1954) can be seen as an anachronistic attempt to apply this understanding to the premodern period. This reliance on 'great names' is hugely frustrating for practitioners outside the charmed circle of established genius (itself something of a contradiction) and is a major obstacle both to the development of design talent and the production of new work of quality. By contrast, if creativity is placed within the context of tradition, that tradition might provide a common framework within which the worth of proposed change can be debated, and perhaps judged.

The conservation of historic buildings is the culturally critical project to safeguard the physical remnants of the past, of whatever age. These are the products of tradition, indisputably in the case of premodern buildings, but also in the case of more recent examples since, as will be argued in Chapter 4, modernity has not, in fact, dispensed with tradition. Central to the case made in this chapter is the observation that since conservation is a product of modernity, and since modernity is at the very least conflicted in its relation to tradition, then we should not be surprised that conservation itself is conflicted. The ongoing argument over the status of modernity is well beyond the scope of this book; for the present purposes it has been enough to observe the antipathy the Enlightenment displayed towards tradition, and to make the minimal assertion that to approach conservation through the theoretical framework of, and employing only the resources offered by, modernity is neither transparent nor straightforward. In marked contrast, premodernity stands for the 'vitality of tradition', both in the sense of its central relevance, and that it is itself living.

2.4 Waking up to context

Cultural landscape and the palimpsest

When searching for the assumptions that animate a given discipline, it can be instructive to engage with adjacent disciplines that build their process from an alternative set of assumptions, particularly when the body of practice produced by that intellectual infrastructure is markedly different in character. Just such a contrast is evident when comparing the respective

approaches to the question of change to heritage in conservation and in cultural landscape. For the latter, the textual metaphor of landscape as a palimpsest of material traces has encouraged a multi-period model of investigation, in contrast to the periodized, 'Great Man' approach typical of architectural history. Furthermore, cultural landscape theory treats people as integral to heritage, recognizing the interests of present and future generations, and with that the expectation of further creative change.

The geographer Carl Sauer developed the idea of the cultural landscape in the early twentieth century to describe the progressive shaping of the land (itself the derivation of the word 'landscape') by successive cultural groups. In his famous definition,

> The cultural landscape is fashioned out of a natural landscape by a culture group. Culture is the agent, the natural area is the medium, the cultural landscape the result. Under the influence of a given culture, itself changing through time, the landscape undergoes development ...
>
> (Sauer 1976: 343)

Landscape is by its nature contextual both at a literal level in asserting the importance of physical context – now well recognized within conservation, for example 'exteriority' being the one difference Cesare Brandi ([1963] 2005: 94) acknowledged between architecture and art – but also at a more theoretical level in the development of Sauer's idea. It is also interdisciplinary, which fits well with the way cultural heritage is managed; Castro et al. (2002: 133) note that landscape encourages interdisciplinary dialogue, thus resisting what they term 'the increasing segmentation of scientific knowledge in present day academia'.

From the outset, cultural landscape acknowledges the ongoing nature of change and recognizes the agency of non-professional communities. Belonging as it does both to everyone and to no one, landscape offers a means of overcoming the democratic deficit that dogs conventional heritage approaches. Noting that 'landscape as a concept is also heavily democratic because landscape is everyone's neighbourhood', Graham Fairclough (2008: 298) takes this as a mandate to call for 'a greater inclusion of public and lay voices as well as expert and professional opinion' in heritage. Furthermore, landscape invites a holistic and synthetic approach to which non-professionals are naturally drawn:

> 'Real' people ('normal' people) automatically have a holistic view which specialists and experts sometimes have to struggle to re-discover. People

do not readily divide the world, or heritage or landscape, into natural or cultural features, instead they think in terms of place or landscape.
(Fairclough 2008: 298–299)

This reference to the context-aware 'place' is typical of the landscape approach and contrasts with the more conventional concern with the defined site or monument. The focus on place was a key innovation of the *Burra Charter*, and was an important element in the incorporation of Indigenous heritage within an otherwise Western-focused system; it has since been widely adopted, for example in the influential report *Power of Place*, which Fairclough coordinated (Historic England 2000). This indicates a significant difference between landscape and conventional conservation understanding.

Daniels and Cosgrove (1988: 4–6) observe John Ruskin's focus on landscape as central to a social, political and environmental morality, and his treatment of it as a text, on the model of biblical exegesis, and in some sense therefore as sacred. They present landscape as iconographical, that is, primarily symbolic and cultural, as opposed to its typical treatment at the hands of human geographers as an empirical object of investigation. Theirs is an integrated view, seeing verbal, written and visual images not as 'illustrations' standing outside of culture, but as constitutive of its meanings. They cite Erwin Panofsky's reading of Gothic architecture as a form of text, indeed an 'architectural scholasticism' (1988: 3), noting his likening of iconography to ethnography, and the parallels in Clifford Geertz's (1973) use of text as a metaphor for culture. The Renaissance emblem was an iconographically rich combination of text and image which embodied an often complex idea; this understanding was extended to the whole material world, for example as expressed by Francis Quarles in the seventeenth century:

Before the knowledge of letters, God was known by hieroglyphs, and indeed what are the heavens, the earth, nay every creature but hieroglyphics and emblems of his glory.
(in Vesely 2004: 222)

The idea that the natural world can be read as a book goes back to Konrad von Megenberg's *Buch der Natur* ([C14] 2003) and beyond.

Fairclough characterizes a landscape (including an urban townscape) as 'a single complex artefact with a long history of change and continuity' (2002: 31), offering a close parallel with many historic buildings. But it was the archaeologist Osbert Crawford who seems first to have likened

the landscape to a palimpsest, a parchment from which the text has been scraped or cleaned ready for reuse, a process which leaves traces of the earlier writing. For Crawford, human interventions in the landscape are:

> letters and words inscribed on the land. But it is not easy to read them because, whereas the vellum document was seldom wiped clean more than once or twice, the land has been subjected to continual change throughout the ages.
>
> (Crawford 1953: 51)

The Greek root of the word 'palimpsest' literally means 'again scraped'; the practice of scraping parchment arose because it was a valuable commodity in limited supply, as is the landscape, and as are historic buildings. The metaphor of the palimpsest shows that preservation is not the only response to this scarcity; enrichment – 'enhancement' – through reuse is another. One drawback of the palimpsest metaphor is that the new text borne by the scraped parchment bears no relation to the old, and if still legible the old is merely juxtaposed with the new; with both landscape and buildings there is greater continuity and the progressive building of a rich composite.

In 1955, William Hoskins published *The Making of the English Landscape,* absorbing the metaphor of the palimpsest but ignoring its theoretical context and Crawford's concern with time depth (Johnson 2005: 56). Hoskins established English local history as a formal academic discipline at the University of Leicester, and his interest remained the local understanding of particular places; this local focus led to accusations of nationalism (Johnson 2007: 128, 174). It is interesting to note that in the same year that Hoskins's book was published, the art historian Nikolaus Pevsner delivered his Reith lectures on the 'Englishness of English art', which appeared in book form the following year (Pevsner 1956), and that the same criticisms were levelled at Pevsner also. Hoskins was deeply distrustful of modernity, despairing of the way the landscape has been ravaged in the twentieth century, producing the 'barbaric England of the scientists, the military men and the politicians' (Hoskins 1955: 232). This is paralleled in Pevsner's resistance to modernist urban planning on Le Corbusier's model of the 'Functional City'; Pevsner's 'Englishness argument' enabled him to oppose this 'barbarism', while leaving him free to defend modernism in the architecture of individual buildings.

These two characteristics of landscape – its democratic character and its 'literary complexity' – combine to offer a quite different understanding of change:

The idea of cultural landscape has the concept of change (in the future as well as in the past) at its very heart. The idea that there are any landscapes where time has stood still, and history has ended, is very strange. No landscape, whether urban or rural, has stopped its evolution, no landscape is relict: it is all continuing and ongoing. [...] The decision that each generation, including archaeologists has to make, is what will happen next to the landscape, and how it will be managed or changed.

(Fairclough 2002: 35)

The evocative word 'relict' is placed in opposition to continuity. The word has the conventional meaning of remaining or surviving, and it is easy to see how on an antiquarian and preservationist view historic buildings could be described as 'relict'; it in this sense, for example, that the *Venice Charter* positions historic buildings as 'living witnesses' of 'age-old traditions'. But in the Latin the literal sense is 'that which is abandoned or left behind', suggesting that the choice to treat buildings or landscapes as monuments is an active desertion, an abandonment, a breaking of relationship, a cutting adrift. And another, still current, meaning of 'relict' is a widow, signalling personal loss and the end of relationship.

Seeing landscape and change as inseparable, Fairclough offers a holistic view:

The cultural landscape is central to the debate about managing change. It is entirely the product of change and of the changing interplay of human and natural processes; our intellectual and spiritual responses to it are ever-changing. [...] Change, both past and ongoing, is one of its principal attributes, fundamental to its present character. There is no question of arresting change.

Change needs to be managed, however. Conservation should not merely be change's witness but a central part of its very process, the better to direct it sustainably.

(Fairclough 2003: 23)

Continued use of both landscapes and buildings is agreed to be desirable; Fairclough insists that this must be matched by an acceptance that 'a consequence of continued use is continued change' (2003: 24). He also argues that age is not a pre-condition of significance, and that the recently altered can be 'valuable and historically significant' (2002: 29, 30), a starkly different understanding both of what counts as historical and of significance than is typical in conservation. Finally, a landscape understanding acknowledges

that contemporary change can be beneficial in revealing previously hidden layers of the palimpsest, as for example when the construction of buildings or transport infrastructure reveals hitherto unknown archaeological remains (Urtane & Urtans 2002: 179).

While the parallels between historic buildings and cultural landscapes are evident, it is clear that there are significant differences of sensibility between the respective bodies of practice that address their conservation and management. It is difficult, however, to base those differences of approach in any question of principle – they seem rather to flow from distinct lines of historical formation. Where conservation grew from an antiquarian wish to 'arrest change', landscape archaeology has never claimed that the whole landscape should be preserved. Perhaps this reflects a difference in a sense of ownership, with buildings more readily treated as objects over which interest groups can stake a claim. For landscape, the textual metaphor of the palimpsest of material traces has encouraged a multi-period model of investigation, with which conventional conservation should be comfortable. Yet much of the advocacy in the conservation process is split between interest groups concerned with distinct periods – in England, for example, four of the six national amenity societies are period-based – or follows the 'Great Man' approach to history discussed earlier.

Period of course remains relevant in the study of historic buildings, but it is not the only approach. The attendant danger of a period approach is that a building's ongoing ability to speak to our present-day concerns – in the sense of Gadamer's classical hermeneutics – is often missed: it is very difficult for anyone whose interest lies in a particular historical period to see proposed change to work of their period as anything other than loss. This is an illustration of the cost of the specialization into smaller and smaller areas of concern which has proved so productive for modern science since the Enlightenment; the price paid is the loss of a sense of the whole. By contrast, cultural landscape has a far stronger appreciation of communal authorship across time and the expectation of creative change; these themes will prove central to the later development of this argument.

Conclusion

Paul de Man noted that 'Nietzsche's ruthless forgetting, the blindness with which he throws himself into an action lightened of all previous experience, captures the authentic spirit of modernity' (de Man 1970: 388). This chapter has sought to locate conservation in its context as a distinctively modern pursuit. Those involved in conservation need to face

up to what this implies, that conservation is not only a heroic counter-balance to modernity's appetite for destructive change, it is in some sense implicated in it, the other side of the same coin, a necessary intimate. A key aspect of this is an ambivalence, if not outright antipathy, towards trad-ition; and the approach Morris takes in his *Manifesto* is consistent with this broader opposition of modernity to tradition. An alternative and non-modern understanding of tradition will be explored in Chapter 4; before that the following case study on the Castelvecchio in Verona considers a mid-twentieth-century example of the reimagination of a medieval struc-ture, and Chapter 3 then focuses more closely on the place of people in the conservation process.

Note

1 Philippot was a founder of ICCROM and wrote the first section of the *Venice Charter*. He was ICCROM Deputy Director 1959–1971, and Director 1971–1977.

References

Arnold, D. (2002). *Reading Architectural History*. Abingdon and New York: Routledge.

Arrhenius, T. (2012). *The Fragile Monument: On Conservation and Modernity*. London: Artifice.

Banham, R. (1963). The Embalmed City. *New Statesman*, LXV (1674): 528–530.

Basile, G. (ed.) ([1963] 2005). *Theory of Restoration*. (C. Rockwell, trans.). Firenze: Nardini Editore.

Baudelaire, C. ([1863] 1981). The Painter of Modern Life. (P.E. Charvet, trans.). In: *Selected Writings on Art and Artists*. Cambridge and New York: Cambridge University Press.

Brandi, C. ([1963] 2005). Theory of Restoration. (C. Rockwell, trans.). In: G. Basile (ed.), *Theory of Restoration*. Firenze: Nardini Editore. pp. 43–170.

Carlyle, T. (1840). *On Heroes, Hero-Worship, and the Heroic in History*. London: Chapman and Hall.

Castro, P.V., Chapman, R.W., et al. (2002). Archaeology in the South East of the Iberian Peninsula: A Bridge between Past and Future Social Spaces. In: G.J. Fairclough & S. Rippon (eds.), *Europe's Cultural Landscape: Archaeologists and the Management of Change*. Brussels: Europae Archaeologiae Consilium. pp. 133–142.

Choay, F. (2001). *The Invention of the Historic Monument*. (L.M. O'Connell, trans.). Cambridge: Cambridge University Press.

Colvin, H. ([1954] 1995). *A Biographical Dictionary of British Architects, 1600–1840*. 3rd ed. New Haven, CT: Yale University Press.

Crawford, O.G.S. (1953). *Archaeology in the Field*. London: Dent.

Daniels, S. & Cosgrove, D.E. (1988). Introduction: Iconography and Landscape. In: *The Iconography of Landscape: Essays on the Symbolic Representation, Design, and Use of Past Environments*. Cambridge and New York: Cambridge University Press. pp. 1–10.

Davey, N. (2016). Gadamer's Aesthetics. In: E.N. Zalta (ed.), *The Stanford Encyclopedia of Philosophy*. Metaphysics Research Lab, Stanford University. [Online]. Available at: https://plato.stanford.edu/archives/win2016/entries/gadamer-aesthetics/.

Eliot, T.S. (1920). Tradition and the Individual Talent. In: *The Sacred Wood*. London: Methuen. pp. 42–53.

Fairclough, G.J. (2002). Archaeologists and the European Landscape Convention. In: G.J. Fairclough & S. Rippon (eds.), *Europe's Cultural Landscape: Archaeologists and the Management of Change*. Brussels: Europae Archaeologiae Consilium. pp. 25–37.

Fairclough, G.J. (2003). Cultural Landscape, Sustainability, and Living with Change. In: J.M. Teutonico & F. Matero (eds.), *Managing Change: Sustainable Approaches to the Conservation of the Built Environment*. Los Angeles, CA: Getty Publications. pp. 23–46.

Fairclough, G.J. (2008). New Heritage, an Introductory Essay – People, Landscape and Change. In: G.J. Fairclough, R. Harrison, J.H. Jameson, & J. Schofield (eds.), *The Heritage Reader*. Abingdon and New York: Routledge. pp. 297–312.

Gadamer, H.-G. ([1960] 1989). *Truth and Method*. (J. Weinsheimer & D.G. Marshall, trans.). 2nd rev. ed. London: Sheed and Ward.

Geertz, C. (1973). *The Interpretation of Cultures: Selected Essays*. New York: Basic Books.

Glendinning, M. (2013). *The Conservation Movement: A History of Architectural Preservation: Antiquity to Modernity*. Abingdon and New York: Routledge.

Habermas, J. (1981). Modernity versus Postmodernity. *New German Critique*, (22): 3–14.

Hardy, T. ([1906] 1967). Memories of Church Restoration. In: H. Orel (ed.), *Thomas Hardy's Personal Writings. Prefaces, Literary Opinions, Reminiscences*. London and Melbourne: Macmillan. pp. 203–218.

Harrison, R. (2013). *Heritage: Critical Approaches*. Abingdon and New York: Routledge.

Harvey, D. (1990). *The Condition of Postmodernity: An Enquiry into the Origins of Cultural Change*. Oxford: Blackwell.

Harvey, J. (1954). *English Mediaeval Architects: A Biographical Dictionary down to 1550: Including Master Masons, Carpenters, Carvers, Building Contractors, and Others Responsible for Design*. London: B. T. Batsford.

Hearn, M.F. (1990). *The Architectural Theory of Viollet-Le-Duc: Readings and Commentary*. Cambridge, MA: MIT Press.

Historic England (2000). *Power of Place: The Future of the Historic Environment*. London: English Heritage.

Hoskins, W.G. (1955). *The Making of the English Landscape*. London: Hodder and Stoughton.

ICOMOS (1964). *International Charter on the Conservation and Restoration of Monuments and Sites*. Paris: ICOMOS.

Jauss, H.R. ([1970] 2005). Modernity and Literary Tradition. *Critical Inquiry*, 31 (2): 329–364.

Johnson, M. (2005). Thinking about Landscape. In: C. Renfrew & P.G. Bahn (eds.), *Archaeology: Theories, Methods and Practice*. London: Thames & Hudson. pp. 156–159.

Johnson, M. (2007). *Ideas of Landscape*. Malden, MA, and Oxford: Blackwell.

Latour, B. (1993). *We Have Never Been Modern*. (C. Porter, trans.). Cambridge, MA: Harvard University Press.

Le Corbusier ([1941] 1973). *The Athens Charter*. (A. Eardley, trans.). New York: Grossman Publishers.

Malpas, J. (2018). Hans-Georg Gadamer. In: E.N. Zalta (ed.), *The Stanford Encyclopedia of Philosophy*. Metaphysics Research Lab, Stanford University. [Online]. Available at: https://plato.stanford.edu/archives/fall2018/entries/gadamer/.

de Man, P. (1970). Literary History and Literary Modernity. *Daedalus*, 99 (2): 384–404.

Mason, T. & Tiratsoo, N. (1990). People, Politics and Planning: The Reconstruction of Coventry's City Centre, 1940–53. In: J.M. Diefendorf (ed.), *Rebuilding Europe's Bombed Cities*. Basingstoke: Macmillan. pp. 94–113.

von Megenberg, K. ([C14] 2003). *Das Buch Der Natur*. Tübingen: M. Niemeyer.

Miele, C. (2005). Conservation and the Enemies of Progress? In: C. Miele (ed.), *From William Morris: Building Conservation and the Arts and Crafts Cult of Authenticity, 1877–1939*. New Haven, CT, and London: Yale University Press. pp. 1–29.

Morris, W. ([1890] 2009). *News from Nowhere: Or, an Epoch of Rest: Being Some Chapters from a Utopian Romance*. Oxford: Oxford University Press.

Morris, W. ([1888] 2012). The Revival of Architecture: An Article in the Fortnightly Review, May 1888. In: M. Morris (ed.), *The Collected Works of William Morris: With Introductions by His Daughter May Morris*. Cambridge: Cambridge University Press. pp. 318–330.

Morris, W. ([1877] 2017). *The Society for the Protection of Ancient Buildings Manifesto*. [Online]. Available at: www.spab.org.uk/about-us/spab-manifesto.

Pevsner, N. (1956). *The Englishness of English Art, an Expanded and Annotated Version of the Reith Lectures Broadcast in October and November 1955*. London: Architectural Press.

Philippot, P. ([1972] 1996). Historic Preservation: Philosophy, Criteria, Guidelines, I. In: N. Stanley-Price, M.K. Talley, & A. Melucco Vaccaro (eds.), *Historical and Philosophical Issues in the Conservation of Cultural Heritage*. Los Angeles, CA: Getty Conservation Institute. pp. 268–274.

Pugin, A.W.N. ([1841] 2013). *Contrasts, or, A Parallel between the Noble Edifices of the Middle Ages, and Corresponding Buildings of the Present Day*. Cambridge: Cambridge University Press.

Pugin, A.W.N. ([1841] 2014). *The True Principles of Pointed or Christian Architecture: Set Forth in Two Lectures Delivered at St Marie's, Oscott*. Cambridge: Cambridge University Press.

Ricoeur, P. (1999). Memory and Forgetting. In: R. Kearney & M. Dooley (eds.), *Questioning Ethics: Contemporary Debates in Philosophy*. Abingdon and New York: Routledge. pp. 5–11.

Rudofsky, B. (1964). *Architecture without Architects: An Introduction to Non-Pedigreed Architecture*. New York: Doubleday.

Sauer, C.O. (1976). The Morphology of Landscape. In: J. Leighly (ed.), *Land and Life: A Selection from the Writings of Carl Ortwin Sauer*. Berkeley, CA, and London: University of California Press. pp. 315–350.

Thoreau, H.D. ([1860] 1906). *Journal*. XIII. Boston, MA, and New York: Houghton Mifflin.

Tomaszewski, A. (2012). Protecting Heritage Places under the New Heritage Paradigm & Defining Its Tolerance for Change. A Leadership Challenge for ICOMOS. In: W. Lipp, J. Štulc, B. Szmygin, & S. Giometti (eds.), *Conservation Turn – Return to Conservation: Tolerance for Change, Limits of Change*. Firenze: Edizioni Polistampa. pp. 43–46.

Urtane, M. & Urtans, J. (2002). Examples of Current National Approaches: IV. Latvia. In: G.J. Fairclough & S. Rippon (eds.), *Europe's Cultural Landscape: Archaeologists and the Management of Change*. Brussels: Europae Archaeologiae Consilium. pp. 179–182.

Vesely, D. (2004). *Architecture in the Age of Divided Representation: The Question of Creativity in the Shadow of Production*. Cambridge, MA, and London: MIT Press.

Walter, N. (2017). The 'Second Battle of Britain': Lessons in Post-War Reconstruction. In: P. Schneider (ed.), *Catastrophe and Challenge: Cultural Heritage in Post-Conflict Recovery. Proceedings of the Fourth International Conference on Heritage Conservation and Site Management. December 5–7, 2016, BTU Cottbus*. Cottbus: Brandenburgische Technische Universität Cottbus-Senftenberg IKMZ-Universitätsbibliothek. pp. 55–72.

Whiteley, N. (2002). *Reyner Banham: Historian of the Immediate Future*. Cambridge, MA, and London: MIT Press.

Case study: Carlo Scarpa, William Morris, and the Castelvecchio, Verona

All continuity of history means is after all perpetual change.
William Morris ([1889] 1936)

The Castelvecchio Museum in Verona, remodelled by Carlo Scarpa from 1958 to 1974, is a point of reference for many architects and an example of bold contemporary architectural intervention in a historic building (Figure 2.1). It is a project that has helped to change the attitude within the architectural profession towards work within existing buildings, and therefore prepared the ground for other exemplary projects of significant change to historic buildings. Scarpa was originally appointed in 1957 to renovate the western part of the complex, the Reggia or residence, for an exhibition, before the brief was extended to the remainder of the site. His interventions are instructive for the way he deals with historic fabric in a contemporary but historically sensitive manner, while the building as a whole now acts as a giant exhibit that narrates the history of the city, becoming an exemplar of historically literate museum design. The relevance to the current argument lies in the way Scarpa understood and then reimagined the building, including picking apart the layers of history in order better to articulate the building's narrative. It is precisely in the 'chapter' that Scarpa himself then wrote, which included selective demolition, that the narrative of the whole is clarified and revealed.

Background

Prior to Scarpa's intervention, the building comprised work from four principal eras: a fragment of the thirteenth-century Commune city wall, which runs approximately north-south and divides the site into two unequal parts (Figure 2.2, M); the subsequent creation of the castle by the ruling Scaligeri family in the fourteenth century; substantial military works by the French in the early nineteenth century; and the 1920s restoration by Ferdinando Forlati when the museum was first created. The site commands a bend in the

Figure 2.1 Verona, Castelvecchio: view of north range of courtyard from southern ramparts

River Adige (I) which flows immediately to the north; the Scaligeri bridge (J), constructed as an integral part of the castle, crosses the river from the north directly into it. In what follows, I am indebted to Richard Murphy, whose *Carlo Scarpa and Castelvecchio Revisited* (2017) provides an exhaustive treatment of Scarpa's work in the development of the complex.

The way Scarpa dealt with this historic building is a long way from a non-committal relativism that refuses to take a view of the relative merit of different eras of work; instead, the power and elegance of the Castelvecchio as it now stands is the direct result of Scarpa's robustly editorial approach. The areas that experienced most editorial change/ 'harm' were the Napoleonic works and the 1920s restoration, both of which obscured the bigger story which, for Scarpa, was of greater interest. Until the construction of the Napoleonic L-shaped barracks (E, G), the eastern courtyard had been open to the river; through his changes, Scarpa revealed the full length of the east face of the Commune wall, including subsequently excavating the moat (N), and reintroducing selective views of the river.

Arguably it was the 1920s restoration that did most to distort the building's narrative, dressing the barracks building in the military, eastern

Figure 2.2 Verona, Castelvecchio: ground floor plan of main courtyard (drawing courtesy
of Richard Murphy Architects)

Key to Plan

A Corso Castelvecchio
B Entrance tower
C Great courtyard
D Museum entrance
E East range
F North east tower
G North range
H Cangrande Space
I River Adige
J Scaligeri bridge
K Reggia courtyard
L Porta del Morbio
M Commune wall
N Excavated moat
O Clock tower

half of the complex as a medieval palazzo, using fragments from the Palazzo
dei Camerlenghi and other buildings destroyed in the flood of 1882. Scarpa
left those salvaged elements in place, only removing two roundels by the
museum entrance (D) and re-rendering the whole; however, he subverted the
resulting neatness by leaving out discrete areas of plasterwork to reveal the
stonework beneath, and running a second, independent façade of glazing

Figure 2.3 Verona, Castelvecchio: north façade of main courtyard, detail

behind the masonry openings (Figure 2.3). His principal 'destructive' intervention was to remove a monumental stair from the north west corner of the courtyard and the westernmost bay of the barracks where it abutted the fragment of Commune wall (H), thereby both reasserting the integrity of the thirteenth-century structure and deliberately compromising the solidity of the Napoleonic work. As viewed from the Adige, the Napoleonic wall was indistinguishable from the Scaligeri fabric at either side; Scarpa peeled apart the different eras of construction, for example cutting back the wall from the north east tower (F), not only asserting their different provenance but also introducing light to the rooms behind and accentuating the identity of the Napoleonic wall by revealing its thickness.

But it is at the west end of this wall where the most significant intervention occurs. Here Scarpa placed at first floor level the statue of Can Francesco della Scala, known as 'Cangrande' and a pivotal figure for the history of Verona (H, Figure 2.4). Until the establishment of the museum in the 1920s, the statue had surmounted the Cangrande's tomb outside the church of S. Maria Antica in the city, where it was admired and sketched by Ruskin, among others.[1] It is around this statue that the whole complex now, appropriately, revolves, both dominating the great courtyard and

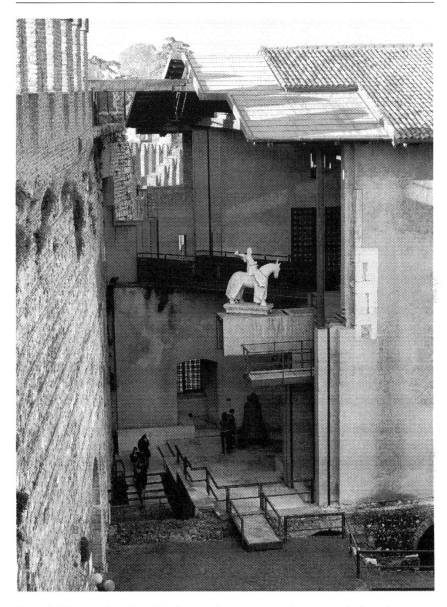

Figure 2.4 Verona, Castelvecchio: Cangrande space created at west end of north range

offering the visitor on the museum route views from below and, later, from above (Figure 2.5). In the process of detaching the nineteenth- from the thirteenth-century work, the Porta del Morbio (L), the original city gate for this section of the wall – which Scarpa had believed to be there from earlier

Figure 2.5 Verona, Castelvecchio: Cangrande space from Commune wall battlements

research – was discovered and reopened, providing an essential ground
level reconnection between the two halves of the complex. This involved
the remaking of a section of the public access to the Scaligeri bridge above;
as elsewhere, Scarpa pulled the newly inserted structure away from the old,
clarifying the historic layering.

This masterful editing and reinterpretation of the existing structures inevitably resulted in some substantial losses of historic fabric, whether in terms of individual elements removed or covered over. For those interested in Napoleonic era fortifications, that particular story, already substantially overwritten by the subsequent restoration which had erased most of the façade treatments, was further undermined. And for those principally concerned with Forlati's 1920s restoration, Scarpa's work could be seen as calamitous. However, that disentangling of the different chapters of the story was the result of thorough historical research and a clear reading of the relative importance of each of the chapters to date. Indeed it can be argued that in his skilful reworking of the 1920s restoration, the Palazzo dei Camerlenghi fragments are rescued from Forlati's attempt to create a palazzo and were thus able for the first time to take their place in the reimagined museum. The richness of the resulting narrative at the Castelvecchio derives not only from what Scarpa has added to the building but also from his determination to expose the preceding chapters of the building's history, including from the nineteenth and earlier twentieth centuries.

As Samia Rab suggests, rather than simply peeling apart the layers of history to make the story legible, Scarpa 'composes the remnants of different historical periods with his additions in a way that each element retains its uniqueness yet forms part of a harmonious whole' (Rab 1998: 444). This is more than Morris's idea of leaving history in the gap discussed in Chapter 2 – it is the work of a writer boldly shaping his story. The completed project is an essay in the coexistence of ancient and modern, and editorial choices are evident in suppressing some aspects of the history of the building, including the Napoleonic work, and highlighting others. Scarpa had sound grounds for doing this. The building as a whole, as much as the exhibits it houses, now relates the history of the Veneto, for which the Napoleonic work is of far lesser significance than what preceded it; it is entirely fitting, therefore, that Napoleon should make way for Cangrande.

It should be noted that the 1951 reconstruction of the adjacent fourteenth-century Scaligeri bridge (J, Figure 2.6) offers a pointed contrast to Scarpa's strongly editorial approach in the Castelvecchio. The bridge was built as an integral part of the Scaligeri Castelvecchio but its main spans were destroyed in the German retreat of 1945. The subsequent reconstruction, reusing the original materials, was carried out by Piero Gazzola, Superintending Architect of Verona, who was later to be one of the principal authors of the *Venice Charter* and first ICOMOS president. While the function of the bridge had changed significantly during its lifetime due to the changes on each bank, in material terms and taken in isolation, the bridge had a much simpler narrative to date.

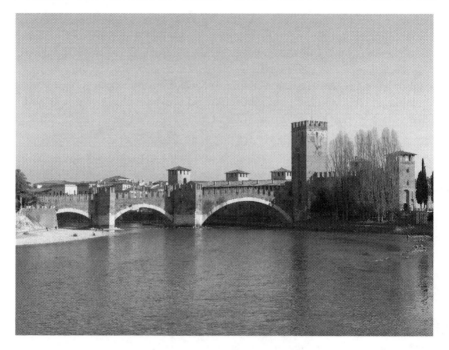

Figure 2.6 Verona, Scaligeri bridge with the Castelvecchio behind

Murphy on Morris

Richard Murphy's commentary, the result of decades of careful study of the complex, includes an engagement with William Morris which itself deserves comment. As an architect, Murphy boasts his own illustrious body of work, in which the poeticism of Scarpa is a major acknowledged influence. His chapter on the historic development of the site makes an explicit link between Scarpa and William Morris;[2] he frames the chapter with a quotation from Morris, including the following:

> All continuity of history means is after all perpetual change, and it is not hard to see that we have changed with a vengeance, and thereby established our claim to be the continuers of history.
>
> (Morris [1889] 1936: 152)

Murphy's concluding paragraph to the chapter begins:

> In his attitude to history Scarpa is inseparable from Morris. He preserved rather than restored. He repaired a fragment as such rather

than reconstruct it in its entirety. And he believed intrinsically in the coexistence of his vocabulary with those of previous eras, the juxta-position never arbitrary but always mutually beneficial. Scarpa was no modernist turning his back on history; rather he wanted to build on and construct within it.

(Murphy 2017: 23)

In this Murphy understands Scarpa well, though not, I think, Morris. He continues: 'Like Morris he was determined to be a continuer of history', noting that 'Scarpa spoke of his "immense desire to belong inside a trad-ition"'. I suggest that, while true of Scarpa, this is a misreading, or at least an oversimplification, of Morris.

The quote with which Murphy's chapter starts is taken from an address Morris gave in 1889 to the Twelfth Annual Meeting of SPAB. It is certainly the case that the modern-day SPAB would prefer interventions in historic buildings to be of their time, rather than historicist – a recent book co-authored by the SPAB Chairman Iain Boyd, *New Design for Old Buildings* (Hunt & Boyd 2017), features bold interventions in thirty historic buildings including Astley Castle (Witherford Watson Mann), Bracken House (Hopkins Architects) and the Holburne Museum in Bath (Eric Parry Architects). On behalf of modern-day SPAB, Hunt and Boyd claim that the projects they discuss are animated by the spirit of Morris, and Murphy argues much the same for Scarpa. I suggest that a close reading of Morris does not support either claim – Morris was a purist whose uncompromising polemic, I would argue, is incompatible with the approach taken at the Castelvecchio and other similar projects.

It should be remembered that Morris enjoyed the luxury of standing aside from the sometimes messy business of making buildings work, and could afford to adopt the purist position that new should not be mixed with old – this was George Gilbert Scott's complaint touched on in Chapter 1. For Morris cannot imagine anything between outright demolition or destructive restoration, on the one hand, and minimal preservation, on the other; he says we must either sweep these buildings away or treat them as relics of the past. And that puts severe limitations on their ongoing use: for Morris, 'If these buildings are to be really preserved by us for our use, that can only be done by understanding the gulf which lies between us and the past' (Morris [1889] 1936: 156).

How then to reconcile these two views of Morris, on the one hand, as the opponent of change in historic buildings and, on the other, as the proto-Scarpian 'continuer of history'? Clearly Scarpa was no practitioner of nineteenth-century restoration, and in that sense the parallel with Morris

is justified. Furthermore, it can be argued that Scarpa's interventions succeeded in 'leaving history in the gap', and that Scarpa was designing in 'a style of [his] own' (Morris [1877] 2017), the lack of which was, rightly, one of Morris's principal complaints against the architects of his day. Morris would surely have seen Scarpa's interventions very differently from the 1920s restoration, and therefore, in those terms at least, there is an argument to support Murphy's view of Scarpa as a Morrisian. But Murphy's claim that Scarpa, is *inseparable* from Morris in his attitude to history requires stronger justification, and that argument cannot be made by appealing to tradition, as Murphy does. There is precious little to suggest that Morris would change his view that the tradition that created a medieval church and subsequently adapted it is any less dead than he declared it in his time; indeed that is the thrust of his 1889 address, from which Murphy quotes only selectively.

The instructive relic

The central theme of Morris's 1889 address was the discontinuity of history, and the absolute death of tradition, including amongst the craftsmen. Because of his commitment to the discontinuity of history, Morris disqualifies craftsmen and designers as standing outside the tradition that formed and then re-formed these gloriously composite buildings; it is on this basis that he would then oppose the argument that continuity of change to sustain contemporary use can be justified. For Morris, the 'value of these buildings has more than one side, they have many parts, and we are unable to discriminate between the value of one part and another' (Morris [1889] 1936: 150). Scarpa, too, saw the Castelvecchio as having 'many parts', but embraced the editorial task of differentiation between those parts with confidence; his whole approach revolved around just this, and the delightful result, rightly celebrated by Murphy, is unthinkable without it.

So how would Morris respond to Scarpa? For Morris:

> The real, the essential purpose, in this day, of our old buildings is to be instructive relics of the past art and past manners of life. If you can do so, without altering them or making shams of them, use them for ecclesiastical, civic, or domestic purposes, just as we are using this building now. That is the best way of preserving them.
>
> (Morris [1889] 1936: 151)

Morris insists that their current use – for example a church as a place of worship – is its *secondary* purpose: 'I say they themselves are of infinitely

more value than any use they can be put to …' (Morris [1889] 1936: 151). Subsequent developments in heritage thinking, including the so-called 'Critical Heritage Studies' to be explored in Chapter 3, have demonstrated the hidden consequences of this approach, including the implied theft of the building from the community which formed it and which it continues to form. In this, Scarpa is wholly different, placing himself firmly within an ongoing, creative tradition.

Murphy's argument would, I suspect, be that Morris might make an exception for Scarpa. It is certainly the case that Scarpa was uninterested in architectural fashion, and also that he used a small group of trusted craftsmen, who often went from project to project with him. And this is a very appealing approach to adopt, since both Scarpa and Morris are in many respects so thoroughly likeable. But this is too easy a reconciliation, and one which passes over a fundamental aspect of Morris's position. What Murphy's reading discounts is that Morris is *attacking* the idea of the continuity of history which, in the sentence preceding Murphy's opening quote, Morris says 'is now pedantry [and] apt to lead to the destruction of buildings and their falsification' (Morris [1889] 1936: 152). What Morris is arguing is that the continuity of history implies perpetual change, and that if they are to survive, historic buildings must be *removed* from the flow of history, that change must be stopped.

So persuasive is his writing, and so revered is his memory, that Morris continues to exert considerable influence in conservation, as discussed in Chapter 2. While there is indeed much to celebrate in his legacy, the uncritical adoption of his polemical approach is fraught with danger, both for the communities associated with many of the historic buildings for which conservation professionals care, and for the buildings themselves. This concern most obviously applies to living buildings: in most cases, it is precisely their ability to flex and change that has preserved them, a point which one imagines Hunt and Boyd, in their survey of contemporary architectural excellence in historic settings, would concede.

Extending the narrative

Under the narrative approach, the Castelvecchio complex now poses the question of whether Scarpa's work formed the closing chapter of the narrative, or whether it should be continued. Certainly there are those, for example a Scarpa specialist, who might now oppose further change to the Castelvecchio – or at least the main spaces Scarpa created – on the basis of the harm to Scarpa's vision. There has indeed been further change to the complex as a whole; in a more recent intervention in 2006 the room and

upper stair outside the Sala Boggian in the east wing (E) was returned to its 1920s restoration phase (Murphy 2017: 18), but this is perhaps best read more as a footnote than a chapter, with minimal impact on the thrust of the narrative as Scarpa left it. By contrast, the work by architect Giuseppe Tommasi to display the equestrian statue of Mastino II in the clock tower (O) in the same year, together with the creation of a secluded roof garden to the west, engages with Scarpa and forms a further more distinct chapter, indeed a skilful one; appropriately, these interventions complement Scarpa's work, extending his story rather than attempting to reshape it.

The living heritage argument would resist the sacralization of the Castelvecchio, insisting that if in future the building is expected to address different needs, the possibility of further change, including to the Scarpa work, must remain open. However, the narrative approach would also recognize the scale of Scarpa's editorial achievement in strengthening the narrative of the building to date, which would raise the threshold for further change in the inevitable balance between impact and benefit. One key aspect of the Castelvecchio is that, while it now enjoys continuity of use as a museum, it long ago ceased to be a palace and fortification; similarly, the great majority of the examples within Hunt and Boyd's book are historic structures which have taken on a different purpose and the modern work has facilitated that adaptive reuse. This is a wholly different situation from living buildings which retain their original use, such as a medieval English parish church.

Intriguingly, in contrasting the fourteenth and the nineteenth centuries, Morris describes the 'unconscious habit of working the stone' as 'the language in which the story was told when stories were told in buildings' (Morris [1889] 1936: 154). Morris, then, can be claimed as a narrativist, as one who imagines buildings as a form of story! If so, our principal point of difference, but a difference on which everything hangs, is that for Morris this language, the ability to write stories in built form, is something that is irretrievably lost. I suggest that the narrative that results from Scarpa's skilful editorial intervention at the Castelvecchio, carefully composed around the Cangrande statue (Figure 2.7), provides a definitive rebuttal of Morris's view, and that this building is therefore representative of what is a profound difference between Morris and Scarpa. The Castelvecchio is so much more than the 'instructive relic' that it would have been had Morris had his way and had Scarpa not intervened. Far from Scarpa being inseparable from Morris, I suggest the two are incompatible. Scarpa was no preservationist, but rather engaged boldly with history, seeing himself as embedded in, and a continuer of, an ongoing tradition; the same cannot be said of Morris.

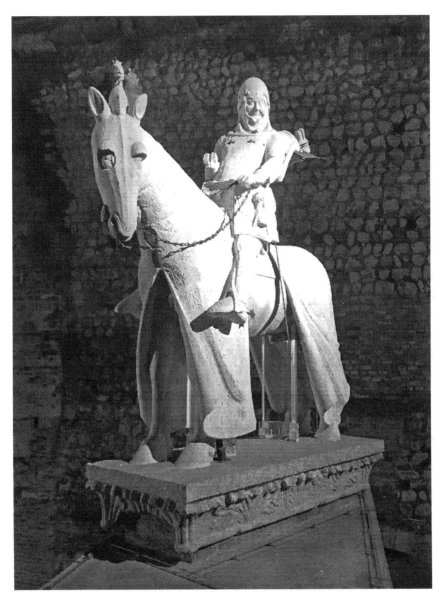

Figure 2.7 Verona, Castelvecchio: statue of Cangrande with Commune wall behind

Notes

1 Ruskin presented his drawings to the Ruskin Drawing School (University of Oxford), in1875; they are now in the Ashmolean Museum. One shows the delightful detail of Cangrande's smiling face.
2 The chapter is entitled 'The Continuity of History Is Perpetual Change' (pp. 14–23).

References

Hunt, R. & Boyd, I. (2017). *New Design for Old Buildings*. Newcastle upon Tyne: RIBA Publishing.

Morris, W. ([1889] 1936). Address at the Twelfth Annual Meeting, 3 July 1889. In: M. Morris (ed.), *William Morris, Artist, Writer, Socialist: Volume 1: The Art of William Morris; Morris as a Writer*. Oxford: Basil Blackwell. pp. 146–157.

Morris, W. ([1877] 2017). *The Society for the Protection of Ancient Buildings Manifesto*. [Online]. Available at: www.spab.org.uk/about-us/spab-manifesto.

Murphy, R. (2017). *Carlo Scarpa and Castelvecchio Revisited*. Edinburgh: Breakfast Mission Publishing.

Rab, S. (1998). Carlo Scarpa's Re-Design of Castelvecchio in Verona, Italy. In: C. Barton (ed.), *86th ACSA Annual Meeting Proceedings, Constructing Identity*. Washington, DC: Association of Collegiate Schools of Architecture. pp. 443–451.

Chapter 3

People
Community, language, and power

> *Experto crede*, I have seene somewhat,
> and therefore I thinke I may say the more.
>
> Stephen Gosson ([1579] 1841)

Where Chapter 2 was chiefly concerned with material aspects of heritage, the focus of this chapter is the role that people play in heritage. There have been many different attempts to account for the relation between the physical fabric of a historic building and those who use and/or visit it. Indeed 'where are the people?' – that is, whether people are integral to or incidental to historic buildings, the terms on which people are able to engage with them and to what ends, and so forth – is a question that should be foremost in the mind of any conservation professional. This issue is inherently political, setting the rules of engagement for the conflicts that will inevitably arise, for example between heritage experts and non-professionals. The outline of those rules is in part revealed through a close reading of the language that is used, not least in the official documentation that structures the care of historic buildings. Or at least that is a dominant belief within some contemporary heritage thinking. This chapter explores these issues.

3.1 Where are the people?

The prominent conservation architect Bernard Sir Feilden, for whom conservation work is inherently multi-disciplinary, positions the architect as the conductor of an orchestra, while 'The building is his musical score – not a note may be altered' (Feilden 2003: xi). For Feilden, first writing in 1982, the professionals are very much in charge, and it is not at all clear that he sees the community as having any role in bringing the 'music' of the building to life, let alone that the community might have good reason to make changes to the 'tune'. On an alternative reading, conservation developed as an attempt by non-professionals to wrest a degree of control over the

built environment from the experts – architects, developers, government etc. In that sense, from its inception conservation has been concerned with power relations; hence the SPAB *Manifesto*, for example, presents a direct challenge to architects, the 'official guardians' of our built heritage. Miles Glendinning charts the democratization of the Conservation Movement in the 1960s–70s, in part aligned with a more general rejection of professionalism and in some locations, for example in West Germany, with radical socialism (Glendinning 2013: 325–329). In the United Kingdom, it was often activists, leading community opposition to slum clearance, who increasingly argued for rehabilitation rather than redevelopment of substandard housing.

While there is ample evidence of an appetite for heritage in the wider population – for example in the burgeoning membership of the National Trust in England and Wales, now standing at some 5,600,000 (National Trust 2019) – the enduring opacity (for the general public) of the conservation process remains a major issue. It is in this context that Erica Avrami (2009) called for a 'new emphasis on the social processes of conservation'. From its inception with David Lowenthal's *The Past a Foreign Country*, the discipline of heritage studies has been critical of the 'heritage industry', including its political conservatism. The contested role of the expert is intimately connected with our understanding of the relative importance of what is called social or communal value. As with any revolution, the question remains as to who are the real beneficiaries of the redistribution of power; where that shift of influence is towards 'the community', the political question of whose voices (and within which communities) are deemed valid remains to be addressed.

Experts, universalism, and the local

Despite greater questioning of the role of the expert in heritage (e.g. Schofield 2014), conservation practice remains largely expert-led, an increasing oddity in a climate of greater public participation (Orbaşli 2017). In her book *The Uses of Heritage*, Laurajane Smith coined the term 'Authorized Heritage Discourse' (AHD) to describe the dominant, established set of ideas and processes that govern the discipline and define its orthodoxy. In the culture generally, the AHD 'works to naturalize a range of assumptions about the nature and meaning of heritage'; for professionals it 'privileges expert values and knowledge about the past and its material manifestations, and dominates and regulates professional heritage practices'. (Smith 2006: 4). This relationship with professionalism works in both directions, since the AHD

is reliant on the power/knowledge claims of technical and aesthetic experts, and institutionalized in state cultural agencies and amenity societies. This discourse [...] privileges monumentality and grand scale, innate artefact/site significance tied to time depth, scientific/aesthetic expert judgement, social consensus and nation building.

(Smith 2006: 11)

Smith contrasts this with popular practices and forms of discourse which sustain the objects in question before they are decontextualized through preservation for future generations.

William Morris's SPAB *Manifesto* ([1877] 2017), considered in Chapter 2, explains how and why the proposed Society would seek to protect ancient buildings. In presenting their 'official guardians' – that is, the architectural profession – as the principal source of threat, the text can be read as a radical rebalancing away from experts towards community interest; greatly to SPAB's credit, the facilitation of the non-professional care of historic buildings is promoted to this day. Yet for all its radical polemic, the *Manifesto* is representative of nineteenth-century attitudes in making no mention whatsoever of the local communities with whose buildings it is concerned; any rebalancing is not towards the community as representatives of any ongoing tradition, but the community as a caretaker whose role is to do no more than 'stave off decay by daily care', in Morris's enduringly resonant phrase. The only reference to non-professionals is to 'the public generally', rather than the specific communities associated with particular buildings; these are at best irrelevant, and at worst deemed complicit in the destruction the Society has been created to resist. This lack of differentiation between distinct levels of community persists, and will be discussed further below.

Following on from this issue of how experts relate to communities, and key for conservation, is the question of the locus of culture. Much of the development of conservation had been driven in the nineteenth century in the service of competing nationalisms, and in the twentieth century by international charters, starting with the *Athens Charter* (ICOMOS [1931] 2015); the development of World Cultural Heritage processes strengthened this further. On the spectrum from the global, through the national, to the local, the word 'community' can be applied at any and all points. In the culture more broadly, appeals are frequently made to 'community', but for the most part the nature of 'community' goes unexamined: it is often assumed in public discourse to refer to communities of interest, that is to aggregates of people with shared attributes. Almost any adjective can be

pressed into service – we might equally talk for example of the Muslim, village, medical or gun-owning communities; in each case, 'community' bears a quite different meaning. In a conservation context, richer definitions become operative, including aspects of geographical location and rooted-ness, together perhaps with a sense of common purpose; in the context of values-based conservation this begins to provide a means to distinguish communal value from social value.

In the nineteenth century, the primary locus of culture was very much understood to be the nation state; accordingly, nationalism had a very sub-stantial role in the early development of conservation, with historic buildings recruited to competing nationalist causes (Jokilehto 1999; Glendinning 2013). It was the mid-twentieth-century disenchantment with nationalism after two world wars that led to the establishment of an international heri-tage infrastructure, which in time produced the World Heritage Convention (UNESCO 1972), with its notion of 'outstanding universal value' (OUV). It should be noted that OUV is 'from the point of view of history, art or science' (UNESCO 1972: Art. 1) but not community; indeed, rather than the communal or social being an essential part of heritage, 'changing social [...] conditions' are seen as part of the problem (Preamble). This universalism involves a substantial claim:

> What makes the concept of World Heritage exceptional is its universal application. World Heritage sites belong to all the peoples of the world, irrespective of the territory on which they are located.
>
> (UNESCO 2017)

In his *Notes Towards a Definition of Culture*, the poet and critic T.S. Eliot argues against this universalism, insisting that (sub-national) regionalism is the essential place from which culture develops. With specific reference to the 1945 draft UNESCO Charter, he criticizes the misuse of the word 'cul-ture' 'as a kind of emotional stimulant – or anaesthetic' (Eliot 1948: 14), and argues throughout for the priority of the particular and local over the universal. Criticism of the implications of a universalist approach con-tinues; for example Sandra Bowdler comments on the traditional practice of repainting Australian aboriginal rock art:

> The phrase which seems to have acted like a bell on the Pavlovian dogs of the heritocracy is 'cultural heritage of all mankind' [...] [D]efining something as belonging to that transcendent category is a means of excluding anyone who might have a particular interest in it.
>
> (Bowdler 1988: 521)

Melanie Hall demonstrates the less recognized internationalizing factors in the development of conservation ('historic preservation') from the late nineteenth century onwards, arguing for a substantial overlap with national initiatives, and noting how substantial religious buildings were used to reimagine 'international romanticized-Christian communities' (2011: 7). While Chris Miele (2011) argues in the same volume that the idea of community underpins much heritage discourse, it is almost invariably the abstractions of an undifferentiated imagined form of universal community that is understood, while the local and particular is routinely overridden or ignored. Keith Emerick (2014: Chapter 4) tells of how British heritage management in colonial-era Cyprus recognized that different communities have divergent readings of the cultural environment, but that this understanding was never transferred back into UK practice. He concludes that conservation professionals must '"trust" a community and let them deliver their own solutions', based on building 'the link between people, story and place' (2014: 226, 230); in this way, the expert becomes an 'enabler' (2014: 177). The link between story and place will become a major theme from Chapter 5 onwards.

Intangible heritage

As already noted, implicit within the World Heritage Convention processes is the promotion of the universal, and that this must, by its very nature, come at the cost of the local. One of the principal challenges to the Western notion of World Heritage came through its forcible engagement, on the basis of its very claims to universality, with alternative and non-Western models of heritage (Harrison 2013: 204). The development of intangible heritage thinking was an attempt to address this challenge, responding to criticism at an international level from countries with indigenous peoples whose heritage was not in tangible forms such as historic buildings but rather in intangible forms such as oral tradition and folklore. Noriko Aikawa-Faure was responsible for the intangible cultural heritage program at UNESCO from 1993 and documents of the development of thinking behind the Convention for the Safeguarding of the Intangible Cultural Heritage (CSICH) (Aikawa-Faure 2009; UNESCO 2018), which was adopted in October 2003 and came into force in 2006. By October 2017, 175 state parties had ratified the Convention, with the notable English-speaking exceptions of the United Kingdom, the United States, Canada, Australia, and New Zealand. As of 2018, the Representative List of the Intangible Cultural Heritage of Humanity contained more than 500 'elements' across 122 countries.

The opening paragraph of Director-General Audrey Azoulay's foreword to the basic texts of the CSICH frames intangible cultural heritage in the following terms:

> Cultural heritage is not only about the buildings and monuments of the past – it is also about the rich traditions that have been passed down the generations. As vehicles of identity and social cohesion, this intangible cultural heritage also needs to be protected and promoted.
>
> (UNESCO 2018: v)

The phrase 'rich traditions' is used to encapsulate intangible heritage – in contrast to the 'buildings and monuments' of tangible heritage – and these traditions are valued for their role in social cohesion and the formation of identity, presumably both for communities and for individuals. Within the Convention itself, Article 2.1 defines intangible cultural heritage as 'the practices, representations, expressions, knowledge, skills […] that communities, groups and, in some cases, individuals recognize as part of their cultural heritage'. It is understood to be 'transmitted from generation to generation', and is 'constantly recreated', pushing the focus of heritage away from a physical product towards an intergenerational process. This ongoing re-creation of heritage is performed 'by communities and groups', with the result that it 'provides them with a sense of identity and continuity'; one implication of this is the promotion of 'respect for cultural diversity and human creativity'. The Convention explicitly excludes intangible cultural heritage that is incompatible with 'existing international human rights instruments' or with 'the requirements of mutual respect among communities, groups and individuals, and of sustainable development'. Article 2.2 then sets out a non-exclusive list of five 'domains' in which intangible cultural heritage is manifested, including '(a) oral traditions and expressions […] (d) knowledge and practices concerning nature and the universe [and] (e) traditional craftsmanship'.

The question of most relevance in the current context is how the relation between intangible and tangible forms of heritage such as historic buildings is understood. On the one hand, Article 2.1 asserts the connection between intangible practices etc. and the tangible aspects such as the 'instruments, objects, artefacts and cultural spaces' associated with them; this has the effect of bringing all tangible heritage – at least that which retains a connection to living practices – into the domain of intangible heritage. On the other hand, Article 3 is careful to stipulate that where an item of the intangible cultural heritage is directly associated with a property protected by the 1972 World

Heritage Convention, that protection is not altered or diminished. The assumption, at this level of international conventions, is that the relationship between the two forms of heritage, operating under separate regimes of protection, will coexist unproblematically; the idea that the significance of heritage might be contested, or that aspects of the one might be inimical to the other, goes unacknowledged.

That concern has, however, been there from the outset. Mounir Bouchenaki, UNESCO Assistant Director-General for Culture, addressed the interdependency of tangible and intangible heritage in his keynote address at the 14th General Assembly of ICOMOS, which took place in October 2003, just two weeks after UNESCO's adoption of the CSICH. Asking how they are interrelated, he describes tangible and intangible heritage as existing in 'a symbiotic relationship' in which 'The intangible heritage should be regarded as the larger framework within which tangible heritage takes on shape and significance' (Bouchenaki 2003). He describes tangible and intangible heritage as 'two sides of the same coin', and identifies 'mixed heritage', for which specific policies are now needed, as 'among the most noble cultural spaces and expressions produced by mankind'. On the other hand, he regards living heritage as synonymous with the intangible, betraying the inescapable dualism of the current system. I want to argue, at least when it comes to historic buildings in community use, that 'mixed heritage' describes the norm rather than the exception and to note that no such 'specific policies' have yet been developed to address this norm. The implication of seeing historic buildings as 'mixed heritage' in this way is to question the orthodoxies of conservation.

In 2004, a year after the CSICH was adopted, the issue of the interrelation of the two forms of heritage was again addressed, at a conference held in Nara, Japan entitled 'The Safeguarding of Tangible and Intangible Cultural Heritage: Towards an Integrated Approach'. Stressing the need for integration between the two regimes, the conference produced the *Yamato Declaration on Integrated Approaches for Safeguarding Tangible and Intangible Cultural Heritage*, which states that:

> taking into account the interdependence, as well as the differences between tangible and intangible cultural heritage, and between the approaches for their safeguarding, we deem it appropriate that, wherever possible, integrated approaches be elaborated to the effect that the safeguarding of the tangible and intangible heritage of communities and groups is consistent and mutually beneficial and reinforcing;'
>
> (UNESCO 2004b: 11)

This represents an appropriate statement of principle that acknowledges the problem, without tackling the question of how in practice it might be resolved. Six weeks later, the Seventh Extraordinary Session of the World Heritage Committee noted the relevance of the *Yamato Declaration* to their work and discussed cooperation and coordination between the 1972 and 2003 conventions. The Committee was clear that the two conventions 'address different forms of heritage and therefore [...] have different scopes' (UNESCO 2004a: 11); and while the 2004 Operational Guidelines to the WHC introduced the latitude to consider elements of intangible cultural heritage for inscription as World Heritage, the two forms of heritage are still envisaged to be two fundamentally dissimilar domains which are acknowledged to overlap, but without any adequate theoretical account of their interrelation.

Frank Hassard is one author to address this overlap between tangible and intangible forms of heritage in more practical terms in the context of the conservation of material heritage. Hassard focuses on the skills/craftsmanship aspect of intangible heritage, arguing that intangible heritage is sustained by the 'the pre-industrial, historically transcendent craft-based perspective' (Hassard 2009: 282) and on that basis claims Ruskin and Morris as prototypical champions of intangible heritage. Notwithstanding their well-known interest in craft skills, Hassard is selective in his reading of both figures. While Ruskin does indeed accept the dynamism of historic buildings, this is only in the sense of gradual decay; when it comes to the medieval churches with which both were so concerned, there is no space for the users of such a building to play a role in shaping its future. While in its own terms Hassard's reading is perfectly valid, it does nothing to acknowledge the role of non-expert community voices in heritage decision-making; as such it can be read as an appropriation of one element of intangible heritage within the existing framework of established interests that dominates material heritage, without causing the least disturbance to the framework as a whole. Hassard cites the philosopher Hans-Georg Gadamer's account of the development of a new hermeneutical consciousness rooted in the Reformation (Hassard 2009: 271) but fails to engage with Gadamer's diagnosis of the romanticism which shaped both Ruskin and Morris as merely the reversal of the axiomatic belief of the Enlightenment in the incompatibility of myth and reason, as discussed in Chapter 2. Central for Gadamer was an understanding of the ongoing relevance of tradition, something neglected or denied by Ruskin and Morris and also by Hassard; the relevance of this will be explored further in Chapter 4.

The uses of intangibility

For Laurajane Smith, the development of the category of intangible heritage is highly significant for her argument against the AHD, relevant both for its embracing of diversity and for its recognition of cultural change. She declares it her task 'to redefine all heritage as inherently intangible in the first place' (Smith 2006: 56). For Smith, intangibility not only expands the definition of heritage beyond the monumental, it subverts the conventional understanding of the significance of tangible heritage and reverses the dominant model of the prizing of tangible heritage and the marginalization of people. Framed within Smith's wider argument, the interrelation of tangible and intangible entails the exercise of power. Thus, for example, 'The Western authorized heritage discourses that define or emphasize the materiality of heritage, work to render the intangible tangible'; and once made tangible, heritage can then be regulated, to the end of creating 'consensus history' (Smith & Waterton 2009: 294). This places tangible heritage under suspicion, suggesting its influence is that of a usurper or colonial aggressor. On this account, heritage 'is something that is done at sites and places' (2009: 300), implying the demotion of buildings to the status of the scenic backdrop against which the heritage action unfolds. While it is not difficult to point to examples where local voices are indeed excluded by those who define heritage in exclusively or predominantly material terms, this politicized reading is as partial as the view it criticizes, and is unable to offer a balanced account of the interrelation of tangible and intangible forms of heritage.

Another benefit of intangibility for Smith is the acknowledgement of the centrality of cultural change to intangible heritage, whereas for the AHD the mutability of cultural significance is anathema (Smith 2006: 111). Amongst its 12 ethical principles for safeguarding intangible cultural heritage, UNESCO recognizes its 'dynamic and living nature', which it stipulates 'should be continuously respected' (UNESCO 2018: 114). Welcome as this is, the association of intangible heritage with 'living culture' leads too easily to a topology that presumes that if the intangible is concerned with the living, then the tangible must be the realm of the inert, the static, the 'dead'. Smith's answer, as already noted, is to define all heritage as intangible and therefore mutable, but in the absence of an explicit theoretical account for how tangible heritage is, in this sense, living, there is little indication of how the mutability of tangible heritage might justifiably be constrained. This illustrates the more general danger, notwithstanding statements to the contrary in the CSICH, of the two conventions leading to a division between two increasingly independent realms: 'the "tangible", concerned

with ideas of reality, evidence and *knowledge*; and the other, the intangible, concerned with the "lesser" ideas of "empathy" and *belief* (Emerick 2014: 182, emphasis original). Britta Rudolph views this dichotomy as positively destructive, posing a threat to the very forms of heritage it is designed to protect, since it 'divides mutually shared meanings and disrupts identities constructed in combined processes'; instead, she suggests the dichotomy can be resolved by treating the two typologies 'as extremes on a gradual scale' (Rudolff 2006: 230). Even this reclassification is problematic, as the tendency will be for professionals to occupy the end of the spectrum with which their training makes them most comfortable, perhaps unaware that it is their very distance from the opposite end that makes those other concerns seem so small in comparison to their own. With a keen eye for how this plays out in the practices of heritage management, Emerick goes on to ask, rhetorically, 'if faced with the choice, would a heritage manager prefer to promote intangible craft skills by supporting the addition of new material over the privileging of historic fabric through "traditional" conservation repair?' (2014: 183).

Defining all heritage as intangible reverses the conventional or 'authorized' priority but, while helpful in highlighting the dynamic nature of heritage, it is insufficient to resolve the problem of the interrelation of tangible and intangible. Aside from being unacceptable from an orthodox conservation point of view, it is fundamentally compromised because it accepts as primary a division between tangible and intangible which itself is part of the problem. Harrison observes that concepts of intangible heritage (and cultural landscapes) are 'fundamentally at odds with the Indigenous ontological position' (2013: 204) to which these innovations sought to respond – by which he refers to the worldviews and philosophical systems that typically shape Indigenous ways of thinking about being in the world. Mirroring Bruno Latour's observations of premodernity discussed above, such non-Western systems do not recognize the dualisms so typical of Western modernity, such as between nature and culture, matter and mind, or indeed tangible and intangible. They thus highlight the cultural specificity of World Heritage, giving the lie to its claims to universality, which are so crucial, both legally and morally, for UNESCO's approach to heritage.

This 'resistance' from non-Western approaches is important in opening the way for modern, Western conservation to consider alternative approaches that might be better suited to the care of historic buildings, approaches that treat tangible and intangible as an integrated whole in which each is always present, even if the proportions may vary. Harrison, for example, goes on to propose 'a relational or dialogical model, which sees heritage as emerging

from the relationship between a range of human and non-human actors and their environments'; this, he suggests, might 'allow us to emancipate and use heritage in more creative, transformative ways in the future' (Harrison 2013: 204, 205). The same language of dialogue was used by Vassilis Ganiatsas in response to ICOMOS President Gustavo Araoz's (2011) call for a new heritage paradigm:

> dialogue means that we encounter something other than ourselves, we engage with it, we are open to change ourselves out of this encounter in order to accept what is new, what is yet unknown, what is the 'big other' out there. We must be open and ready to accept 'what the monument wants to be', in quoting the architect Louis Kahn. [...] This engagement and openness to dialogue is beyond any theory or practice, it is really an ethical attitude, to which sooner or later we should tune ourselves ...
> (Ganiatsas 2012: 159–160)

He concludes that 'Monuments are interlocutors to enter in a dialogue with on an equal basis; not objects to manipulate, no matter how sensitive and careful we could be' (2012: 160–161). This is a theme that parallels the central argument of this book, and which he clearly sees as having wider application beyond the concerns of World Heritage.

The argument for the primacy of the intangible cannot help but downplay the tangible, and it is notable that at times Smith and others appear to treat physical material with disdain. While Smith's critique has proved influential – and rightly so – it is equally valid to ask whether her approach does not itself wilfully misuse material heritage to pursue its own ideological agenda in a 'Subversive Heritage Discourse'. While it is clear that the conventional focus on the materiality of heritage risks losing sight of the people associated with it, there is an equal and opposite danger that a focus on intangible heritage might lose sight of the material. Central to this book is a concern for material heritage and the communities that form and are formed by it. Rather than simply furnishing the backdrop to human action, buildings play a far more active role in the creation of community, themselves becoming actors in the drama. On this view, whatever is agreed about the contested nature of heritage and its abuse in the pursuit of power, dividing intangible from tangible obscures their essential interrelation, and rules out the more demanding possibility, argued for here, of their essential unity. Calls to attend to their interrelation from within a framework predicated on their division – notably at the level of World Heritage – remain ineffectual and tokenistic.

People and social value

The mechanism by which the current orthodoxy of international conservation accounts for the role of people in heritage conservation is through social and/or communal value. Following the introduction of the idea with the *Burra Charter*, the conservation process now revolves around the assessment of significance, understood to comprise a series of discrete values. Of these, social value is touted as the means of democratizing heritage, giving a voice to local communities alongside the specialist interests of the expert which hitherto had determined conservation decision-making. 'Social value' has a large degree of overlap with communal or community value, and these terms are often used interchangeably. Historic England's framework, directly derived from the *Burra Charter*, treats *communal* value as the primary category. This it defines as deriving 'from the meanings of a place for the people who relate to it, or for whom it figures in their collective experience or memory', and includes within it commemorative, symbolic, social and spiritual values (Historic England 2008: 31–32). Meanwhile, a more recent UK-based academic review of existing approaches describes social value as 'fluid [and] culturally specific', encompassing 'the ways in which the historic environment provides a basis for identity, distinctiveness, belonging, and social interaction' (Jones & Leech 2015: 5–6).

On the face of it, this system has notable advantages over what preceded it, but it has nevertheless been criticized for failing to deliver on its promise to give voice to the concerns of local communities. Siân Jones (2017: 22), developing her research with Leech, notes that the conventional 'expert-driven' methodology often fails 'to capture the dynamic, iterative and embodied nature of people's relationships with the historic environment in the present' that constitute its social value. She goes further, questioning whether 'a value-based model, which inevitably tends to objectify and fix different categories of value, is even appropriate' (ibid.). Waterton et al. judge the inclusion of community participation in the *Burra Charter* as 'inherently tokenistic', with its differentiation between 'experts', who possess the skills and authority to determine cultural significance, and 'participants' who are relegated to the status of passive recipients, so that 'cultural significance becomes something non-experts have to understand rather than contribute to' (Waterton et al. 2006: 350). Their suggestion is a more genuinely participatory process in which not only heritage values but also the conservation ethic itself is open to renegotiation and redefinition' (2006: 351). For Jones, the solution is to add social research methods including qualitative interviews and focus groups to conventional practices; the argument of this book is that, while the problem may be correctly diagnosed, a more radical solution is required of the sort Waterton et al. envisage, one that

acknowledges the unique forms of expertise community groups possess, without which heritage significance cannot be adequately understood or accounted for.

The significance system common to the *Burra Charter* and all that has been developed from it supposes that understanding proceeds from breaking something down into its smallest possible 'units of meaning' and that the significance of the whole is then naturally discerned from the resulting collection of parts. This atomistic method of analysis was foundational for the success of the new science in the early modern period and continues to deliver technological advances; this has led many to assume it to be universally applicable. But the question, as always, is what such a method excludes, and what other, less desirable and unacknowledged work it might do. Just as Harrison observes Indigenous ontologies presenting a challenge to this model, so the Romantic poets resisted the march of the scientific method: for example William Wordsworth railed against the way

> Our meddling intellect
> Mis-shapes the beauteous forms of things:–
> We murder to dissect
>
> (Wordsworth [1798] 2006).

We could term the current methodology of deriving significance from an assemblage of values as a 'significance calculus'. However, historic buildings are often highly complex and resist reduction through this sort of analysis. As a framing epistemology, this significance calculus is mechanistic and scientistic, and ignores the possibility that a significant building might – and arguably in the case of a historic building necessarily does – add up to more than the sum of its parts.

Under current conservation methodologies, it is to social value that local communities must look to articulate their interests in a historic building. Behind the values system in general, and social value in particular, is the understanding that all meaning is socially constructed in the present. While in general terms this may often be the case – we are constantly making meaning in order to navigate the world – we should at least pause to question what might be lost when this understanding is transferred onto something as complex as a historic building which has already endured through many generations, many of which may have intervened to adjust the building to their changing needs. A building such as this presents the obvious question as to why the understanding of the present generation should overrule that of previous and future generations. On the principle that possession is nine tenths of the law the present generation already enjoys a preferential status

in this regard. Social value questions the idea that the significance of the past is fixed and somehow inherent in the physical building or object. In challenging the hegemony of the past, its acknowledgement of the fluidity of meaning is welcome. But replacing that with a 'hegemony of the present' gives rise to a further set of problems, and the obvious need to introduce some constraint on the present in its use of the past too easily leads social value to be ignored altogether. If a culture is to retain its sense of rootedness and orientation, but also to remain a living culture, it will need a different means of reconciling the competing claims of past and present.

The 1913 Völkerschlachtdenkmal in Leipzig, Germany illustrates the vagaries of this model of the attachment of meaning, and its inherently political nature (Figures 3.1 and 3.2). This huge early twentieth-century building is heroic in scope, intentionally intimidating in size, its huge granite

Figure 3.1 Leipzig, Völkerschlachtdenkmal: approach

Figure 3.2 Leipzig, Völkerschlachtdenkmal: crypt

blocks speaking loudly of an enduring monumentality. Its explicit purpose was the commemoration, 100 years on, of the 1813 Battle of the Nations, in which Napoleon was decisively defeated by Prussian, Austrian, Russian, and Swedish forces, thus marking the end of French power east of the Rhine. That explicit purpose, however, has not prevented this monument being subject to a variety of competing interpretations: it has been symbolically appropriated first by those seeking a return of the German monarchy, then in turn by the Nazis, the Communists, and again more recently by the Far Right. It thus serves as a good illustration of the attachment of significance to things – in this case by different political groups – but by the same token demonstrates the fluidity and relativism implicit in this understanding of meaning. On the one hand, this building provides an excellent example of the operation of the social construction of value, but equally it demonstrates its ephemeral and transitory nature, in that it shows how successive groups of *specific* people have viewed the building at *particular* times. This suggests two questions for social value to address – who it is whose voice is heard in the determination of social value, and for how long that view is deemed valid. In less overtly politicized contexts, the first of these is addressable through the creation of conservation processes

that more rigorously reflect public opinions, for example through Jones's proposed remedy noted above. But since social value on the constructivist model must be created *in the present*, it remains powerless to address the question of time depth, of a continuity of understanding between generations.

Heritage as discourse

In a lecture entitled *All Heritage is Intangible*, Laurajane Smith argues that at an early stage of its development, heritage studies took a mis-step, dividing between two distinct and narrow understandings:

> The first was a technical path where it was believed that the political use of heritage could be ignored, or even controlled, through the provision of trained and so-called objective and professional experts, who are well versed in the technical application of national and international legal and policy instruments. The second was an academic path, based on the rather elitist idea that heritage is an oppositional, or popular, form of history that must be regarded with suspicion and brought under the control of such professionals as historians, archaeologists and museums curators.
>
> (Smith 2011: 13–15)

This genealogy is helpful in accounting for significant differences between conservation and academic heritage studies in their respective approaches to historic buildings. The first path has its roots firmly within nineteenth-century Western European architectural conservation, the history of which has been rehearsed above, and is dominated by architects; the second path, started by David Lowenthal and others in the 1980s, has greater prominence in academia. The implication of this divergence is a separation of practice from theory, to the detriment of both. While conservation architects (myself included) are firmly heirs to the first approach, we may still recognize that 'the moral imperative [...] to pass on cultural treasures to future generations unaltered' (Smith 2011: 11) can have hugely damaging effects, resulting in the disengagement of the current community from their buildings. It is the purpose of this book to offer a possible means of reintegration, recognizing that this cannot be achieved either by ignoring the political dimension of heritage, or by an ideological approach that treats the politics of oppression as always primary.

The approach pioneered by Smith has come to be known as Critical Heritage Studies (CHS), a term which Smith ascribes to Harrison (Harrison

2010: 8; Smith 2011: 9). Its designation as *Critical* Heritage Studies acknowledges it as an application to the field of heritage of Critical Discourse Analysis (CDA). CDA is a branch of sociolinguistics that treats language as a social practice, implying that society can be studied through the way language is used; it is particularly concerned with the deployment of language to establish and perpetuate power relations in society. It sees texts, broadly defined, as used by elite groups and institutions to claim and retain power (van Dijk 1993). The use of the label 'Critical' also signals an earlier debt to Max Horkheimer and the Frankfurt School, who first developed 'Critical Theory' in the 1930s (Horkheimer 1972: 188–243). Horkheimer contrasts 'traditional theory', established by Descartes and developed through the specialized sciences, to Marxian critical theory which is concerned not merely with the positivistic description of reality but with the liberation of mankind: 'The critical theory of society [...] has for its object men as producers of their own historical way of life in its totality. [...] Its goal is man's emancipation from slavery' (Horkheimer 1972: 244–246). Following German idealism, Horkheimer sees the relationship between humanity and the world as a dynamic one, and protests 'against the adoration of facts and the social conformism this brings with it' (1972: 245).

Stanley Aronowitz, in his introduction to this volume of Horkheimer's essays, states that:

> The task of critical theory, according to Horkheimer, is to penetrate the world of things to show the underlying relations between persons. [...] to see 'the human bottom of nonhuman things' and to demystify the surface forms of equality. [...] For Horkheimer, critical theory proceeds from the theorist's awareness of his own partiality. Thus theory is neither neutral nor objective.
>
> (Aronowitz 1972: xii–xiv)

Critical Discourse Analysis foregrounds the political, seeing discourse as critical to the creation and sustaining of systems of power. For example, for Norman Fairclough, a principal exponent, 'Discourse is a practice not just of representing the world, but of signifying the world, constituting and constructing the world in meaning' (Fairclough 1992: 64). Critical Heritage Studies draws on Fairclough and others to frame heritage as inherently political and shows a particular sensitivity to who holds power in a given situation. CHS is therefore very much concerned with ideology and its social expression in the control of heritage decision-making as, for example, in the criticism of the *Burra Charter* touched on earlier (Waterton et al. 2006). However, it faces the same criticisms as does Critical Theory, not least for its

perpetual need to divide between oppressed and oppressor, with little reflec-
tion as to what else this categorization might itself suppress.

In Smith's critique of the AHD, the discourse of contemporary conser-
vation is seen to be distinctly ideological in that, wittingly or otherwise,
it reinforces the exercise of control over the historical environment. This,
one suspects, would be sharply at odds with the self-image of most heritage
professionals who, as Keith Emerick observes:

> believe that their work is 'for the nation' and defines a national story
> [and who] would be aghast at the suggestion that professional expertise
> has been political and detrimental to communities' ownership of places.
> Rather than being people who could present a perspective on the past,
> the heritage experts have become its owners.
>
> (Emerick 2014: 11)

In principle, the *Burra Charter* and its related processes, with their prom-
inent inclusion of social value, represent a major step towards inclusive-
ness. But principle does not always translate into practice: merely bolting
social value onto the pre-existing structures can be seen as a deception,
offering the semblance of democracy by attending to the view 'from below'
while in reality giving up none of the decision-making power. On this view,
conservation appears cynically ideological, granting limited public access
to decision-making in order to constrain meaningful involvement in a sim-
ultaneous act of welcome and exclusion. Nevertheless, for Smith, democ-
ratization is a key aspect of CHS, and one which will lead to changes to
heritage theory:

> democratizing heritage means that a broad range of community
> interests, some of them artificially silenced by the way heritage has
> been traditionally approached, need to drive new directions in thinking
> about heritage'.
>
> (Smith 2011: 40)

One significant contribution of the CDA-informed approach to the his-
toric environment is its foregrounding of the question of ownership. John
Schofield's opening chapter to his edited volume on the role of the expert in
heritage management addresses the inclusivity – or otherwise – of owner-
ship, noting how non-experts 'often feel unconfident or unqualified to articu-
late views on the heritage they value' (2014: 1). Suggesting that the *Faro
Convention* – the *Framework Convention on the Value of Cultural Heritage
for Society* (Council of Europe 2005) – comes closest to an appropriate

definition of inclusive heritage, he quotes from Robert Palmer's foreword to *Heritage and Beyond*:

> Heritage involves continual creation and transformation. We can make heritage by adding new ideas to old ideas. Heritage is never merely something to be conserved or protected, but rather to be modified or enhanced. Heritage atrophies in the absence of public involvement and public support. This is why heritage processes must move beyond the preoccupations of the experts in government ministries and the managers of public institutions, and include the different publics who inhabit our cities, towns and villages. Such a process is social and creative.
> (Palmer 2009: 8; cited in Schofield 2014: 8)

Here Palmer forcefully combines the idea that heritage is on the one hand by nature 'creative' – hence we should expect it to be 'modified' or 'enhanced' – and on the other 'social' and must remain rooted in the support and involvement of the public, without which it dies. For Palmer, the two issues of change and community involvement are intimately intertwined, and jointly inherent in cultural heritage. While the *Faro Convention* has not been adopted everywhere in Europe – the United Kingdom, again, being a non-signatory – its ideas have nevertheless succeeded in exerting some influence over heritage policy.

Community discourse

Central to the CDA approach is a concern with the pivotal role that language plays in the assertion of power. On this view, attention to the ways in which language is deployed is likely to illustrate the clash of competing understandings. As a general rule, experts are well practised at establishing their credibility, indeed their superiority, by such means. By contrast, community groups are often woefully underprepared to question a professional opinion that is casually stated as fact, or to quote an alternative authority, or indeed to push back against any aspect of the understanding of the experts. The idea that, on the basis of their in-depth knowledge of their local area and its needs, a community group might have an expertise of at least equivalent status is rarely understood or acknowledged by the experts, so the onus must be on encouraging community groups to own and articulate their unique expertise.

One of the key insights of a CDA approach is that the process of exclusion operates at a variety of levels, including the simple choice of language. As discussed above, a principal aim behind the development of the *Burra*

Charter was precisely to develop a language and processes for heritage that would deal both with Australia's Western heritage – already well served by existing processes – and its Indigenous heritage which had hitherto been effectively excluded. The logic of the current values-based conservation process is that, when dealing with places of religion and ritual, the importance of the community's religious discourse should be acknowledged. Hence, under the umbrella of communal value, Historic England's *Conservation Principles* explicitly identifies 'spiritual value', which 'can emanate from the beliefs and teachings of an organised religion' (2008: 32). For some conservation professionals who may not share a religious faith this intrusion of religious discourse may be viewed with suspicion and discomfort. Funding criteria from grant-giving bodies – for example in the United Kingdom, the National Lottery Heritage Fund – encourage this secularization of vocabulary in the grant application process, with the strong implication that religion is an exclusively privatized concern, and that there is no space for religious discourse in the public realm. But if such a value is to be engaged with at all, it should be taken seriously, and not reduced to purely secular terms in this way.

By contrast, we should note that, for these communities, there is a much bigger picture in play than is allowed by a secularized description, whether of a tangible historic building or a set of intangible practices. It is telling how Smith dismisses religious buildings such as churches and cathedrals as examples of elitist architecture, placing them firmly among 'the usual authorized material suspects' (2006: 134). While it is not difficult to come to this conclusion if you approach these buildings through the AHD framework which she rejects, if these buildings are approached from the point of view of the communities that live with and manage them, the view is quite different. And once religious language – in this case Christian theological language – is accepted as a valid form of discourse, then the ability of such communities to situate the particular in the broader cultural landscape emerges as a substantial strength. It is therefore not necessary to hold a religious faith to recognize the relevance of this theological/spiritual dimension, and which one finds not only present but central to religious heritage when working with such clients.

Equally, it should also be recognized that, with its genealogy touched on above, CHS might itself fail to recognize forms of community defined by anything more than common interest. Communities of religious tradition, for example, are in their self-understanding more than an assemblage of individuals with a common interest. The historic buildings of such communities are therefore more than the object of common interest and may themselves be an actor in the formation of that community. This example

of an alternative model for thinking of historic religious buildings holds well beyond the bounds of any given religious faith, but it does require an acknowledgement of the way our understanding is passed on between generations, that is, the role of tradition. Discourse analysis, whether critical or otherwise, can only take us so far. The more fundamental issue at play here is the question of how different traditions – most often a particular religious tradition on the one hand and secular modernity on the other – are able to talk to one another, a theme considered further in Chapter 4.

3.2 Living heritage

The foregoing has considered a variety of ways in which the interrelation of people with the physical manifestations of heritage have been conceived in the disciplines of conservation and heritage studies. In this closing section, attention turns to another model, one which also provides an account of the continuity of heritage through time.

The *Nara Document on Authenticity* states, "Responsibility for cultural heritage and the management of it belongs, in the first place, to the cultural community that has generated it, and subsequently to that which cares for it' (UNESCO 1994: 8). This was reiterated in the subsequent *Nara+20* statement (Japan ICOMOS 2014: 3), which also introduces the idea of dispersed communities of interest. *Nara+20* also provides a definition of community as 'Any group sharing cultural or social characteristics, interests, and perceived continuity through time …' This acknowledgement of continuity through time is a central consideration for a so-called 'living heritage' approach. Indeed, many of the issues outlined earlier in this chapter concerning the ways in which conservation processes serve the interests of the experts – who, under the CHS view, are seen to have designed them at the expense of the communities that care for historic buildings – are addressed under the heading of 'living heritage'.

Living heritage emphasizes the relationship between communities of people and their physical heritage, but the term is used in a variety of ways. For example, the social anthropologist Keiko Miura contrasts the official description of the Angkor World Heritage Site as a 'living heritage site', with the severe constraints on the lives and cultural practices of local villagers within the 400 km^2 designated area (Miura 2005). In this weak sense, 'living heritage' seems to refer to no more than tolerating the presence of existing communities within a heritage area, without granting them any input into heritage decision-making. In a stronger sense, living heritage refers to heritage places where the animating role of specific communities is recognized; here, the focus is on the continuity of use, traditions and practices, including

craft skills, and the ongoing role of a community in shaping their tangible heritage (Wijesuriya 2015: 1). ICCROM has been at the centre of developing a distinctive body of thinking on this subject, starting with a 2003 forum on the theme of 'Living Religious Heritage: Conserving the Sacred' organized by Herb Stovel and Britta Rudolff (Stovel et al. 2005); this section attempts to provide a summary of this approach.

One of those developing this body of thinking within ICCROM was Gamini Wijesuriya, an architect and archaeologist who for many years was director of conservation in the Sri Lankan government's department of archaeology. He was responsible for the restoration of the Temple of the Tooth Relic in Kandy, which suffered extensive damage in a terrorist bombing by Tamil separatists in January 1998 (Wijesuriya 2000, 2007). This case provides an example of local cultural practices of living heritage overriding international conservation orthodoxy; however, these were additionally overlaid by a clear sense of threat to national identity from the deliberate targeting of cultural heritage, resulting in intense media interest and immediate political pressure to restore the building to its 'pristine condition'. Wijesuriya also describes Sri Lanka's unique experience in reconciling religious use and practices with modern conservation approaches in response to public pressure in the post-colonial period, with the aim of facilitating the religious use of Buddhist heritage sites, and with a strong focus on continuity of the heritage (2005: 34, 37).

Ioannis Poulios (2014) helpfully addresses the issues of change to historic structures in community ownership in the context of the cluster of Orthodox monastic sites at Meteora in Greece and develops this focus on continuity. For Poulios, the development of historic building conservation thus far can be divided into two approaches – the initial, material-based approach focused on the authenticity of material culture and exemplified in the *Venice Charter*, and the subsequent values-based approach. In his analysis, the material-based approach to conservation fails because it creates 'a form of discontinuity [...] between the monuments and the people, and between the past and the present' (Poulios 2014: 20). The subsequent values-based approach, while attempting to accommodate community voices within the conservation process, does nothing to address this historical discontinuity, with the result that 'the aim of conservation remains the preservation of heritage, considered to belong to the past, *from the people of the present*, for the sake of the future generations (discontinuity)' (2014: 22, emphasis added).

By contrast, Poulios demonstrates that *continuity* is 'the key concept for the definition of a living heritage site'. This he breaks down into the four criteria of continuity of function, continuity of the community's connection

with the heritage site, continuity of care through communal management and ownership mechanisms, and continual change (within tradition) in the expression of heritage (2014: 115–119). Critical to the health of living heritage is the acknowledgement that community is differentiated rather than monolithic; the implication within this approach is that the 'core community' has 'the primary role in the conservation process, while conservation professionals provide an enabling framework of support, guidance and assistance to the core community' (2014: 130). On this understanding, historic buildings are framed as an expression of community life, rather than community being treated as an adjunct, one stakeholder among many others. It is this prioritization of continuity that sets this approach apart from other attempts discussed above to account for the role of people in heritage.

This same fourfold understanding of continuity and the role of the core community also features prominently in ICCROM's approach to living heritage, which is summarized by Wijesuriya as follows:

> As a philosophy: It emphasizes continuity which invariably brings change as the primary driver for the definition, conservation and management of heritage.
>
> As a process: It facilitates a community-led (bottom-up), interactive approach to conservation and management by: emphasizing a core community and their values (recognizing the hierarchy of values and stakeholders); recognizing change as inevitable; utilizing traditional or established management systems (in terms of knowledge, practices & materials) for the long term care of heritage and bring reciprocal benefits.
>
> As a product: long term sustainability in safeguarding heritage with an empowered community engaged in decisions made for them and their heritage.
>
> (Wijesuriya 2015: 10)

Three things stand out from this summary – that change is normalized (indeed, 'inevitable') rather than pathologized; that the core community is empowered; and that it is these two factors that offer the best conditions for the long-term survival of the built heritage. Within this framework, ICCROM aims to build the skills capacity of communities, rather than merely to increase community participation in existing management structures. This is a crucial distinction, the effect of which is to reframe the whole process of conservation around the people most closely connected to the heritage, who are seen not as another interest group but as integral to

the heritage and its ongoing well-being (Wijesuriya et al. 2017: 48). As with Poulios, this 'people-centred' approach to conservation explicitly seeks to move beyond values-based conservation, addressing the perennial inability of the latter to accommodate community interests alongside those of the professionals (Wijesuriya et al. 2017: 40).

English parish churches

While much of the challenge to the dominant Western view of conservation has come from non-Western and particularly indigenous sources, the West also has its own dissenting voices for whom the living heritage approach is highly relevant. The English parish church, perhaps surprisingly for some, fits this description. There are some 16,000 Anglican church buildings in England, of which approximately half are substantially medieval. The Church of England takes responsibility for the 'cure of souls' – that is, for the care of everyone – in each parish; in a meaningful sense each church building thus belongs to *everyone* in that community, regardless of religious affiliation. This broader sense of community ownership is not a recent understanding, but one that has survived from the premodern age; hence rural parish churches, which are typically medieval, have been described as 'truly democratic buildings, the meeting place of ordinary people through the ages' (Strong 2007: 233). Typically, of course, it is on the core community of those who choose to attend a given church that the burden of the building's upkeep falls. It was the early recognition of churches as what we now call living heritage that led to the development in England of a parallel regulatory system, the 'ecclesiastical exemption', which is described in more detail in the following case study.

These church buildings face increasing pressure for change, both reactively as a result of often dwindling congregations, and proactively where local congregations seek to adapt their historic buildings to changing worship, mission and community needs. The resulting projects, naturally, vary hugely in scope; alongside a growing number of major alteration schemes there must now be thousands of examples of more modest change, such as the addition of toilet facilities and/or a kitchen for making light refreshments; these are often combined with the removal of some or all of the fixed seating. While there is a broad acceptance that it is important to keep these buildings in use, when it comes to discussing change the cultural differences between those within these church communities and those outside can be substantial. The latter, particularly heritage professionals, will often see a willingness to countenance change to historic buildings as ignorant and cavalier. Conservation processes can be very adept at erecting barriers to change,

frustrating community ambition and leading to the progressive detachment of already fragile communities from their buildings. The uncomfortable truth is that any process that conceives of heritage in narrowly architectural and historic terms – as legislative frameworks typically do in the West, including the United Kingdom – easily becomes complicit in the destruction of the very heritage which it seeks to protect. That it can be easier to obtain permission for adaptive reuse where the original faith community has died out than it is for the changes that enable that core community to survive and thrive demonstrates the lack of understanding of the living heritage link between buildings and people.

Nevertheless, significant change is possible, as demonstrated by the recent scheme of alterations to the Church of St Mary and St Thomas of Canterbury, Wymondham ('Wymondham Abbey') in Norfolk (Figure 3.3). The church, recognized as being of international historic and architectural importance, is the surviving fragment of what, prior to the dissolution of the monasteries, was a much larger twelfth-century Benedictine priory complex (Cattermole 2007). As well as being listed Grade I,[1] the ruined east tower and adjacent standing remains are a scheduled ancient monument, and the church also has a remarkable gilded reredos by the renowned

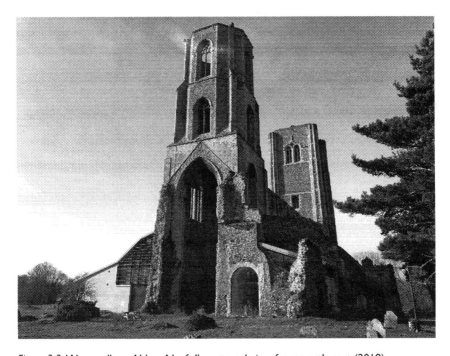

Figure 3.3 Wymondham Abbey, Norfolk: external view from north-east (2019)

Figure 3.4 Wymondham Abbey, Norfolk: view of south extension interpretation/meeting
space, looking east (2019)

twentieth-century architect Sir Ninian Comper. The recent project, under
development for some 15 years, aimed to provide meeting rooms and ancil-
lary facilities, to open the church up to visitors and to create an educa-
tion and interpretation centre; this involved the removal of some internal

accretions, the reopening of the west door for ceremonial use, and the construction of two extensions in strikingly contemporary architectural language. Of these, the northern extension to the east of the north aisle was less controversial as it replaced a derelict boiler room on the site of the Lady Margaret Chapel, and is largely bounded by existing walls. The focus of concern was the more ambitious southern extension, which enlarged the south aisle eastwards to flank the east tower (to the left in Figure 3.3), and southwards beyond the line of the south aisle. Stakeholder consultations failed to resolve all of their concerns, and substantial reservations remained, but permission was given for the works, which were completed in late 2015 (Figure 3.4).

Contrary to what some professionals may suggest, church communities such as Wymondham typically care deeply about the buildings for which they are responsible; their openness to change, which for some manifests carelessness, may instead demonstrate an alternative and in some respects richer understanding of history. There is a growing acknowledgement that church buildings are often complex hybrids that have changed multiple times through their history, and indeed that many owe their very survival to that ability to flex as the community's needs have changed; in this sense, change is part of their nature. In their willingness to countenance change, church communities are able to provide some account of how heritage is actually *produced*, and may understand better than the professionals that their historic building is capable of being *enhanced*. They are able to do this by bringing their buildings from the distant past into meaningful (historical) dialogue with the present through the vehicle of tradition; how this is possible, through a hermeneutic rather than an aesthetic-historical understanding, is explored in Chapter 4.

Conclusion

This chapter has considered some competing accounts of the nature of the relationship between people and built heritage. The foundational understanding for modern conservation, as exemplified by the World Heritage Convention, is of heritage as comprising an identified canon, a finite stock which can only be preserved or diminished; as a result, attempts to engage with those communities associated with tangible heritage remain tokenistic, as has been argued in Laurajane Smith's analysis of the Authorized Heritage Discourse. However, while theories of intangible heritage are an important development, they fail to account for the interrelatedness of tangible and intangible, and risk reinforcing some of the harmful effects of the conventional understanding.

The resulting tensions are not resolved by the current conservation methodology, not least since the language of values attachment is largely inaccessible to non-professionals, who simply do not naturally talk in these terms. Even working within a values-based methodology, social value fails to represent community interest for at least three reasons. First, since social/communal value is believed, like all values, to be attached to the tangible heritage in question, it remains easily *detached* by those with most influence over conservation outcomes. Second, the differentiation of community is inadequately acknowledged, which risks rendering the core community that is most intimately connected with the building invisible. And third, social value is temporally confined, explicitly concerned only with the present-day iteration of the community, thus raising the obvious objection as to why the views of this particular manifestation of community at this particular moment should take precedence over any others, when by definition social value is fluid.

By contrast, the living heritage approach treats heritage as a single, indivisible cultural whole comprising the physical materiality of a historic building *and* its animating community, and it sees that community as intergenerational, enduring through time. The recognition of continuity as the central concern of conservation is a major step forward, and it is this that differentiates conservation on this model from preservation, because it acknowledges historic change and anticipates that this will continue. The English parish church offers a good example of a living relationship between people and their buildings, sharing as it does the same four continuities that Poulios identifies as characteristic of living heritage: continuity of use, of the core community's involvement with the building, of communal responsibility for maintenance, and of change.

Note

1 In the United Kingdom, lists of buildings under statutory protection are maintained by the national governments; in England and Wales the three levels of protection are Grade I (highest), Grade II*, and Grade II (lowest), for buildings of 'exceptional', 'more than special', and 'special' interest, respectively.

References

Aikawa-Faure, N. (2009). From the Proclamation of Masterpieces to the Convention for the Safeguarding of Intangible Cultural Heritage. In: L. Smith & N. Akagawa (eds.) *Intangible Heritage*. Abingdon and New York: Routledge. pp. 13–44.
Araoz, G.F. (2011). Preserving Heritage Places under a New Paradigm. *Journal of Cultural Heritage Management and Sustainable Development*, 1(1): 55–60.

Aronowitz, S. (1972). Introduction. In: *Critical Theory: Selected Essays.* New York: Herder and Herder. pp. xi–xxi.

Avrami, E. (2009). Heritage, Values, and Sustainability. In: A. Richmond & A.L. Bracker (eds.) *Conservation: Principles, Dilemmas and Uncomfortable Truths.* Amsterdam: Elsevier/Butterworth-Heinemann. pp. 177–183.

Bouchenaki, M. (2003). The Interdependency of the Tangible and Intangible Cultural Heritage: Keynote Address. In: *14th ICOMOS General Assembly and International Symposium: Place, Memory, Meaning: Preserving Intangible Values in Monuments and Sites.* Victoria Falls, Zimbabwe. [Online]. Available at: http://openarchive.icomos.org/468/.

Bowdler, S. (1988). Repainting Australian Rock Art. *Antiquity,* 62 (236): 517–523.

Cattermole, P. (ed.) (2007). *Wymondham Abbey: A History of the Monastery and Parish Church.* Wymondham: Wymondham Abbey.

Council of Europe (2005). *Framework Convention on the Value of Cultural Heritage for Society.* [Online]. Available at: https://rm.coe.int/1680083746.

van Dijk, T.A. (1993). Principles of Critical Discourse Analysis. *Discourse & Society,* 4 (2): 249–283.

Eliot, T.S. (1948). *Notes towards the Definition of Culture.* London: Faber.

Emerick, K. (2014). *Conserving and Managing Ancient Monuments: Heritage, Democracy, and Inclusion.* Woodbridge: Boydell Press.

Fairclough, N. (1992). *Discourse and Social Change.* Cambridge: Polity Press.

Feilden, B.M. (2003). *Conservation of Historic Buildings.* 3rd ed. Oxford: Architectural Press.

Ganiatsas, V. (2012). Heritage as Ethical Paradigms of Identity and Change: In Need of New Conceptual Tools, Practices or Attitude? In: W. Lipp, J. Štulc, B. Szmygin, & S. Giometti (eds.), *Conservation Turn – Return to Conservation: Tolerance for Change, Limits of Change.* Firenze: Edizioni Polistampa. pp. 53–56.

Glendinning, M. (2013). *The Conservation Movement: A History of Architectural Preservation: Antiquity to Modernity.* Abingdon and New York: Routledge.

Gosson, S. ([1579] 1841). *The Schoole of Abuse.* London: Shakespeare Society.

Hall, M. (2011). Introduction: Towards World Heritage. In: M. Hall (ed.), *Towards World Heritage: International Origins of the Preservation Movement 1870–1930.* Farnham: Ashgate. pp. 1–19.

Harrison, R. (2010). What Is Heritage? In: R. Harrison (ed.), *Understanding the Politics of Heritage.* Manchester: Manchester University Press. pp. 5–42.

Harrison, R. (2013). *Heritage: Critical Approaches.* Abingdon and New York: Routledge.

Hassard, F. (2009). Intangible Heritage in the United Kingdom: The Dark Side of Enlightenment? In: L. Smith & N. Akagawa (eds.), *Intangible Heritage.* Abingdon and New York: Routledge. pp. 270–288.

Historic England (2008). *Conservation Principles: Policies and Guidance for the Sustainable Management of the Historic Environment.* London: English Heritage.

Horkheimer, M. (1972). *Critical Theory: Selected Essays.* New York: Herder and Herder.

ICOMOS ([1931] 2015). *The Athens Charter for the Restoration of Historic Monuments – 1931.* [Online]. Available at: www.icomos.org/en/charters-and-texts/179-articles-en-francais/ressources/charters-and-standards/167-the-athens-charter-for-the-restoration-of-historic-monuments.

Japan ICOMOS (2014). *Nara + 20: On Heritage Practices, Cultural Values, and the Concept of Authenticity.* [Online]. Available at: www.japan-icomos.org/pdf/nara20_final_eng.pdf.

Jokilehto, J. (1999). *A History of Architectural Conservation.* Oxford: Butterworth-Heinemann.

Jones, S. (2017). Wrestling with the Social Value of Heritage: Problems, Dilemmas and Opportunities. *Journal of Community Archaeology & Heritage,* 4 (1): 21–37.

Jones, S. & Leech, S. (2015). *Valuing the Historic Environment: A Critical Review of Existing Approaches to Social Value.* Manchester: University of Manchester.

Miele, C. (2011). Heritage and Its Communities: Reflections on the English Experience in the Nineteenth and Twentieth Centuries. In: M. Hall (ed.), *Towards World Heritage: International Origins of the Preservation Movement 1870–1930.* Farnham: Ashgate. pp. 155–179.

Miura, K. (2005). Conservation of a 'Living Heritage Site' A Contradiction in Terms? A Case Study of Angkor World Heritage Site. *Conservation and Management of Archaeological Sites,* 7 (1): 3–18.

Morris, W. ([1877] 2017). *The Society for the Protection of Ancient Buildings Manifesto.* [Online]. Available at: www.spab.org.uk/about-us/spab-manifesto.

National Trust (2019). *National Trust Reports Record Spend on Conservation, Supported by Highest Membership and Visitor Numbers.* [Online]. Available at: www.nationaltrust.org.uk/press-release/national-trust-reports-record-spend-on-conservation-supported-by-highest-membership-and-visitor-numbers.

Orbaşli, A. (2017). Conservation Theory in the Twenty-First Century: Slow Evolution or a Paradigm Shift? *Journal of Architectural Conservation,* 1–14.

Palmer, R. (2009). Preface. In: Council of Europe, *Heritage and Beyond.* Strasbourg: Council of Europe. pp. 7–8.

Poulios, I. (2014). *The Past in the Present: A Living Heritage Approach – Meteora, Greece.* London: Ubiquity Press.

Rudolff, B. (2006). *Intangible' and 'Tangible' Heritage: A Topology of Culture in Contexts of Faith.* Mainz: Johannes Gutenberg-University of Mainz. PhD thesis.

Schofield, A.J. (2014). Heritage Expertise and the Everyday: Citizens and Authority in the Twenty-First Century. In: A. J. Schofield (ed.), *Who Needs Experts?: Counter-Mapping Cultural Heritage.* Farnham: Ashgate. pp. 1–11.

Smith, L. (2006). *Uses of Heritage.* Abingdon and New York: Routledge.

Smith, L. (2011). *All Heritage Is Intangible: Critical Heritage Studies and Museums. Text of the Reinwardt Memorial Lecture May 26, 2011.* [Online]. Available at: www.ahk.nl/fileadmin/download/reinwardt/lectoraat/All_heritage_is_intangible.pdf.

Smith, L. & Waterton, E. (2009). 'The Envy of the World?': Intangible Heritage in England. In: L. Smith & N. Akagawa (eds.), *Intangible Heritage.* Abingdon and New York: Routledge. pp. 289–302.

Stovel, H., Stanley-Price, N. & Killick, R.G. (eds.) (2005). *Conservation of Living Religious Heritage: Papers from the ICCROM 2003 Forum on Living Religious Heritage: Conserving the Sacred.* Rome: ICCROM.

Strong, R. (2007). *A Little History of the English Country Church.* London: Jonathan Cape.

UNESCO (1972). *Convention Concerning the Protection of the World Cultural and Natural Heritage*. [Online]. Available at: http://whc.unesco.org/archive/convention-en.pdf.

UNESCO (1994). *The Nara Document on Authenticity*. [Online]. Available at: http://whc.unesco.org/document/9379.

UNESCO (2004a). *Co-Operation and Coordination between UNESCO Conventions Concerning Heritage (WHC-04/7 EXT.COM/9)*. [Online]. Available at: https://whc.unesco.org/archive/2004/whc04-7extcom-09e.pdf.

UNESCO (2004b). *Yamato Declaration on Integrated Approaches for Safeguarding Tangible and Intangible Cultural Heritage (WHC-04/7 EXT.COM/INF.9)*. [Online]. Available at: https://whc.unesco.org/archive/2004/whc04-7extcom-inf09e.pdf.

UNESCO (2017). *World Heritage Centre*. [Online]. Available at: http://whc.unesco.org/en/about/.

UNESCO (2018). *Basic Texts of the 2003 Convention for the Safeguarding of the Intangible Cultural Heritage: 2018 Edition*. Paris: UNESCO.

Waterton, E., Smith, L. & Campbell, G. (2006). The Utility of Discourse Analysis to Heritage Studies: The Burra Charter and Social Inclusion. *International Journal of Heritage Studies*, 12 (4): 339–355.

Wijesuriya, G. (2000). Conserving the Temple of the Tooth Relic, Sri Lanka. *Public Archaeology*, 1 (2): 99–108.

Wijesuriya, G. (2005). The Past in the Present: Perspectives in Caring for Buddhist Heritage Sites in Sri Lanka. In: H. Stovel, N. Stanley-Price, & R.G. Killick (eds.), *Conservation of Living Religious Heritage: Papers from the ICCROM 2003 Forum on Living Religious Heritage: Conserving the Sacred*. Rome: ICCROM. pp. 31–43.

Wijesuriya, G. (2007). The Restoration of the Temple of the Tooth Relic in Kandy, Sri Lanka: A Post-Conflict Cultural Response to Loss of Identity. In: N. Stanley-Price (ed.), *Cultural Heritage in Postwar Recovery: Papers from the ICCROM Forum Held on October 4–6, 2005*. Rome: ICCROM. pp. 87–97.

Wijesuriya, G. (2015). *Annexe 1: Living Heritage: A Summary*. [Online]. Available at: www.iccrom.org/wp-content/uploads/PCA_Annexe-1.pdf.

Wijesuriya, G., Thompson, J. & Court, S. (2017). People-Centred Approaches: Engaging Communities and Developing Capacities for Managing Heritage. In: G. Chitty (ed.), *Heritage, Conservation and Community: Engagement, Participation and Capacity Building*. Abingdon and New York: Routledge. pp. 34–49.

Wordsworth, W. ([1798] 2006). The Tables Turned – an Evening Scene on the Same Subject. In: W. Wordsworth & S. T. Coleridge (ed.), *Lyrical Ballads: With a Few Other Poems*. London: Penguin. p. 102.

Case study: St Alkmund, Duffield, and the ecclesiastical exemption

> If it should be decided to erect a chancel screen, its architectural effect will be admirable.
>
> John Oldrid Scott (cited in Court of Arches 2012: para. 9)

At an early stage in the development of conservation legislation in the United Kingdom it was recognized that English cathedrals should be exempted from secular control due to their ongoing use; this subsequently developed into the 'ecclesiastical exemption', a separate system of control for most church buildings that parallels the secular listed building consent administered through the planning system (Morrice 2009). Five denominations in England (plus the Church in Wales) currently enjoy the exemption; by virtue of the number and importance of the buildings in its care, the Church of England system is the most fully developed, in the form of *The Faculty Jurisdiction Rules 2015* (General Synod of the Church of England 2015). This case study considers the provisions of this system, and how it deals with the voice(s) of the local community, including the landmark case of the church of St Alkmund, Duffield.

Parish churches and the Faculty Jurisdiction system

Under the legislation governing the system – *Ecclesiastical Jurisdiction and Care of Churches Measure 2018* (General Synod of the Church of England 2018), hereafter 'the 2018 Measure' – each of the 42 dioceses of the Church of England must establish a legal court of the bishop of the diocese, known as a 'consistory court', presided over by a judge, known as the 'chancellor'. Each diocese appoints a Diocesan Advisory Committee (DAC) whose members between them have (a) knowledge of the history, development and use of church buildings, (b) knowledge of Church of England liturgy and worship, (c) knowledge of architecture, archaeology, art and history, and (d) experience of the care of historic buildings and their contents. Any

Anglican congregation wishing to change their building is obliged to seek the advice of their DAC before applying to the chancellor for approval; this is given in the form of a 'faculty'. Due to its legal basis, the system involves the arguing out of conservation principles in legal judgments which are both readily available and surprisingly accessible. The ecclesiastical exemption, under which the faculty system operates, is subject to periodic renewal, something of which those involved are very much aware; it is also politically contested, with some secular voices continuing to call for its abolition.

Any process under the ecclesiastical exemption must be at least as stringent as the secular system, and opposition to the faculty system stems from its perceived failings in this regard. The system entails a scope of consultation similar to its secular equivalent (Department for Digital, Culture, Media and Sport 2010: 7; Mynors 2016: 56). Applicants must consult Historic England, those of the six national amenity societies that are relevant to the building in question, and the local planning authority. The exemption only replaces the need for secular listed building consent, so in cases where the proposed works include external changes to the building the normal planning process still applies in addition. The Church Buildings Council (CBC), a statutory body which produces guidance for the Church of England, also comments on proposals for more prominent buildings (Church of England 2018b).[1] An unofficial but necessary role played by every DAC, and at a national level by the CBC, is to educate and encourage church communities to engage with their historic buildings as an opportunity, rather than as a burden, a further example of the interrelation of heritage and community implicit in this process.

As already alluded to, there is a political dimension to the exemption. The view 'from above' – that is, the national view from the non-church conservation system – is at times highly critical; the system can be seen as anomalous, the result of special pleading on the part of the Church, and to be ripe for repeal. By contrast, the view 'from below' in light of the discussion in Chapter 3 is that the exemption does a better job of bringing the universal (safeguarded by a robust legal process) into dialogue with the local. Rob Lennox (2016: 51) cites the continuation of the ecclesiastical exemption as evidence of the lasting influence of the early history of conservation regulation; the view 'from below' would agree, in the sense that an alternative to the secular system is needed as much as ever for dealing with living buildings such as parish churches.

The focus of the faculty system is the individual DAC, which is responsible for dealing with applications within its diocese and providing a recommendation to the chancellor; DAC membership is by invitation and is unpaid. At their best, DACs offer an unbeatable range of knowledge and expertise, and

combine the technical with the cultural/theological, giving a greater level of scrutiny and support than is possible under the secular system. How well the DAC works depends on the availability of that expertise, the quality of chairmanship, and the administrative efficiency of the officers who support the DAC; the CBC actively seeks to encourage common standards and working practices among DACs. The operation of the system as a whole also depends on the capabilities of those making the application for permission. Church congregations that include members with a professional background are more likely to have the confidence to engage with and navigate a system which appears highly complex. Most will look to their clergy to lead them, but clergy typically receive no input on buildings whatsoever during their ordination training; whether they have the necessary skills will therefore depend on their working experience before ordination, or other projects with which they happen to have been involved.

The secular and ecclesiastical systems overlap when proposed work includes change to the exterior of a church building; in that case both the faculty system and the secular planning system apply. While the latter is in theory limited to external changes, the planning process can be used by an unsympathetic conservation officer as a means of obstructing what might to them seem harmful and unjustifiable internal work. Partly for this reason DACs will usually first advise churches to explore solutions within the existing footprint of their building in order to avoid these additional complexities. In some cases, the remains of earlier buildings – whether adjacent to or even integrated within the church building – may be protected as scheduled monuments, as for example at Wymondham Abbey (considered in Chapter 3), and the process is then made more complex still by the need for scheduled monument consent (SMC) through a separate system administered by the Government's Department for Digital, Culture, Media & Sport (DCMS).

It should also be noted that in some respects the Church of England's faculty system goes beyond the requirements of both the secular system and the ecclesiastical exemption (DCMS 2010: 27–29), for example extending control to a building's furnishings. It also allows a party that has formally *opposed* a scheme to appeal against the granting of faculty, something with no equivalent under secular legislation, where only the applicant can appeal against a refusal. Clearly, neither the secular nor the ecclesiastical system is perfect, and in neither case is implementation always consistent. The key differentiators of the faculty system are the breadth of experience that can be drawn upon, the voice given to the local church community (see the St Alkmund case that follows), and the cultural embeddedness arising from the need to consider a specifically theological understanding of church

buildings. It should be noted that the centrality of this religious discourse has the force of law; section 35 of the 2018 Measure frames its requirements for the care of church buildings with the general duty that:

> A person carrying out functions of care and conservation under this Measure, or under any other enactment or any rule of law relating to churches, must have due regard to the role of a church as a local centre of worship and mission.

In providing a distinctive answer to the perennial question of where the people are represented within the process, the faculty system allows for the voice of the core community to be heard within the conservation decision-making process, and perhaps therefore offers important lessons for conservation methodology more broadly.

The case of St Alkmund, Duffield

The 2012 St Alkmund, Duffield, appeal judgment plays an important role in the current operation of the Faculty Jurisdiction (Court of Arches 2012). The judgment sets out a framework with the explicit purpose of guiding chancellors in subsequent consistory court judgments, and now shapes the process as a whole, since DACs and amenity societies use it as a point of reference. This framework has been questioned and challenged but remains the authoritative structure within which decisions are made. This section briefly describes that framework, before considering some other points in the judgment of relevance to the place of non-professionals in the conservation process.

The church of St Alkmund, Duffield is a Grade I listed church of medieval origin (Figure 3.5). The church underwent two Victorian restorations; among other works the 1896 restoration by John Oldrid Scott involved a refurbishment of the chancel, including a new, finely carved chancel screen, altar, and reredos. The chancel east window by the noted C.E. Kempe had been planned prior to the Scott works, and was installed at approximately the same time. The chancel screen was, however, a theological embarrassment to the current church community, who saw it as separating the congregation from God (Figure 3.6); they wished to move it a short distance within the building to the arch of a side chapel, in the process creating much-needed space for musicians in the main body of the church. A consistory court had been held specifically to consider the move of the screen, and in a judgment dated 2 March 2012 the chancellor had found against the church. This decision was then appealed, resulting in the Court of Arches judgment of 1

Figure 3.5 Church of St Alkmund, Duffield, Derbyshire: external view from north-west (2019)

Figure 3.6 Church of St Alkmund, Duffield, Derbyshire: interior view looking east, with chancel screen in original position (Photo: Marion Taulbut, 2012)

Figure 3.7 Church of St Alkmund, Duffield, Derbyshire: interior view looking north-east, with screen relocated to Bradshaw chapel to the left (2019)

October 2012; the higher court allowed the appeal and then granted the faculty, subject to conditions. The work has since been completed (Figure 3.7).

The significance of the Duffield judgment is that it establishes a framework for determining future faculty petitions, comprising five questions; in abridged form, these are:

1. Would the proposals, if implemented, result in harm to the significance of the church as a building of special architectural or historic interest?
2. If not, a faculty can be granted and questions 3, 4, and 5 do not arise.
3. If the answer to question 1 is "yes", how serious would the harm be?
4. How clear and convincing is the justification for carrying out the proposals?
5. Does the public benefit outweigh the harm? In answering question 5, the more serious the harm, the greater will be the level of benefit needed before the proposals should be permitted. This will particularly be the case if the harm is to a building which is listed Grade I or II*, where serious harm should only exceptionally be allowed.

<div align="right">(Court of Arches 2012: para. 87, abridged)</div>

Assuming that harm to significance is established in question 1, the focus is therefore firstly on the seriousness of the harm, secondly whether the justification for the proposed changes is convincing, and finally whether there is sufficient public benefit that would outweigh that harm. Of these, the answers to questions 4 and 5 depend a great deal on the petitioners' powers of persuasion, both in providing adequate justification for the scheme in their statement of needs, and in articulating the public benefit. The language of 'significance' and 'substantial harm', and the 'weighing' of harm against 'public benefits' (para. 41) is all drawn from the prevailing secular legislation. It should be noted that these public benefits include 'matters such as liturgical freedom, pastoral well-being, opportunities for mission, and putting the church to viable uses that are consistent with its role as a place of worship and mission' (ibid.).

Prior to the St Alkmund appeal judgment, petitioners were required to prove the *necessity* of their proposals. It was the removal of this test that gave rise to the new framework; since there is no test of necessity in the secular system it was deemed unreasonable to apply a stricter test to church buildings (para. 84). After reviewing the current guidance on the ecclesiastical exemption, the court was clear that 'equivalence' did not require exactly the same approach to proposed alterations as is adopted in the secular system, and even that in some cases the two systems could be *expected* to produce different outcomes (para. 39), not least since the purpose of the ecclesiastical exemption is that it enables the Church 'to retain control of any alteration that may affect its worship and liturgy' (para. 38).

Critiquing the original judgment

The setting aside of the chancellor's original decision hinged on his 'erroneous approach to the assessment of adverse impact on the listed building' (Court of Arches 2012: para. 53), which led to his misjudging the impact of the proposals on the character of the listed building; this in turn flowed from a misunderstanding of the status conferred by listing on a historic building. In his original judgment the chancellor stated that at the point of listing, 'the particular form and layout of the church took on a particular character' (para. 48), implying that listing removes the building from the flow of history, exemplifying the modern understanding of a radical discontinuity with the past. The Planning Act 1990, however, defines a listed building as 'a building which is *for the time being* included in a list compiled or approved by the Secretary of State' (para. 36, emphasis added). The appeal judgment notes that 'listing does not "fix" a building at a particular moment in time; rather it "accords it a particular status on

an *ambulatory* basis, for so long as the building remains listed"' (para. 52[ii], emphasis added). This 'ambulatory' understanding of listed status implies the mutability, the potential waxing or waning, of significance and, unlike the 'fixity thesis', is far more congruent with the idea of living buildings discussed in Chapter 3. It would appear that this 'fixity thesis' lead the chancellor to treat the building as an undifferentiated 'lump of significance', ignoring which aspects of the church as it stood were more important, and which less so.

By contrast, the appeal judgment, in its analysis of the effect on the character of the building, differentiates between its various types of interest (Court of Arches 2012: para. 56). Turning first to architectural interest, it states that the interest and character of the interior 'lies primarily in the building's medieval elements and the spatial proportions derived therefrom, both of which are exceptionally pleasing' (para. 57). When judged against this broader medieval context, the Victorian work, fine as it undoubtedly is in its own right, is found 'not wholly beneficial', while the screen 'impacts adversely on the overall character of the architecture' (ibid.). The chancellor was also criticized for leaving out 'any consideration of the potential benefit to the architectural character and historic interest of the listed building' (para. 51) of the proposed changes. This suggests a nuanced appreciation both of the building's ability to accommodate change positively, and of its multi-layered temporal nature. The Court found that the architectural interest was not adversely affected by the proposals. The judgment then considers the question of historic interest, which 'includes a consideration not merely of the building's medieval elements, but also of the way in which the church has been altered over time, including the works to it undertaken during the two rounds of Victorian alteration' (para. 58–59); here it is judged there is indeed a degree of harm.

Having looked at these aspects of interest separately, the question of overall harm was then considered:

> If one asks the composite question, will there be a loss to the character of the building as one of special architectural and historic interest, the answer must be 'yes', unless the view were taken that the architectural gain outweighs the loss of historic interest (which is a fine judgement which we do not feel qualified to make, nor do we feel it necessary to do so).
>
> (Court of Arches 2012: para. 60)

The view is that harm would result, because harm had been identified to the historic interest. Most interestingly, even though the Court did not feel

qualified to make the 'fine judgement' of balancing the impact on the two types of interest considered, the implication is that such a judgement is nevertheless possible. Indeed, this is precisely the sort of judgement conservation professionals are routinely called upon to make, and which accounts for the success of Scarpa's work to the Castelvecchio, considered in the previous case study. Not only is it clear that change can bring benefit and is thus markedly distinct from harm, it also opens up the possibility that the process should consider 'harm on balance', rather than merely harm of any kind.

Formal objections to the proposals had been received from Historic England, the Society for the Protection of Ancient Buildings and the Victorian Society, each of which focused solely on the Victorian work that was 'threatened', without reference to the temporal context – that this was a medieval church that had undergone multiple changes of which the Scott works were merely the most recent. None of the objectors even acknowledged the broader communal/theological context, as demanded in very similar terms by the 1991 predecessor to the 2018 Measure. The appeal judgment turned on the Court's finding that the chancellor had misread the effect on the character of the listed building, due to his erroneous interpretation of the 'adverse' effect of the proposals (para. 53). For the chancellor:

> An *'adverse'* effect is one that alters or affects *in a material way*, the appearance of form and layout of the listed building at the time it was listed, or as it has become by subsequent authorized changes. The change may be made by the introduction of some item, or by its removal, as well as by alteration of existing features.
>
> (Court of Arches 2012: para. 48, emphasis original)

Here is a clear example of the conflation of change and harm which runs through much conservation discourse. By contrast, the Court of Arches asserted that:

> Not every change that alters or affects the appearance and layout of a listed building in a material way (the definition used by the chancellor) will necessarily adversely affect its character as a building of special architectural or historic interest.
>
> (Court of Arches 2012: para. 52[i])

Thus far, therefore, we have seen three distinct missteps in the chancellor's judgment that also, arguably, characterize much conservation discourse:

first, the view that listing somehow 'fixes' the nature of a historic building; second, a failure to differentiate types of interest, and to consider the impact of proposals on each in turn; and, third, the overstatement of adverse effects and the conflation of change with harm. These three errors were found to have combined to exaggerate the perceived threat to the listed building.

Justification and enhancement

After considering the approach taken to the effect on the character of the listed building by Historic England and the amenity societies (Court of Arches 2012: paras 40–43), the Court then considers the contrasting approach of the petitioners (paras 44–46). Unsurprisingly, where the language of enhancement had been entirely absent from the reported interventions of the objecting consultees, it is more prominent in the comments of those speaking in support of the proposals. In their view, their particular church, and by extension historic buildings in general, are capable of being enriched and enhanced by allowing them to continue to change.

In marked contrast to the language of fragility and peril so familiar in conservation discourse, the insight undergirding the community view is of the essential *robustness* of heritage. Such non-expert opinions are all too readily dismissed as the voice of ignorance. While it is certainly possible for the inexperienced to underestimate the fragility of historic fabric and to cause significant damage, in this case those articulating this understanding were highly experienced in dealing with what is a building of 'exceptional interest', and should be regarded as bringing their own expertise to the discussion. Certainly, that expertise is partial, but then so is aesthetic-historical expertise, since by definition no single participant in this dialogue has a complete grasp of the whole. For opponents to dismiss out of hand the community's view of the robustness of their historic building is to suppress a potentially valuable set of insights, however challenging they may be to received professional wisdom.

Inherent to the design process which produced Scott's chancel screen is a sense of playfulness, which in turn implies contingency and mutability, that things can be (or could have been) done differently. We should therefore expect playfulness not only to be present in the completed fine craftsmanship of Scott's exuberant screen, but also that the screen itself would remain legitimately, perhaps even necessarily, open to such playfulness. Indeed, Scott himself acknowledged this:

> It is clear from reports prepared by Scott before the works started that he did not regard the chancel screen as an essential component of his

proposed reordering, although in his view 'if it should be decided to erect a chancel screen, its architectural effect will be admirable'.

(Court of Arches 2012: para. 9)

All of the objectors assume that the significance of the screen, and of the interior as a whole, is greatly diminished by its move within the building; what none seems to have asked is whether Scott, were he able to be respond to such a changed liturgical practice within this building, might not himself have supported the proposals.

Theology and community

It is to be expected that an active church community will articulate the importance of its building at least partly in theological terms. The admissibility of theological language into the debate, and the terms on which it is admitted, therefore provides a strong indication of the seriousness with which communal value is taken, and the worth attached to it. In the case of the appeal judgment, that place is prominent and its consideration nuanced. The statement of needs had articulated a threefold justification for the proposals, under the headings of the theological, the visual and the practical (Court of Arches 2012: para. 64), and the Court concluded (para. 77) that, 'Taking all these matters together, in our view they constitute "public benefits" and a "clear and convincing" justification for the proposal'.

Fully 17 paragraphs (Court of Arches 2012: paras 18–34) across ten pages of the judgment are devoted to a discussion of matters theological, including the status of the Thirty-nine Articles (Church of England 2018a) and whether a chancel screen imposes a 'Temple' theology (paras 32–33) on the building. By contrast, the chancellor is explicitly criticized for his dismissive treatment of the theological dimension of the proposals, dealing with it as a question of mere doctrine detached from other aspects of the justification and concluding that, since the existing screen was not *contrary* to Anglican teaching in general, that this aspect of the petitioners' justification should be rejected (para. 67). The Court took a different view, stating that:

> In so far as it may, the consistory court must strive in the exercise of its faculty jurisdiction to ensure that any decision it makes permits the proper reflection of the doctrinal beliefs of the priest and congregation.
>
> (Court of Arches 2012: para. 25)

Clearly local wishes cannot be the sole determinant, and that balance is reasserted at the close of the theological section:

The theological/doctrinal stance of a particular congregation cannot of itself determine whether or not a faculty should issue, and it is not a basis on which, taken alone, we would have allowed this appeal. Nevertheless, it is certainly a matter which needs to be taken into consideration in assessing the totality of the petitioners' case.

(Court of Arches 2012: para. 34)

This is a very significant acknowledgement that the voice of the local congregation – the core community – deserves a more than marginal place in the decision-making process. This same approach is evident elsewhere in the judgment; for example, two of the three voices quoted in the section on the petitioners' approach to the character of the building (paras 44–46) are lay people, both quoted at length.

In more general terms, there is a marked contrast between the language used by the experts opposing the scheme on the one side, and the 'people of the parish' on the other. The opponents' comments are marked by the use of dramatic language such as 'serious impact', 'highly detrimental', 'substantial damage', 'exceptional quality', phrases clearly intended to accentuate the sense of threat should the proposals be allowed; at the same time they entirely fail to acknowledge the interrelation between the worshipping community and its building. The danger of this strategy is that when it fails, as in this case, it risks being seen as alarmist hyperbole, eroding the opponents' authority both in this and subsequent cases. By contrast, the language used by the non-professionals is far calmer, more measured, and more balanced. There is also far less assumed authority, with these views being owned by the individual – e.g. 'it strikes us ...' and 'I think ...' – rather than being declaimed as fact. This contrast of language reflects a conspicuous asymmetry between expert and community voices (cf. Shanks 2007, Schofield 2014). It is a particular mark of the Court of Arches that both expert and non-expert voices appear to have been closely attended to, in seeming contrast to the chancellor's earlier judgment.

Conclusion

The Duffield framework influences the faculty system as a whole, providing guidance for chancellors in their subsequent judgments, and a point of reference for all parties, including DACs, the CBC, and amenity societies. The consequences of that influence can be very positive, for example in forcing churches to think through a clear statement of needs, resulting in a more robust rationale for better quality proposals. But working in a professional capacity with such churches reveals that the costs (in the broadest sense) of

engaging in a building project are often very high. Unsurprisingly, therefore, there is a strong correlation between the successful delivery of projects for change to historic churches, and church congregations with skills capacity, and the confidence to engage with a legalized, professionalized and time-consuming process. Such churches display a welcome degree of 'ontological security', a phrase derived from Anthony Giddens (1986, 1991) and applied in a heritage context by Jane Grenville (2007), denoting a degree of confidence in identity, purpose, and action, in this case derived from the communal distinctiveness of the Church. For many more typical congregations – those lacking professional skills within the church community and the confidence that brings – this high threshold can be enough to prevent them from ever proposing change, or once proposed to abandon a project.

While schemes involving significant change to historic churches may still be contested, at times meeting vehement opposition, the understanding as to the extent of acceptable change is itself changing, at least for the majority of stakeholders. The confidence in our capacity to produce the heritage of the future in this generation may of course at times be misplaced, but it should not be assumed that this is always or even typically the case. There is a broad acceptance amongst conservation bodies in the United Kingdom that it is important to keep historic buildings in use, and an encouragement from both Church authorities and funding bodies to broaden access to and involvement in church buildings. What has thus far been missing is the conservation theory to match this understanding; Chapters 4 and 5 aim to sketch out such a theory based on the themes of tradition and narrative.

Note

1 The author was appointed to the CBC as a DCMS nominee in 2016.

References

Church of England (2018a). *Articles of Religion*. [Online]. Available at: www.churchofengland.org/prayer-and-worship/worship-texts-and-resources/book-common-prayer/articles-religion.

Church of England (2018b). *Church Buildings Council | The Church of England*. [Online]. Available at: www.churchofengland.org/more/church-resources/cathedral-and-church-buildings/church-buildings-council.

Court of Arches (2012). *Re St Alkmund Duffield [2012] Fam 158*. [Online]. Available at: http://www.ecclesiasticallawassociation.org.uk/index.php/judgements/reordering/re-st-alkmund-duffield-2012-court-of-arches/.

Department for Digital, Culture, Media and Sport (2010). *The Operation of the Ecclesiastical Exemption and Related Planning Matters for Places of Worship*

in England. [Online]. Available at: www.gov.uk/government/uploads/system/uploads/attachment_data/file/77372/OPSEEguidance.pdf.

General Synod of the Church of England (2015). *The Faculty Jurisdiction Rules 2015*. (No. 1568). [Online]. Available at: www.legislation.gov.uk/uksi/2015/1568/pdfs/uksi_20151568_en.pdf.

General Synod of the Church of England (2018). *Ecclesiastical Jurisdiction and Care of Churches Measure 2018*. (No. 3). [Online]. Available at: www.legislation.gov.uk/ukcm/2018/3/pdfs/ukcm_20180003_en.pdf.

Giddens, A. (1986). *Central Problems in Social Theory: Action, Structure and Contradiction in Social Analysis*. London: Macmillan.

Giddens, A. (1991). *Modernity and Self-Identity: Self and Society in the Late Modern Age*. Cambridge: Polity Press.

Grenville, J. (2007). Conservation as Psychology: Ontological Security and the Built Environment. *International Journal of Heritage Studies*, 13 (6): 447–461.

Lennox, R. (2016). *Heritage and Politics in the Public Value Era: An Analysis of the Historic Environment Sector, the Public, and the State in England since 1997*. York: University of York. PhD thesis.

Morrice, R. (2009). *Ecclesiastical Exemption in England*. [Online]. Historic Churches. Available at: www.buildingconservation.com/articles/eccexemption/ecclesiastical_exemption.htm.

Mynors, C. (2016). *Changing Churches: A Practical Guide to the Faculty System*. London: Bloomsbury.

Schofield, A.J. (2014). Heritage Expertise and the Everyday: Citizens and Authority in the Twenty-First Century. In: A. J. Schofield (ed.) *Who Needs Experts?: Counter-Mapping Cultural Heritage*. Farnham: Ashgate. pp. 1–11.

Shanks, M. (2007). Symmetrical Archaeology. *World Archaeology*, 39 (4): 589–596.

Tradition

Change and continuity

> The spectator's judgement is sure to miss the root of the matter and to possess no truth.
>
> William James ([1899] 1925)

The legacy of the reclassification of historic buildings as monuments discussed in Section 1.2 endures. Bound up with the question of how we approach the built remains of the past is the issue of what we see as the relevance (or otherwise) of tradition, which in turn will depend on what we understand tradition to be. If a modern (and thus sceptical) approach to tradition is adhered to, our ability to read premodern buildings in their appropriate cultural context will be frustrated. What seems unsupportable is the idea that tradition has no relevance, when conservation is concerned with the care and change of buildings that are themselves the products of tradition. In attempting to engage in a hermeneutically literate way with the objects of premodern tradition, it is therefore not unreasonable to look beyond modernity's partisan portrayal of tradition and to consider the premodern understanding that preceded it. Not only does this seem to be a prerequisite for an adequate engagement with this particular type of building, it may also offer resources of broader relevance which may help address some of the contemporary challenges facing conservation that have emerged in the preceding chapters. If those resources can inform contemporary questions of culture, then this argument would have relevance to the conservation of buildings of all eras.

4.1 Modernity, tradition, and continuity

The English word 'tradition' is derived from the Latin roots *trans-* (over) and *dare* (to give): tradition is therefore that which is 'given over' or passed on from generation to generation, often implying at least a degree of authority and stability, and the possibility of an orientation towards preserving things

as they are. Raymond Williams (1976: 269) observes that the word 'tradition' brings with it 'a very strong and often predominant sense of this entailing respect and duty' and that it does not take long for something to become traditional; he adds that this is natural, since tradition is an active process. He notes with regret the way in which the meaning of the word is constantly pulled 'towards age-old and towards ceremony' which he sees as 'both a betrayal and a surrender'. For these reasons the traditional is often placed in opposition to the progressive.

In *How Societies Remember*, the social anthropologist Paul Connerton (1989) explores communal as opposed to individual memory to account for the transmission of social practices through traditions. He argues that current thinking provides no adequate account for the longevity/persistence of communal memory, noting that historians now typically focus on the *invention* of traditions, and thus on the intentionality of their creators, while failing to engage with the means by which traditions can endure across many generations, even millennia (Connerton 1989: 102–104). Eric Hobsbawm famously has observed the ease with which traditions continue to be invented, and the 'contrast between the constant change and innovation of the modern world and the attempt to structure at least some part of social life within it as unchanging and invariant' (Hobsbawm 1983: 2). Traditions are of particular relevance to the relatively recent innovation of the nation state, which 'generally claim[s] to be the opposite of novel, namely rooted in the remotest antiquity, and the opposite of constructed' (1983: 14). Conservation, which since its inception has been deployed in the creation of national identity, can be described as traditional in this modern sense.

Tradition and conservatism

Edmund Burke, the eighteenth-century philosopher and British parliamentarian, is widely regarded as the father of modern conservatism, with particular relevance in the United Kingdom and the United States. He was an early and fierce critic of the French Revolution in his *Reflections on the Revolution in France* ([1790] 2001) to which Thomas Paine ([1792] 1984) responded in *The Rights of Man*. Burke interpreted the social contract intergenerationally, as 'a partnership not only between those who are living, but between those who are living, those who are dead, and those who are to be born' (Burke [1790] 2001: 261). His relevance to this argument is his appeal to tradition within the frame of political conservatism, which has coloured the subsequent treatment of tradition down to the present day. Reacting against Enlightenment liberal rationalism he laid the

ground for the more traditionalist Romantic conservatism. The desire to conserve indigenous traditions, now exemplified by the Convention for the Safeguarding of Intangible Cultural Heritage (CSICH), can trace its roots here. It is interesting to note that Burke also played an important role in the development of eighteenth-century aesthetics through his highly influential *Philosophical Enquiry into the Origin of Our Ideas of the Sublime and Beautiful* (Burke [1757] 1990). Ruskin was clearly influenced by Burke, quoting him in his formative *Modern Painters Vol. I* (Ruskin [1843] 1903, e.g. 128); through Ruskin, Burke thus also helped to shape the development of modern conservation.

Tradition has not been of much recent concern for philosophy. Robin Downie (1995) defines tradition in the *Oxford Companion to Philosophy* as 'customary sets of belief […] which are transmitted by unreflective example and imitation', and, as elsewhere, frames it as of 'particular interest in political philosophy'. The *Routledge Encyclopaedia of Philosophy* entry for 'Tradition and traditionalism' by Anthony O'Hear (1998) is again classified under 'political philosophy', and deals principally with Edmund Burke and Friedrich Hayek, though concludes with a section on the flexibility of traditions which discusses John Henry Newman's approach to tradition in a theological context. O'Hear is also the author of entries for 'conservatism' in both the *Routledge Encyclopaedia* and the *Oxford Companion*. It is clear, therefore, at this level of the encyclopaedia definition that tradition is principally seen as a question of political philosophy, and in that context as an adjunct to conservatism. It is this entanglement of tradition within the definition of conservatism in the wake of the French Revolution that accounts for the typical opposition of tradition to reason. While O'Hear does nuance this by suggesting that 'traditions often turn out upon inspection to be not so much irrational as subtle and flexible deployments of reason in particular spheres', his treatment of tradition remains constrained by its categorization within political philosophy, and is thus of limited use for an exploration of its broader relevance.

The Marxist political philosopher G.A. Cohen is one author who does distinguish tradition from political conservatism; for Cohen, writing about the identity of All Souls College, Oxford, tradition is to be held lightly, and the preservation of identity is not active but the passive 'result of our not aiming to change it' (Cohen 2013: 169). He defends the 'small-c conservatism' of valued things and argues for its compatibility with a Left-leaning liberal modernity. To illustrate his argument he uses the example of historic buildings: 'We do not keep the cathedrals just because they're beautiful, but also because they are part of our past' (Cohen 2013: 168–169), and cites Burke's view of the partnership of the generations in support. Andy Hamilton (2016), a philosopher of politics and aesthetics, expands on Cohen's theme

of cultural conservation, touching on William Morris (as an example of socialism cohabiting with conservatism), the Cambridge Camden Society, post-war reconstruction and T.S. Eliot. He then specifically relates medieval church buildings (and towns) to society:

> Cohen's conservative model would encourage the organic development exhibited by medieval English towns and buildings – perhaps especially by churches – and which parallels the organic model of political development. This model rejects the blueprint model involving an individual creator. Rather, the town or building evolves – apparently spontaneously, over generations – without reference to a blueprint, and often without stylistic consistency. The church as a building – or on the conservative model, a society – are like organisms, seemingly not the product of individual intentional action, but evolving naturally.
>
> (Hamilton 2016: sn 4)

Hamilton makes many of the same linkages as proposed in this chapter, and with Cohen seeks to demonstrate that small-c conservatism does not necessitate embracing large-C political Conservatism. The difference, for both authors, is a question of justice. However, both are political philosophers with an explicit interest in conservatism, and accordingly both treat tradition as a second order issue.

Tradition and the canon

In general cultural terms, the contemporary understanding of a canon fulfils much the same function as did the notion of tradition which it largely replaced. The *Oxford English Dictionary* defines canon, among its non-religious meanings, as 'a standard of judgement or authority; a test, criterion, means of discrimination'. Within a given area of the arts it is therefore common to refer to a small selection of works as 'canonical' to denote that these are regarded as being of the highest quality, and therefore both representative and definitive of the art as a whole. For works to be deemed canonical they must be both sanctioned by an authority and agreed to be authentic. The idea of canon is religious in origin, denoting those writings that are divinely inspired, and the idea retains a quasi-theological dimension in the reverence with which canonical works are frequently viewed. Indeed, the frequent use of sacral language to describe objects of high culture, including protected buildings, is a theme discussed in Chapter 2.

The idea of a canon implies a degree of permanence and fixity, characteristics which are often assumed to be shared with tradition, and

both ideas can provide a basis for judging the quality of other works. In its secularized form, the notion of a canon of works has been highly influential in literature and the arts more generally; for example the critic F.R. Leavis (1948) proposed a series of canonical works that together defined the English novel. Such attempts to define a canon of work is closely analogous to the collecting together of treasured objects in the traditional museum, or indeed a national collection of treasured buildings. Hence Rodney Harrison identifies the development of 'a *canonical* model of heritage [...] that was distinguished markedly from the everyday' (Harrison 2013: 18, emphasis original), to which he contrasts representative forms of heritage which more readily accommodate continuity with the past.

But the two ideas of canon and tradition are not the same; given their proximity, it is important to distinguish them from one another. The philosopher of literature Stein Olsen (2016: 158–160) concludes his recent examination of canon by teasing out of dictionary definitions four significant aspects of tradition that are absent from canon. Olsen first tells us that tradition is tied to the notion of practice, that is, to the way in which a work is *produced*; it is on the basis of this set of practices that it is possible to determine what counts as excellence. We can add therefore that a focus on the *means* of cultural production, while missing from canon, contributes to tradition's normative power, a theme also addressed by sociologist and philosopher Richard Sennett (2009), in his attention to the role of craftsmanship. Second, 'tradition has continuity', with subsequent generations of authors locating themselves in relation to those that have gone before. Again, we can add that in a tradition this continuity is intergenerational, resulting in a richer communal landscape of reference and that the setting of a new work within that landscape of tradition is a key determinant of how the quality of that work is judged. Third, tradition is anonymous and collective, an 'immemorial usage'; a tradition in this strong sense cannot be created, nor its development dictated, by any one individual, as can a canon. Olsen adds that a tradition develops; I will go on to argue that, to remain alive, a tradition is *necessarily* developmental and dynamic, and for conservation this is perhaps the single critical differentiator between a tradition-based approach to the past and other possibilities. And fourth, tradition is closely related to locality: 'traditions are culturally embedded and are by their nature local and culture specific' (Olsen 2016: 159). Olsen concludes that, while the concept of tradition of itself does not definitively settle questions such as what is a great literary work or the value of literary practice, it does provide a framework within which these issues can be profitably explored, something that is not possible within the closed system of a literary canon.

The theme of the open-ended and developing nature of tradition was explored by the poet and critic T.S. Eliot in the early twentieth century in his celebrated essay 'Tradition and the Individual Talent'. For Eliot (1920: 44), to work within a tradition requires the author to possess the 'historical sense [which] involves a perception, not only of the pastness of the past, but of its presence [...] of the timeless as well as the temporal'. Furthermore, in Eliot's understanding, tradition is fundamentally dynamic rather than static; not only should a new work of art be judged against the tradition which precedes it rather than in isolation, but most startlingly, in the process of the new taking its place, the existing order is *modified*:

> No poet, no artist of any art, has his complete meaning alone. His sig-nificance, his appreciation is the appreciation of his relation to the dead poets and artists. You cannot value him alone; you must set him, for contrast and comparison, among the dead. I mean this as a principle of aesthetic, not merely historical, criticism. The necessity that he shall conform, that he shall cohere, is not one-sided; what happens when a new work of art is created is something that happens simultaneously to all the works of art which preceded it. The existing monuments form an ideal order among themselves, which is modified by the introduction of the new (the really new) work of art among them. The existing order is complete before the new work arrives; for order to persist after the supervention of novelty, the *whole* existing order must be, if ever so slightly, altered; and so the relations, proportions, values of each work of art toward the whole are readjusted.
>
> (Eliot 1920: 44–45, emphasis original)

This suggests that conformity to tradition need be neither stultifying nor conservative, but profoundly creative and, for the poet who understands tradition, brings with it both 'great difficulties and responsibilities' (ibid.).

Eliot's claim that the past order of the tradition is modified by the present on account of the continuity of that tradition is extraordinary and runs counter to the conventional modern understanding of culture, and the canon-ical. In applying Eliot's understanding to the buildings of a tradition, it is self-evident that a building does not literally have its physical fabric modified by later work, aside from the particular case of two episodes of creative work carried out to the same building. Nevertheless, following Eliot, the cultural landscape of which the old building forms a part *is* modified by the new, and with it therefore the old building itself, since it is only through that altered 'landscape' that the building is interpretively approached. Indeed, it is the effi-cacy (or otherwise) of this interpretive claim made by the tradition as a whole

on the individual part that provides the most obvious measure of the vitality of that tradition, a theme returned to in the final section of this chapter.

4.2 Hermeneutics

The interpretation of the specific in its broader context is an essential requirement of almost any cultural endeavour; this is the task of hermeneutics, and it applies as much to conservation as it does to literary criticism. Hans-Georg Gadamer was central to the development of philosophical hermeneutics in the twentieth century, and it is no coincidence that he was also one of the foremost philosophical voices to challenge the Enlightenment emasculation of tradition. Meanwhile, the moral philosopher Alasdair MacIntyre has focused on the workings of tradition in the context of his rehabilitation of virtue ethics. While each approaches tradition in the context of contrasting philosophical projects and from very different philosophical backgrounds, they nevertheless hold much in common; MacIntyre's (2002) essay contributed in honour of Gadamer's one-hundredth birthday casts more light on both difference and debt.

Both Gadamer and MacIntyre are profoundly critical of the 'Enlightenment project' (MacIntyre 1985) and seek to rescue tradition from the position to which modernity has demoted it. As part of this, both are adamant that the conventional opposition of tradition to reason, a founding principle of Enlightenment thinking, is mistaken. Where Gadamer's argument concerns the (central) place of tradition in understanding, MacIntyre gives a fuller treatment of tradition in the context of moral philosophy and explores questions of competing rationalities. Both draw significantly on Aristotle, with his stress on the role of practical wisdom (*phronesis*) alongside theoretical knowledge; this complements well the concern with practices and craft skills that is foundational for conservation. And both root their respective explorations of tradition in a thorough engagement with premodernity. The remainder of this chapter will firstly focus on Gadamer's hermeneutics, noting Charles Taylor's response to Gadamer, before considering MacIntyre's distinctive contribution to the theorization of tradition. It is hoped that this will lay the groundwork for the development of an alternative theoretical approach to the treatment of historic buildings as the objects of tradition.

Gadamer and tradition

Gadamer's particular relevance to the argument of this book lies in his understanding of the means by which we engage with the past, and the

mediating role that tradition plays in that process. Gadamer stands at the centre of the development of hermeneutics in the twentieth century; following the lead of his teacher Martin Heidegger, he redefined the role of hermeneutics as the basis for all understanding in the humanities. For Gadamer, understanding flows from the linguistically mediated event of tradition: 'belonging to a tradition is a condition of hermeneutics' ([1960] 1989: 291), which is to say that we rely on tradition (acknowledged or otherwise) for all understanding. Where modernity elevates method as the means of validating its truth claims, Gadamer seeks to assert the premodern understanding of tradition as the source of that authority. For him, an understanding of truth rooted in tradition has three sources, in art, history, and language respectively. His *magnum opus, Truth and Method* (Gadamer [1960] 1989), is accordingly divided into three parts, dealing with each of these three in turn.

German offers three words that can be translated by the English word 'tradition'. The first, *die Überlieferung*, follows a similar etymological logic to the English word 'tradition' discussed above: *liefern* translates as 'to deliver', hence *die Überlieferung* is that which is 'delivered over' by one generation to the next. The second, the loan word *die Tradition*, is more associated with tradition in the static and ideological sense. The third, *das Brauchtum*, translates as 'traditions' or customs, and provides a useful distinction between tradition in general and particular traditions or customs. It is the first of these, *Überlieferung* – with its implied sense of activity – that Gadamer makes most use of, with *Tradition* usually denoting or implying a specific tradition, and *Brauchtum* used least frequently to denote a custom. In addition, the translators at times render *Überlieferung* as '[a] traditionary text' (e.g. [1960] 1989: 277), that is, as a specific work of tradition (literary or otherwise); the adjective 'traditionary' draws a deliberate distinction with the more familiar 'traditional', to avoid the suggestion of traditionalism as generally understood.

For Gadamer, tradition (*Überlieferung*) is not an abstract body of knowledge, but something with which one engages in conversational partnership:

> Hermeneutical experience is concerned with *tradition*. This is what is to be experienced. But tradition is not simply a process that experience teaches us to know and govern; it is *language* – i.e., it expresses itself like a Thou. A Thou is not an object; it relates itself to us. [...] For tradition is a genuine partner in dialogue, and we belong to it, as does the I with a Thou.
>
> (Gadamer [1960] 1989: 358, emphasis original)

Thus, on this view, tradition is an ongoing (that is, intergenerational) conversation; it is that which not only lies behind us but, most crucially, also confronts us in the present. G.K. Chesterton's similar notion that tradition is 'democracy extended through time' was noted in Chapter 1.

Naturally, this view is not uncontested. In mid-1960s Jürgen Habermas's published a critical review of *Truth and Method* (Habermas [1967] 1977), sparking a celebrated debate of relevance to this argument, and to which others such as Karl-Otto Apel and Paul Ricoeur subsequently contributed. For Habermas, defending Western Enlightenment-based rationality, tradition is ideological and should itself be subjected to critique. Habermas distinguishes between the technical, the practical, and the emancipatory as the three basic forms of cognitive interest; the first is associated with what he terms the empirical-analytic sciences, the second with the historical-hermeneutic sciences, and the third with the critically oriented sciences (Habermas [1968] 1971: 308). In this he adopts Gadamer's distinction, drawn from Aristotle, between *praxis* and *techne*, refuting (with Gadamer) the modern identification of the practical with the technical. This presents a particular challenge to the modern conservation system, whose readiness to define the care of historic buildings as primarily a technical problem (rather than a cultural opportunity) is so effective in excluding community voices.

But it is in the priority that Habermas accords to the emancipatory interest, and its independence from the practical, that their approaches diverge. For Gadamer, to believe one can think apart from within some form of tradition, a key characteristic of modernity, is a dangerous form of self-deception. For him, hermeneutics is at the root of all philosophy, and is thus in that sense universal. Gadamer states in his foreword to the second edition of *Truth and Method*, seemingly responding on this point, that his book 'asks [...] how is understanding possible? This is a question which precedes any action of understanding on the part of subjectivity' ([1960] 1989: xxvii). Richard Bernstein summarizes Gadamer's position in his debate with Habermas thus:

> [Gadamer] charges Habermas with succumbing to the worst utopian illusions of the Enlightenment in his attempt to delineate an independent domain of the "new" critical social sciences. Gadamer does not reject the idea of emancipation. He even agrees that it is implicit in Reason itself. But it is not an independent cognitive interest. Rather, it is already intrinsic in hermeneutic understanding.
>
> (Bernstein 2002: 271)

It is in this different ordering of priorities that their contrasting approaches are rooted. Given the depth of his engagement with and positive stance

towards tradition, together with his greater willingness to challenge the legacy of the Enlightenment, it is Gadamer's approach that is followed here.

One explanation for such strongly divergent views of tradition is the distinction Gerald Bruns makes between tradition itself and 'the forms of cultural transmission that try to fix and control it', with which it is often conflated (Bruns 1992: 202). Bruns contrasts two modes of coping with the historicality of being: allegory and satire. He describes all interpretation as allegorical:

> in the sense of being a conversion of the strange into the familiar, or of the different into the same. Allegory is a mode of translation that rewrites an alien discourse in order to make it come out right – according to prevailing norms of what is right.
>
> (Bruns 1992: 202–203)

But while the allegorical approach appears to accommodate difference, it does so by converting everything into itself, cleansing the other of the scandalous aspects that do not fit within the prevailing order. By contrast:

> Satire is the discourse of the Other against the Same: counterallegory. Satire explodes the conceptual schemes or mechanical operations of the spirit by which we try to objectify and control things, including all that comes down to us from the past. Satire is unconvertible, uncontainable, uncontrollable [...] from a hermeneutical standpoint the encounter with tradition is more likely to resemble satire than allegory, unmasking of the present rather than translation of the past.
>
> (Bruns 1992: 204)

Under an allegorical approach to tradition, the new is subsumed within an established understanding; this is the conservative view of tradition as a stable structure, and we could call this approach 'edificial', not least because this is the view that has dominated modern conservation thus far, with the idea of passing on the inherited patrimony of historic buildings to the next generation as little changed as possible. By contrast, the satirical approach to tradition cannot be accommodated within a fixed structure; it constantly probes and challenges. To engage with tradition in satirical mode is to enter a dialogue from which one cannot but emerge changed. Bruns's distinction between allegorical and satirical modes is pivotal.

The literary theorist Terry Eagleton characterizes Gadamer's understanding of tradition as of a 'unifying essence' running 'beneath all history, silently spanning past, present and future' (Eagleton 1996: 62), very much on the

first, allegorical model. He criticizes Gadamer for believing 'that history forms an unbroken continuum, free of decisive rupture, conflict and contradiction', and on this basis accuses him of offering 'a grossly complacent theory of history. [...] History for Gadamer is not a place for struggle, discontinuity and exclusion but a continuing "chain," an ever-flowing river, almost, one might say, a club of the like-minded' (1996: 63). But while Gadamer does indeed see continuity where modernity only sees rupture, this does not mean that tradition is tidy or obedient. Rather, for Gadamer it comprises multiple voices:

> Our historical consciousness is always filled with a variety of voices in which the echo of the past is heard. Only in the multifariousness of such voices does it exist: this constitutes the nature of the tradition in which we want to share and have a part.
>
> (Gadamer [1960] 1989: 284)

As the translators of the second revised edition of *Truth and Method* say in their preface, a Gadamerian understanding of tradition 'precludes complacency, passivity, and self-satisfaction with what we securely possess; instead it requires active questioning and self-questioning' (Weinsheimer & Marshall 1989: xvi) a theme developed later in this section. Similarly, for Bruns, tradition is 'a satirical process in which the other is encountered in its otherness as a radical difference, a singularity, a refusal of typology, a questioning of self-identity, a resistance to interpretation, an unsilenceable questioning' (Bruns 1992: 208).

The political scientist Yaacov Yadgar, in drawing common themes from the contributions of Gadamer, MacIntyre and others presents tradition as a 'background, textual and constitutive, *contemporary* precondition of both community and self' (Yadgar 2013: 457, emphasis original). The division, axiomatic in the social sciences, between modern and traditional reduces discussion of the role of tradition to an argument between 'rationalist-secularists against conservatives-"traditionalists" as the two exclusive, exhaustive opposites of a historical and ethical argument regarding the worth and value of tradition in modern life'; both of these treat tradition as a 'sealed "package"' of approved truths and behaviours and the past as a 'given, unchanging and univocal "fact"' (Yadgar 2013: 454), a restatement of Bruns's allegorical position. Given this common understanding, the difference lies simply in what each sees as the appropriate response – abiding by tradition thus imagined or ignoring/rebelling against it. By contrast Yadgar highlights the dynamic and contemporaneous nature of tradition:

Contrary to both rationalist-secular and conservative perceptions of tradition as a rather firm and unchanging set of beliefs and practices, a 'narrative understanding' of tradition shows it to be essentially dynamic and ever changing. Seen as a narrative in the process of being written and re-written, a story that is not only told and retold but also, in the same process, as it is enacted, being constantly reshaped by the various interpretations of it enactors (i.e., individuals and communities who carry this tradition), tradition is revealed to be as much contemporary as it is ancient (or at least as much as it is viewed as rooted in the past).

(Yadgar 2013: 465)

This reading of tradition is thus a long way from that which Eagleton, for example, opposes. The relation of narrative to tradition will be explored further in the next chapter.

The fusion of horizons

For Gadamer, historical objectivity is illusory, since we are always already part of the process of interpretation. In a key section, Gadamer coins the phrase *wirkungsgeschichtliches Bewußtsein*, opaquely translated as 'historically effected consciousness', to insist that historical phenomena cannot be isolated and understood 'innocently', but always have an effect in history. Accordingly, when we attempt to understand a historical phenomenon, we 'are always already affected by history' ([1960] 1989: 300). To be historically literate means to acknowledge the operation of this historically effected consciousness, which is 'already effectual in *finding the right questions to ask*' (p. 301, emphasis original). From his understanding of the hermeneutical situation Gadamer builds the concept of horizon, which he defines in general terms as 'the range of vision that includes everything that can be seen from a particular vantage point' (p. 302). In place of the negative connotations (of limitation and constraint) that the idea of a horizon typically receives in modern thought, Gadamer suggests that having a horizon means not being limited to what is nearest to hand, but rather being able to judge the relative significance of everything within that horizon (p. 302).

For Gadamer, the process of understanding a historical 'text' involves the interplay of two horizons – that of the interpreter and that of the historical situation to be understood. Historical understanding is neither the imposition of the interpreter's horizon on the past nor, as romantic hermeneutics supposed, the acquisition of an alternative horizon from the past. Instead, what Gadamer terms a 'classical' approach allows history to address us directly, and thereby to venture its truth claims, through what he terms a 'fusion

of horizons' between present and past. Gadamer is clear that understanding does not result in the formation of a single horizon, as in Bruns's allegorical mode. Rather:

> In a tradition this process of fusion is continually going on, for there old and new are always combining into something of living value, without either being explicitly foregrounded from the other.
>
> (Gadamer [1960] 1989: 306)

This Gadamerian language of foregrounding is immediately recognizable in conservation. Time and again, from Ruskin and Morris onwards, conservation has justifiably been energized by resistance to the destructive effects of modernity's foregrounding of the new from the old. However, in its resistance, conservation then follows the logic of its roots in romanticism by simply inverting that priority, explicitly foregrounding the old from the new. The unacknowledged cost of this approach is to cut the old off from that fusion of horizons which, on the Gadamerian understanding, is essential to the ongoing health of both the tradition as a whole and of the object/ building in question within that tradition. And it is living buildings that best highlight this cost.

In relation to this fusion of horizons Gadamer introduces another idea, that of *conversation*. In a genuine conversation between two or more people, each party puts themselves at risk, and as a result the outcome of a genuine conversation cannot be known at the outset – indeed, for Gadamer, it is *only* by 'being put at risk' that 'our own prejudice is properly brought into play' (Gadamer [1960] 1989: 299).[1] Contrast this with the frustration we have all experienced when attempting to engage with someone who insists they already have all the answers; there is a strong sense that nothing is at stake for the other party, and meaningful dialogue is not possible. Gadamer's point is that we have the same choice in the way we approach the past: either, on the one hand, as something we treat as an object of study and which, in principle at least, can be fully known, or, on the other hand, as something approached dialogically which might challenge our assumptions and change the questions we ask. No party in a genuine conversation can remain unchanged:

> To reach an understanding in a dialogue is not merely a matter of putting oneself forward and successfully asserting one's own point of view, but being transformed into a communion in which we do not remain what we were.
>
> (Gadamer [1960] 1989: 379)

We have already noted the same point made by Vassilis Ganiatsas (2012) in the discussion of intangibility in Chapter 3. The conversations that are integral to current conservation consultation processes may or may not be dialogical in this sense, and some participants have gained a reputation for failing to engage at all. The dialogical is also used by Rodney Harrison to describe his preferred model of heritage, referring both to the importance of connectivity 'as part of a dialogue between people and things' and to what he terms 'hybrid forums' that combine 'experts, non-experts, ordinary citizens and politicians' (2013: 229, 230) engaging on equal ground.

This primary orientation towards the cultural question rather than the technical answer is a key part of Gadamer's approach, and, as Nicholas Davey notes, the resulting dynamism is essential to his understanding of tradition:

> Movement and development is intrinsic to the German word for tradition: *Überlieferung* has the active connotation of both transmitting and handing something on. What a tradition transmits from age to age are questions, problems and issues. The importance of canonic works is not that they are peerless exemplars of an idiom or style but rather that they raise issues and difficulties in an exemplary way.
>
> (Davey 2016: sn 10)

It might be preferable to speak of the exemplary rather than the canonical, since in light of Olsen's distinction above the latter term suggests at least a degree of immutability. By contrast, the inherent mutability of Gadamer's dialogical understanding brings with it a profound implication for our understanding of tradition. Common to almost any form of life is change and movement, and Gadamer specifically describes our horizon as:

> something into which we move and that moves with us. Horizons change for a person who is moving. Thus the horizon of the past, out of which all human life lives and which exists in the form of tradition, is always in motion.
>
> (Gadamer [1960] 1989: 304)

He insists that the horizon 'is not set in motion by historical consciousness. But in it this motion becomes aware of itself' (ibid.). In this context, the distinction between seeing a historic building as living and subject to further development on the one hand, or as a completed monument on the other, takes on a particular relevance.

Understanding the other

Gadamer's treatment of horizon has been productively applied by the Canadian philosopher Charles Taylor to what he sees as the greatest contemporary challenge to society, that of understanding the other, with obvious application to the increasingly participatory nature of conservation.[2] To claim objectivity is to avoid putting one's identity at risk, something demanded by Gadamer's dialogical model; this is why scientific knowledge tends to progress by breakthrough and consolidation, as elaborated by Thomas Kuhn in *The Structure of Scientific Revolutions* (1970). While a paradigm of detached objectivity has proved productive for the natural sciences, Gadamer's argument is that it is wholly inappropriate to the so-called 'human sciences', which are concerned with continuity and relationship. Taylor turns this around, suggesting that the slogan for Gadamer's approach might be 'no understanding the other without a changed understanding of self' (Taylor 2002: 295). As noted above, Gadamer would apply this to the 'historical other' through a dialogical understanding of tradition – that in engaging with history we are changed – and, as we saw earlier, T.S. Eliot argued that the relationship is reciprocal, with the tradition itself changed by a genuinely new addition.

This book argues that the distinction between an aesthetic-historical and a hermeneutic understanding of historic buildings is critical for the care of living buildings. In a direct parallel to that distinction, Taylor sees knowing an object and reaching an understanding with an interlocutor as two entirely distinct forms of activity. He suggests that there are three features of the latter that do not fit the usual model of the former derived from Enlightenment epistemology – first, such processes are bilateral; second, they are party-dependent; and, third, they involve the revision of goals (Taylor 2002: 281). While Taylor's concern in his brief paper is with what we could term the 'social other' – as opposed to the 'historical other' which is our principal focus – the force of Gadamer's argument applies equally to both. If we are to seek the sort of historical understanding necessary for responsible change to historic buildings within a living tradition, as opposed to the mere historical knowledge of the antiquarian, then we should expect conservation to display the features that both Taylor and Gadamer associate with reaching a mutual understanding in conversation.

Taylor's third criterion – that Gadamer's model involves the revision of goals – has significant practical implications, since 'taking in the other will involve an identity shift in us. That is why it is so often resisted and rejected' (Taylor 2002: 295). Let us take the example of a historic building

encountered by a heritage professional for the first time. If one adopts the representational epistemology on which modern science is based, then the thrill of encounter is the thrill of potential intellectual 'possession' of the 'object', of filling in a lacuna in one's knowledge (whether personal or corporate), perhaps of adding to one's 'collection'. In this context, historical information is separated from present day concerns around the use of the building, the stock of such historic property is understood to be finite and diminishing, and change to the object of study is almost inevitably seen as loss. But in approaching the building in this way, in bracketing and isolating it through the use of what Gadamer would term a romantic hermeneutic, we silence its voice; there can be no conversation, no 'fusion of horizons', no surprises; in that sense, for all the information we may glean, we can learn nothing. By contrast, the Gadamerian model offers a positive role for change, building it in from the outset: both a change of horizon, and from this therefore a change of identity for all participants in the conversation, including the building and the professional. Change to historic physical fabric makes demands on both the building and the professional but also opens up possibilities for both; carried out within the boundedness provided by an active tradition it should, in principle, be welcomed.

The relevance of this discussion of hermeneutics is to suggest that the differences of approach to the process of managing change to historic buildings are animated by differences in the understanding of understanding, as proposed by Gadamer and elaborated by Taylor. The adoption of a romantic approach to historic buildings by anyone involved in their care isolates that party in three important respects: first, from reaching a historically grounded understanding of the building in question, second, from the truth claims that the building will make on us in the process of our 'dialogue' with it, and, third, from the stakeholder conversation from which a common understanding of appropriate change is supposed develop. This is illustrated in the differences of approach often seen between conservation professionals and community representatives when change to historic buildings is mooted. Any approach that refuses to put at risk its own assumptions (and every position has such assumptions) will be incapable of reaching agreement with those operating from non-identical assumptions. The more closely an individual or organization is identified with a particular issue, for example the preservation of architecture from a particular period, the more they will struggle to engage in meaningful dialogue, or to countenance change. This Gadamerian analysis suggests that the very specificity of their self-description – particularly when that involves the safeguarding of architecture from a particular period – leads such stakeholders to adopt a framework that is ill-suited to the hermeneutic task at hand. In this way they

risk marginalizing themselves, and thereby depriving the process as a whole of the valid and much-needed contribution they could be making.

4.3 Virtue ethics

In Chapter 1, it was suggested that conservation is a form of applied ethics, and that ethics can helpfully be divided between universal, subversive and virtue approaches; having considered the modern understanding of tradition and some of the implications of Gadamer's hermeneutic alternative, we now return to that ethical framework. The aesthetic-historical approach in conservation can be seen to equate to a top-down universalist ethics, exemplified in Chapter 2 by the SPAB *Manifesto*, by much national legislation, by foundational documents such as the *Athens* and *Venice Charters*, and by the subsequent development of World Heritage designation. The universal approach to conservation claims an authoritative and objective understanding of the historic artefact and treats the current generation of occupiers as no more than caretakers; in this context, change is too readily categorized as harm. By contrast, subversive ethics offers a good match for the critical approaches to heritage which dominate heritage studies, in which heritage discourse is primarily concerned with power relations in the here and now. A subversive approach recognizes the social aspect of heritage but as a consequence is over-invested in the present. Both of these approaches to conservation – the universal and the subversive – are products of modernity and share its premise of a fundamental discontinuity with the past. Chapter 3 also presented a living heritage approach as offering a distinctive understanding of the role of people in conservation; where this focuses on social values for the present generation it represents a form of subversive ethics; where it accommodates a greater degree of time depth, engaging with previous and future generations, it moves towards a virtue ethics approach.

This section briefly examines the moral philosopher Alasdair MacIntyre's revival of virtue ethics, including its concern with the development of moral character. It then considers the implications of this for conservation, before focusing on the pivotal role of living traditions within such an approach.

MacIntyre's contribution

Three interrelated volumes published between 1981 and 1990 – *After Virtue* (1985), *Whose Justice? Which Rationality?* (1988) and *Three Rival Versions of Moral Enquiry* (1990) – form the basis of MacIntyre's approach. Together,

these offer a critique of modernity as hopelessly fragmented and propose a revival of virtue ethics on the Aristotelian model. The books are written in an open and readable style, and are aimed as much at the general reader as the academic philosopher; as D'Andrea (2006: 290) notes, this choice of style is in deliberate opposition to the academization of philosophy, and its separation from the social practices of the culture as a whole. This specialization to which MacIntyre is reacting afflicts much of our culture, not least professional and academic life, and is paralleled in the world of heritage in the redefinition of conservation in predominantly technical, rather than cultural, terms. MacIntyre's concern with practice and tradition should be of interest to the conservation community because it aligns so well with the work we do: conservation is very much concerned with specific practices of making and thus with traditional craftsmanship, and its purpose is the care of the objects of tradition in the form of historic buildings and their associated artefacts.

In the first of these three books, *After Virtue*, MacIntyre observes that our contemporary culture finds contentious moral issues such as abortion and euthanasia particularly problematic, in stark contrast to modernity's promise that these should be resolvable within a secular morality based on reason. Nietzsche understood that this secular morality was inherently dishonest in its presentation of inherited ideals in rational clothing and went on to generalize this challenge to modernity into a 'genealogy of morals', an important precursor for the subsequent development of postmodernism. For MacIntyre, however, Nietzsche is *insufficiently* radical in failing to question some assumptions inherited from the Enlightenment, including its rejection of Aristotle's ethics and politics, and he goes on to suggest that a moral Aristotelianism, rightly understood, cannot be undermined by Nietzsche's critique. MacIntyre proposes a return to a premodern approach, central to which are the virtues, which he seeks to rehabilitate. His account of the moral virtues has a multilayered structure comprising practices, from which is developed the narrative order of a single human life, which finally is located within a moral tradition (1985: 15). In applying this to the concerns of conservation, the narrative element could be expanded from the personal to include the narrative order of a local community, specifically that of a community with responsibility for the care of a historic building.

In *Whose Justice? Which Rationality?* (1988) MacIntyre challenges the Enlightenment opposition of reason to tradition and develops an account of rationality consistent with tradition. Starting from three alternative ideas of justice – from ancient Greece, medieval Europe, and eighteenth-century Britain respectively – he demonstrates that these alternatives are not resolvable by rational argument within a neutral framework, as supposed by the

Enlightenment view, since the claims on which each idea judges the rationality of an argument are incommensurate. In Chapter X ('Overcoming a Conflict of Traditions'), he uses the example of St Thomas Aquinas's *Summa Theologiae*, which reconciled what hitherto had seemed the largely incompatible philosophies of Augustine and Aristotle. This reconciliation was possible not by means of abstraction *away from* these competing traditions but *by entering them fully*, exposing each to the resources of the other. For MacIntyre, this process results in greater openness. He observes that for all its size, the *Summa Theologiae* is unfinished, not only because some of the third part remained unwritten at the time of Aquinas's death in 1274, but more significantly on account of its construction. Each discussion within the work is taken as far as it needed to be in light of Aquinas's knowledge of the question but is left open to be taken further. MacIntyre argues that this is an important aspect of Aquinas's method of enquiry, and in the present context of living buildings offers a useful indicator of an alternative notion of completeness: that the argument, like the building, can always be taken further, and that the author/architect/community can and should construct the work in that full knowledge. MacIntyre's wider point is that the working of a tradition in good health is dialogical in nature, and this has profound implications for our understanding of the provisional nature of the completeness of historic buildings, particularly those that have been formed through a process of change across multiple generations.

The last of the three books mentioned, *Three Rival Versions of Moral Enquiry*, considers three publications from the late 1870s – the ninth edition of the *Encyclopaedia Britannica* (1875–1889), Nietzsche's *Genealogy of Morals* ([1879] 1998), and Pope Leo XIII's encyclical *Aeterni Patris* ([1879] 2017). Simplifying considerably, these texts stand for modernity, postmodernity, and premodernity respectively, with the first representing modernity's ambition to create an all-encompassing and internally consistent account of the entire sum of human knowledge. MacIntyre critiques both 'Encyclopaedia' (modernity) and 'Genealogy' (postmodernity) for claiming to stand outside tradition; while thereby lacking many of the resources which he sees as necessary to rational thought, they nevertheless operate as traditions of sorts. While on MacIntyre's account the Encyclopaedist ignores tradition, believing that 'both truth and rationality are independent of our apprehensions of or strivings towards them' (1990: 202), all the Genealogist can do in his belief that truth is relative 'is to flirt with different traditions, rather like an actor playing different roles, yet all the while maintaining a certain degree of knowing irony and distance' (Fuller 1998: 132). As repeatedly seen in Chapter 2, mainstream conservation practice, based on the assumed authority of a universal ethics approach, largely ignores the

ongoing and tradition-formed particularity of historic buildings in favour of a supposedly independent truth (authenticity or significance) furnished by its methodology. In practice this approach is anything but neutral, and in an age of greater public participation appears increasingly threadbare.

If the old interpretive certainties of a universal approach will no longer suffice, how can a descent into the relativism of the Genealogist be averted? How can the conservation process arbitrate between Thomas Hardy's 'incompatibles' ([1906] 1967), those multiple stakeholders in the current process with radically different readings of the importance of a historic building? MacIntyre suggests that Dante supplied one possible answer to the competing forms of moral enquiry:

> that narrative prevails over its rivals which is able to include its rivals within it, not only to retell their stories as episodes within its story, but to tell the story of the telling of their stories as such episodes.
>
> (MacIntyre 1990: 81)

Accordingly, MacIntyre proceeds to demonstrate the shortcomings and inconsistencies of each of the first two rivals *in their own terms*. He concludes that only an Aristotelian virtue ethics, represented, however imperfectly, by the last of his three 'rival versions', is capable both of presenting a coherent account in its own right and crucially of providing resources to resolve outstanding issues within the other rival traditions.

The vitality of tradition

As discussed in Section 4.1, the understanding established by Edmund Burke and followed through thereafter was that a concern with tradition brings with it a commitment to conservatism. MacIntyre differentiates his understanding of the working of tradition from that which has been constrained within political conservatism:

> We are apt to be misled here by the ideological uses to which the concept of a tradition has been put by conservative political theorists. Characteristically such theorists have followed Burke in contrasting tradition with reason and the stability of tradition with conflict. Both contrasts obfuscate. For all reasoning takes place within the context of some traditional mode of thought, transcending through criticism and invention the limitations of what had hitherto been reasoned in that tradition [...] Traditions, when vital, embody continuities of conflict. Indeed when a tradition becomes Burkean, it is always dying or dead.
>
> (MacIntyre 1985: 221–222)

This reiterates a consistent theme; in an earlier paper also reacting to Burke he says that 'it is traditions which are the bearers of reason, and traditions at certain periods actually require and need revolutions for their continuance' (MacIntyre 1977: 461). He defines a living tradition as 'an historically extended, socially embodied argument, and an argument precisely in part about the goods which constitute that tradition' (MacIntyre 1985: 222). On MacIntyre's view, Burke's mistake, writing in the aftermath of the French Revolution, was to accept the Enlightenment's opposition of reason to tradition and then simply to reverse it. Gadamer ([1960] 1989: 273) similarly sees Burke's critique of the Enlightenment as facilitating the rise of German romanticism and, as we have seen earlier, noted the selfsame reversal. The Enlightenment failed to understand that a live tradition is very much concerned with reason, since a key concern for any such tradition is the ongoing debate about its own nature, and Burke shared this misunderstanding. In contrast to the Burkean view of tradition as static, MacIntyre's is necessarily and unashamedly dynamic; in this, MacIntyre and Gadamer are in close agreement.

Over the last 60 years, modernity's aversion to tradition has increasingly been questioned, and it has been argued earlier that this alternative stream of theory employing the resources of premodernity offers the prospect of a far more interesting, creative and productive relationship between conservation and tradition. Nicholas Davey, in commenting on Gadamer's contribution, contrasts two distinct approaches to tradition:

> A commitment to tradition is not a commitment to an academic antiquarianism. It is, essentially, a commitment to a field of debate. Tradition is presented as a resource and a provocation for thinking and creativity: whereas sameness is the currency of a conservative conception of tradition, instability, questions and the challenge of otherness are the drivers of Gadamer's more dialogical concept of tradition.
>
> (Davey 2016: sn 10)

This is very much in line with the distinction Bruns makes between 'allegorical' and 'satirical' approaches to tradition, discussed earlier.

An example of this contrast in contemporary conservation practice can be seen in India, where two quite distinct attitudes to heritage protection work in parallel. On the 'antiquarian' side, a relative handful (some 5,000) of designated monuments are protected at national level by the Archaeological Survey of India, which from its creation in the nineteenth century during British rule has pursued a Western approach to cultural heritage; a few thousand more buildings are cared for at state level in a similar manner.

On the side of a 'dialogical' concept of tradition, the Indian National Trust for Art and Cultural Heritage (INTACH) has developed a charter for the protection of unprotected heritage (INTACH 2004), with an approach that stands in marked contrast to the 'antiquarian' one. In this, INTACH reflects the increasing pluralism in heritage practice since the 1990s, specifically quoting (and reproducing) the *Nara Document on Authenticity* (UNESCO 1994). However, INTACH goes further, stating that in preference to 'official and legal guidelines' such as the *Nara Document*:

> The traditional knowledge systems and the cultural landscape in which it exists, particularly if these are 'living', should define the authenticity of the heritage value to be conserved.
>
> (INTACH 2004: Art. 3.1.1)

Under the conservation objective to retain visual identity, the charter notes how this unprotected architectural heritage is important to the 'specific visual identity of a place', but insists that 'this image should not be preserved in the manner of legally protected monuments, but must accommodate the imperatives of change in making the heritage relevant in contemporary society' (Art. 4.1.1). Within INTACH's remit, authenticity resides less in material fabric and more in embedded practices, including religious observance, and accordingly the charter places considerable stress on the retention and development of craft skills. From a non-Western perspective such as that of the *INTACH Charter* it seems strange that so many conservation professionals, particularly in the West, should hitherto have ignored this 'dialogical concept of tradition', which offers obvious potential for productive overlap with the contemporary concerns of conservation, including the central question of how to manage continuity and accommodate appropriate change.

Conclusion

Given that premodern buildings – and arguably many others besides – are the product of an active tradition, modern conservation is placed in a conflicted position: it is asked to care for those artefacts of tradition using tools and resources developed within an intellectual framework antithetical to it. Modernity typically presents tradition as entailing a commitment to political conservatism, making it unpalatable for many down to the present day; and yet it must be acknowledged that this depiction of tradition is itself highly partisan. Based as it was on rupture and a new beginning, the Enlightenment characterized tradition pejoratively as an anti-rational

constraint that must be overcome if humanity is to attain its freedom. In arguing for continuity in the context of revolution, Burke did not challenge the Enlightenment's opposition of tradition to reason. At the very least, a more considered understanding of the workings of tradition will be of relevance to the care of premodern buildings, and the central argument of this book proceeds on that basis. Beyond that, however, is the stronger claim that a non-modern understanding of tradition has the potential to reframe modern conservation and to resolve, at least partially, many of the conflicts inherent to it.

Notes

1 'Prejudice' is not a negative term for Gadamer. He argues that we cannot help but approach the world already equipped with a set of prejudices – perhaps 'pre-judgement' is a less emotive term.
2 In addition to his academic work, Charles Taylor also co-chaired the 2008 Bouchard-Taylor Commission on Accommodation Practices Related to Cultural Differences for the Quebec government which considered the question of 'reasonable accommodation' of religious and cultural practices in public life.

References

Bernstein, R.J. (2002). The Constellation of Hermeneutics, Critical Theory, and Deconstruction. In: R. J. Dostal (ed.), *The Cambridge Companion to Gadamer*. Cambridge: Cambridge University Press. pp. 267–282.

Bruns, G.L. (1992). *Hermeneutics Ancient and Modern*. New Haven, CT, and London: Yale University Press.

Burke, E. ([1757] 1990). *A Philosophical Enquiry into the Origin of Our Ideas of the Sublime and Beautiful*. Oxford: Oxford University Press.

Burke, E. ([1790] 2001). *Reflections on the Revolution in France*. Stanford, CA: Stanford University Press.

Cohen, G.A. (2013). *Finding Oneself in the Other*. Princeton, NJ: Princeton University Press.

Connerton, P. (1989). *How Societies Remember*. Cambridge: Cambridge University Press.

D'Andrea, T. (2006). *Tradition, Rationality, and Virtue: The Thought of Alasdair MacIntyre*. Aldershot: Ashgate.

Davey, N. (2016). Gadamer's Aesthetics. In: E.N. Zalta (ed.), *The Stanford Encyclopedia of Philosophy*. Metaphysics Research Lab, Stanford University. [Online]. Available at: https://plato.stanford.edu/archives/win2016/entries/gadamer-aesthetics/.

Downie, R.S. (1995). Tradition. In: T. Honderich (ed.), *The Oxford Companion to Philosophy*. Oxford: Oxford University Press. p. 878.

Eagleton, T. (1996). *Literary Theory: An Introduction*. 2nd ed. Oxford: Blackwell.

Eliot, T.S. (1920). Tradition and the Individual Talent. In: *The Sacred Wood*. London: Methuen. pp. 42–53.

Encyclopaedia Britannica (1875). *The Encyclopaedia Britannica: A Dictionary of Arts, Sciences, and General Literature*. 9th ed. Edinburgh: A & C Black.

Fuller, M. (1998). *Making Sense of MacIntyre*. Aldershot: Ashgate.

Gadamer, H.-G. ([1960] 1989). *Truth and Method*. (J. Weinsheimer & D.G. Marshall, trans.). 2nd, rev. ed. London: Sheed and Ward.

Ganiatsas, V. (2012). Heritage as Ethical Paradigms of Identity and Change: In Need of New Conceptual Tools, Practices or Attitude? In: W. Lipp, J. Štulc, B. Szmygin, & S. Giometti (eds.), *Conservation Turn – Return to Conservation: Tolerance for Change, Limits of Change*. Firenze: Edizioni Polistampa. pp. 53–56.

Habermas, J. ([1968] 1971). *Knowledge and Human Interests*. (J.J. Shapiro, trans.). Boston: Beacon Press.

Habermas, J. ([1967] 1977). A Review of Gadamer's Truth and Method. In: F.R. Dallmayr & T.A. McCarthy (eds.), *Understanding and Social Inquiry*. Notre Dame, IN: University of Notre Dame Press. pp. 335–363.

Hamilton, A. (2016). Conservatism. In: E.N. Zalta (ed.), *The Stanford Encyclopedia of Philosophy*. Metaphysics Research Lab, Stanford University. [Online]. Available at: https://plato.stanford.edu/archives/fall2016/entries/conservatism/.

Hardy, T. ([1906] 1967). Memories of Church Restoration. In: H. Orel (ed.), *Thomas Hardy's Personal Writings. Prefaces, Literary Opinions, Reminiscences*. London and Melbourne: Macmillan. pp. 203–218.

Harrison, R. (2013). *Heritage: Critical Approaches*. Abingdon and New York: Routledge.

Hobsbawm, E.J. (1983). Introduction: Inventing Traditions. In: E.J. Hobsbawm & T.O. Ranger (eds.), *The Invention of Tradition*. Cambridge and New York: Cambridge University Press. pp. 1–14.

Indian National Trust For Art and Cultural Heritage (INTACH) (2004). *Charter for the Conservation of Unprotected Architectural Heritage and Sites in India*. [Online]. Available at: http://www.intach.org/about-charter-guidelines.php.

James, W. ([1899] 1925). *Talks to Teachers on Psychology: And to Students on Some of Life's Ideals*. New York: Henry Holt.

Kuhn, T.S. (1970). *The Structure of Scientific Revolutions*. 2nd ed. Chicago, IL, and London: University of Chicago Press.

Leavis, F.R. (1948). *The Great Tradition: George Eliot, Henry James, Joseph Conrad*. London: Chatto & Windus.

Leo XIII ([1879] 2017). *Aeterni Patris: Encyclical of Pope Leo XIII on the Restoration of Christian Philosophy*. [Online]. Available at: http://w2.vatican.va/content/leo-xiii/en/encyclicals/documents/hf_l-xiii_enc_04081879_aeterni-patris.html.

MacIntyre, A.C. (1977). Epistemological Crises, Dramatic Narrative and the Philosophy of Science. *Monist*, 60 (4): 453–472.

MacIntyre, A.C. (1985). *After Virtue: A Study in Moral Theory*. 3rd ed. London: Duckworth.

MacIntyre, A.C. (1988). *Whose Justice? Which Rationality?* London: Duckworth.

MacIntyre, A.C. (1990). *Three Rival Versions of Moral Enquiry: Encyclopaedia, Genealogy, and Tradition: Being Gifford Lectures Delivered in the University of Edinburgh in 1988*. London: Duckworth.

MacIntyre, A.C. (2002). On Not Having the Last Word: Thoughts on Our Debts to Gadamer. In: J. Malpas, U. von Arnswald, & J. Kertscher (eds.), *Gadamer's Century: Essays in Honor of Hans-Georg Gadamer*. Cambridge, MA, and London: MIT Press. pp. 157–172.

Nietzsche, F.W. ([1879] 1998). *On the Genealogy of Morals: A Polemic: By Way of Clarification and Supplement to My Last Book 'Beyond Good and Evil'*. (D.S. Smith, trans.). Oxford and New York: Oxford University Press.

O'Hear, A. (1998). *Tradition and Traditionalism*. [Online]. Routledge Encyclopedia of Philosophy. Available at: www.rep.routledge.com/articles/thematic/tradition-and-traditionalism/v-1.

Olsen, S.H. (2016). Canon and Tradition. In: N. Carroll & J. Gibson (eds.), *The Routledge Companion to Philosophy of Literature*. Abingdon and New York: Routledge. pp. 147–160.

Paine, T. ([1792] 1984). *Rights of Man*. Harmondsworth: Penguin Books.

Ruskin, J. ([1843] 1903). Modern Painters, Volume 1. In: E.T. Cook & A.D.O. Wedderburn (eds.), *The Works of John Ruskin*. London: George Allen.

Sennett, R. (2009). *The Craftsman*. London: Penguin.

Taylor, C. (2002). Understanding the Other: A Gadamerian View on Conceptual Schemes. In: J. Malpas, U. von Arnswald, & J. Kertscher (eds.), *Gadamer's Century: Essays in Honor of Hans-Georg Gadamer*. Cambridge, MA, and London: MIT Press. pp. 279–298.

UNESCO (1994). *The Nara Document on Authenticity*. [Online]. Available at: http://whc.unesco.org/document/9379.

Weinsheimer, J. & Marshall, D.G. (1989). Translators' Preface. In: H. G. Gadamer (ed.), *Truth and Method*. London: Sheed and Ward. pp. xi–xxv.

Williams, R. (1976). *Keywords: A Vocabulary of Culture and Society*. London: Fontana.

Yadgar, Y. (2013). Tradition. *Human Studies*, 36 (4): 451–470.

Chapter 5

Narrative

Time, history, and what happens next

> Live in fragments no longer. Only connect, and the beast and the
> monk, robbed of the isolation that is life to either, will die.
>
> E.M. Forster (1910)

In the previous chapter, we noted Yadgar's description of the dynamic and contemporaneous nature of tradition, constantly being reshaped by the interpretations of those who carry it and belonging as much in the present as the past; this he labelled a 'narrative understanding'. Narrative also forms a key element of MacIntyre's virtue ethics, providing a means of understanding character formation in an individual's or a community's response to the events through which they live, and accounting for continuity of identity through the inevitable changes of life. Recognizing tradition as essential to conservation, a narrative approach thus focuses on continuity through time – a key concern of living heritage – and provides a positive account of change to historic buildings as a sign of life, not an admission of failure. The central metaphor proposed here is that a historic building is best understood not as an assemblage of primarily art historical values, but as an intergenerational, communal, ongoing narrative. In this definition, 'intergenerational' signals the importance of tradition in enabling dialogue with the past; 'communal' views the current generation as co-authors of heritage; 'ongoing' asserts that the story has not concluded, that more chapters will follow; and 'narrative' promises a degree of continuity between past, present, and future.

5.1 Temporality

History and transition

Saint Augustine, in one much discussed passage about the nature of time from his *Confessions*, famously asks:

> What, then, is time? If no one asks me, I know what it is. If I wish to explain it to him who asks me, I do not know. [...] Can we not truly say that time *is* only as it tends toward nonbeing?
>
> (Augustine [C5] 2006: XI 14:17)

This comment has often been used as the starting point for philosophical investigations of time. One such was Hans-Georg Gadamer's paper on the philosophy of time entitled 'Concerning empty and ful-filled time' (Gadamer 1970).[1] As could be expected from his hermeneutical approach, Gadamer rejects the idea that the present is the simple abutment of past and future, a dimensionless 'now' that merely 'couples together what has gone before and what is to come, while it itself does not endure' (1970: 350). Pursuing this opposition, he explores the character of transition, noting that:

> If one looks to the old that passes away, the process looks like a downfall. If one looks to the new that arises, the same process looks like an evolution, a genesis, a beginning.
>
> (Gadamer 1970: 351)

His point is not that transition has two aspects depending on your point of view, but more challengingly that this sense of 'downfall' is *inherent* to the passage of time and therefore to that which is to come:

> And further, the point is that in this insight, time itself is experienced. The distinguishing characteristic of transition is not that it is both passing away and developing at the same time, but rather that the new comes to be as the old is recollected in its dissolution.
>
> (Ibid.)

For Gadamer it is only in this negotiation of loss and gain, in the 'dissolution' and 'development' of transition, that the vitality of what he terms 'organic time' survives.

In this light we can see conservation in its more preservationist yearnings as the attempt to avoid transition, to remove the historic building from the flow of time. As already noted, the urge to maintain a historic building in an unchanging, officially sanctioned condition through preservation might arguably be appropriate for the static monument, but it cannot be for the living building. In her 2017 Reith Lectures, the historical novelist Hilary Mantel reflected on the relation of the discipline of history to the facts of the past:

History is not the past – it is the method we have evolved of organizing our ignorance of the past. [...] It's the plan of the positions taken, when we stop the dance to note them down. It's what's left in the sieve when the centuries have run through it. [...] It is no more "the past" than a birth certificate is a birth, or a script is a performance, or a map is a journey.

(Mantel 2017: 4)

The language here is playful – as befits a novelist – and suggests that to attempt to turn the past into something static is profoundly mistaken. It also suggests that since history is inevitably interpretative, the past will never submit to a single authoritative account; such attempts fail to engage with history, and positively misrepresent the past. Mantel also helpfully addresses the role history plays in providing an account of change through time. It follows that ownership of the word 'historic' in conservation is ripe for reassignment from the static/preservationist (monument) side of this disagreement as Morris or Ruskin might claim, to the dynamic/tradition-centred (living building) side. It is in light of this dynamic sense of history that the arch-modernist Reyner Banham (1963: 529) had some grounds for accusing the preservationists of being anti-historical.

What Gadamer expresses as the 'downfall' in the process of change involves a relinquishing of one's grip on the old before fully being able to grasp the new; this requires courage, like the courage of the trapeze artist. Gadamer (1970: 352) notes that 'the ability to bid farewell, just as much as the openness for the new which is undetermined, is in the "all in all" character of transition'. Gadamer's broader point is that change is an integral part of life, whether for individuals, communities, buildings, or entire cultures: to partake in history inevitably means to submit to a process involving multiple transitions. To take the contrary approach of seeking to avoid all 'dissolution' is also to abandon all hope of development; to cease to change is to die (cf. Newman [1845] 1909). The still stronger implication is that preservation, in seeking to prevent change, might 'kill' the object of its attention. Gadamer's point brings to mind Heidegger's essay 'The Origin of the Work of Art', in which he asks whether we give heed to art as an origin:

a distinctive way in which truth comes into being, that is, becomes historical. [...] Or, in our relation to art, do we still merely make appeal to a cultivated acquaintance with the past?

(Heidegger [1950] 2001: 75)

For Gadamer (1970: 352), drawing on the poet Friederich Hölderlin, the 'downfall' or 'dissolution' is necessary in opening up the infinity of possibility, and that 'transition [...] *is time*' (emphasis original). He goes on:

> If [...] transition is always a strained position between departure and opening into something indeterminately new, then the possibility of something indeterminately new is dependent upon the force with which we are able to bid farewell.
>
> (Gadamer 1970: 353)

To bid farewell, in this context, is an exertion; and as we have said, this requires courage. It is analogous to the bittersweet feeling a parent commonly has as their child grows into adulthood and leaves home. By whatever means, the parent must grasp that to care as before is not what is now needed; indeed, to care as though an adult child was still an adolescent or a toddler has now become inappropriate and potentially destructive. Wise parenting in this situation involves a letting go, a bidding farewell, since it is only through the dissolution of one form of relationship between parent and child that another, more adult form, can emerge. This is an example of the 'strained position' that is transition.

Gadamer's language of force is startling; he tells us that the future, the 'indeterminately new', is dependent on our ability to bid the past farewell. That is to say that change is necessarily intentional, that if our trapeze artist holds too firmly to the old they will endanger themselves and never learn to fly through the air, nor can the parent hold too firmly to their child without harming them and failing as a parent. In this context conservation professionals can all too frequently seem incapable of letting go. Rather than change being an expected aspect of historic buildings, the doctrine of minimal intervention treats it as the exception that should only be allowed once all other options have been exhausted. This contributes to the extended timescales which often afflict conservation projects, and which *in extremis* risk hastening the closure, and ultimately the loss, of the building in question.

Double temporality

Both Gadamer's 'strained position' and the vertiginous flight of the trapeze artist discussed above are attempts to characterize the middle 'present' in a tripartite process of transition that is narrative in structure. Paul Ricoeur has provided arguably the most detailed exploration to date of that narrative structure, principally in his three volume *Time and Narrative* (1984, 1985,

1988), but also continuing through his later writings. In the second volume of *Time and Narrative* he considers three novels which he calls 'tales about time' (1985: 100–152). Each displays what William Dowling calls

> the double temporality of narrative structure: a *telos* that carries characters forward in a state of imperfect knowledge about the consequences of their actions, with a narrator who, gazing backward on events from a fixed or *totum simul* perspective, has arrived at certain conclusions about their meaning or significance.
>
> (Dowling 2011: 88)

In this, Ricoeur draws on the work of philosopher of history Louis Mink, for whom all understanding has the goal 'of comprehending the world as a *totality*', quoting Mink's linkage to Boethius's definition of 'God's knowledge of the world as a *totum simul*, in which the successive moments of all time are copresent in a single perception, as of a landscape of events' (Mink 1970: 549; Ricoeur 1984: 159–160). This perspective is implied when an author uses a narrator to recount a story in the past tense; the outcome cannot be foreseen by the protagonists who, because they are within the story, lack the benefit of hindsight. This notion of double temporality is central to Ricoeur's philosophy of time – that the experience from within the narrative is *contingent*, and that it is only the narrator, standing at the end of the story looking back, who can truly assign conclusions about the meaning and significance of the events retold. In this connection Anthony Rudd notes Kierkegaard's view that:

> life can only be understood backwards, but has to be lived forwards. But (as I think Kierkegaard was well aware) we only live our lives forwards by living them from the self-understanding that we have come to at any moment by looking back on what our lives have been to that point.
>
> (Rudd 2009: 66)

If time does indeed have this narrative structure, then the implications for conservation are considerable. Any assessment of 'significance', whether of the 'modern' variety from the pen of the 'Great Man' (e.g. Nikolaus Pevsner), or of the 'postmodern' variety (the arbitration of values as in the *Burra Charter*) must be *provisional*. And yet both varieties in somewhat different ways make the narrator's claim of comprehensive knowledge. This is to make the same error as the secondary character in a murder mystery who attempts to bring the narrative to a premature end, believing that all can be seen clearly, case closed. But if time does have a narrative structure, the

implication for conservation is that we are unable to reach firm conclusions about the significance of a building while it remains living, and that at best our understanding is provisional. An exception might be granted for living buildings that close and make the transition, a final episode of change, to the status of static monument; but such an exception proves the rule.

Morrisian preservation is characterized by this same belief that the significance of events can be judged definitively – that is, that there is no such open-endedness. This is possible either on the basis of claiming the perfect retrospective knowledge of the narrator, or by believing the production of meaning to have stopped. In this Morris follows the broader cultural orientations of modernity, sharing with Banham what is, from the viewpoint of tradition, an impoverished view of time, and a belief in an *ahistorical* present. This should come as no surprise; modernity's promise of a new beginning *must* come at the cost of temporal continuity. For Ricoeur, by contrast, human action is only comprehensible, indeed only possible, in the context of a broader understanding of the present that incorporates elements of past and future, of meaningful action and projects, of horizons of expectation. This suggests that rehabilitating an understanding of this *historical* present will be of central concern in the development of an alternative framework capable of addressing heritage within a living cultural continuity. In order to do this, it is necessary to consider the workings of narrative in further detail.

5.2 Narrativity

Narrative is seemingly ubiquitous; as Barbara Hardy (1968: 5), an early proponent of its explanatory relevance, put it, 'we dream in narrative, daydream in narrative, remember, anticipate, hope, despair, believe, doubt, plan, revise, criticize, construct, gossip, learn, hate and love by narrative'. But beyond its prevalence, many proponents of narrative make strong claims for its foundational role, whether for psychology, ethics, or culture, to name three primary applications. Following Ricoeur and others, narrative is seen to be the key to creating a unity – essential, so the argument goes, for personal identity – from disjunctive parts dispersed through time. Drawing on the work of Louis Mink (1970, 1972), Ricoeur (1980: 178) describes this as a configurational act, a 'grasping together', by means of which the plot 'construes significant wholes out of scattered events, [...] eliciting a pattern from a succession'. After a brief discussion of questions of genre, this section considers two particular aspects of the configuring effect of narrative: first, its role in the formation of individual identity, and, second, the relation between narrative and community.

The nature of narrative

At the outset, it is worth observing that the derivation of the word 'narrative' is itself of interest. The *Oxford English Dictionary* states that the verb 'to narrate' is mid-seventeenth-century from the Latin *narrare*, in turn developed from *gnarus* (knowing); this provides a strong indication of the potential epistemological relevance of narrative. If narrative is indeed a form of knowing, then it is not unreasonable to consider that it might legitimately play a role, perhaps even a foundational one, in our understanding of the world. The idea that buildings might helpfully be viewed in the narrative terms set out in this chapter has not been previously explored in any detail. As discussed in Chapter 1, Edward Hollis (2010) frames historic buildings in narrative terms, recounting a history of architecture 'in Thirteen Stories'; but thus far no-one has attempted to set out a detailed theoretical basis for this approach.

Certainly, to treat a historic building as a form of text is not a new idea; for example it is not uncommon for buildings to be compared to biographies or chronicles, and so the idea of a building as a narrative joins a field of competing textual metaphors. There are, however, distinctions to be drawn between each of these literary forms. Biography is a specific form of narrative, and certainly includes a significant element of authorial shaping – comparing competing biographies of the same figure reveals the importance of the selection and interpretation of the 'raw material' of events, with that selection determining the nature of the story told. The question of who controls the narration is a central issue for any narrative approach to address; the issue is critical when it comes to a historic building, since the way in which the story is told will significantly shape the future development of that building, and this central practical question is considered further in the next chapter. One significant distinction between biography and other forms of narrative is that, whether or not the subject is dead, biographies are most often presented as *completed* narratives; in this, they can be seen as a special form of narrative that is primarily backward-facing.

'Building-as-biography' is, therefore, a perfectly serviceable metaphor for, say, the architectural historian. Gavin Lucas has explored biography in archaeology, noting its potential to mediate between the otherwise disparate descriptive and interpretive schools of historical archaeology (Lucas 2006: 41). Matthew Jenkins (2013) uses building biographies to investigate individual houses and entire streets in eighteenth-century York. And in her *Medieval Life*, Roberta Gilchrist combines methodologies, including object biographies of everything from shoes and wedding rings to buildings, to argue for the medieval understanding of

the 'extended life course – from conception to afterlife – which was fully realized in the materiality of the parish church and cemetery' (2012: 169). But, productive as these uses undoubtedly are, biography does not usually attempt to shape the *future* of its subject matter, and thus cannot address the particular concerns of living buildings, specifically the ethical question of how they can change well. For these, conservation must not only grasp the chapters of the biography to date, but also decide what *next* chapter should be written. For living buildings in community ownership, the responsibility of conservation is to determine what should be done in the present for the future benefit of that community whose health is inseparably bound up with the building in the balanced totality that is 'living heritage'.

Chronicle is a different sub-genre again, typically describing a factual account that follows the order in which the described events occurred, as a sort of *temporal catalogue* of events. Like a biography, therefore, a chronicle is also backward-facing but differs from biography in its more overt claim to be factual, resisting the idea that it is created through the interpretative process of selection and organization. The philosophy of history over recent decades has been much concerned with the relationship and distinctions between chronicle and narrative, and the extent to which history is inevitably shaped in the telling, that is, the extent to which history is story. Frederick Olafson, in his *Dialectic of Action* (1979), argues that narrative offers a similar structure to that of human action, making it particularly relevant to interpreting the motivations and goals of individuals and groups, about which historians write.

In an article entitled 'Narrative Explanation and Its Malcontents', David Carr (2008) provides two reasons why narrative is readily able to supply a satisfactory account of events. Like Olafson, he argues, first, that the narrative mode of explanation closely matches the way in which an agent might themselves describe the structure of their action; and he suggests, second, that 'narrative explanation is satisfying precisely because it never strays far from ordinary discourse' (2008: 21). Narrative is not a panacea since, however apparently satisfying, there always remains the possibility that the story told may not reflect reality; but Carr's central point remains that narrative explanation retains its efficacy because of its familiarity of form, that it matches the way human beings typically envisage action, whether in prospect or retrospect. This can be labelled the 'simplicity argument'; in a heritage context, with its focus on application and public involvement, that simplicity, if valid, would represent a substantial benefit.

Identity

As indicated earlier, for its proponents narrative is seen as essential for the creation of a sense of unity, and thus for personal identity; this has formed a major focus in the debate over narrative, not least for its detractors. Alasdair MacIntyre, whose approach to virtue ethics was discussed in the previous chapter, was one of the first philosophers to suggest that the locus of ethical decisions is wider than the single act, or the single point of decision in the mind of the individual agent. He famously uses the example of a man digging in his garden to highlight the impossibility of discerning the meaning of an action without a prior understanding of the interrelation of the multiple and overlapping possible aspects of that action:

> To the question 'What is he doing?' the answers may with equal truth and appropriateness be 'Digging', 'Gardening', 'Taking exercise', 'Preparing for winter' or 'Pleasing his wife'.
>
> (MacIntyre 1985: 206)

That is to say that we are unable to interpret an action correctly without first attending to the enfolding narrative histories that provide that action with its essential social setting and context; with respect to buildings, this focus on social context underlines the need for a view of heritage that balances the often competing claims of fabric and people.

MacIntyre proposes narrative as a means of relating human action to individual identity. He asks: 'In what does the unity of an individual life consist? The answer is that its unity is the unity of a narrative embodied in a single life' and concludes that 'The unity of a human life is the unity of a narrative quest' (MacIntyre 1985: 218–219). He identifies two key features of the medieval understanding of quest as having particular relevance: first, that a quest has a direction and aim, a *telos*, and, second, that that which is searched for is inadequately characterized at the outset. It is only in the course of the quest itself that the goal is properly understood, indeed perhaps recognized at all. This is a key distinction with immediate application to the process of architectural design. Unlike other forms of quest such as a miner looking for gold (MacIntyre's example) or perhaps a consumer shopping for some shoes, this richer, premodern understanding not only involves the progressive discovery of the goal as the journey unfolds but also the formation of the character of those embarked upon it. MacIntyre's argument is that narrative, quest and identity are intimately related.

Subsequent to the publication of *Time and Narrative*, Ricoeur moved on to consider the extent to which human identity is narrative in its construction,

in a paper entitled 'Narrative identity' (1991), and then more fully in the book *Oneself as Another* (1992). In an interview from 1988 (q.v. Ricoeur 1991: 189; Reagan 1996: 113) he suggests there are two quite distinct meanings of the word 'identity': first, as sameness, in the way that a person retains the same genetic structure through their life; and, second, as what he terms '*ipséité*', which one might translate 'himselfness', or 'selfhood'. He observes that sameness endures through time: 'Sameness of structure is a kind of denial of time. In spite of time the same structure prevails'. By contrast '*ipséité*' has the characteristic of the experience of responsibility: 'I don't claim to be the same, but I impose on myself the duty to be faithful to my word. This will to keep one's word implies a quite different sense of identity' (ibid.). And Ricoeur is clear that narrative identity is as applicable to a historical community as it is to an individual (1991: 188).

It is not difficult to find application in a conservation context for Ricoeur's assertion that 'many of the difficulties which obscure the question of personal identity result from failing to distinguish between these two senses of the term identity' (1991: 189). Many of the disagreements that attend proposals for change to historic buildings can be seen to stem from the reductivist assumption that the identity of a historic building is primarily a question of sameness, not only of structure but also of material; the disagreement between Michael Petzet and Gustavo Araoz discussed in Section 1.2 can be seen in these same terms. By contrast, when viewed within a 'living heritage' framework that balances building *and* community, identity is primarily a question of *ipséité*. If this is the case, then the principal responsibility of conservation professionals should be keeping alive the cultural questions from which that identity flows, not the preservation of the material half of the heritage narrative in the state in which the current generation happens to have found it, as an end in itself. In the context of conservation as a form of applied ethics, Ricoeur's further assertion that 'it is this narrative identity which is the basis for an ethical life' (Reagan 1996: 113) has a particular resonance.

David Kaplan (2003: 89) expands on Ricoeur's distinction of sameness and selfhood by defining selfhood as a dialectic of 'character' and 'keeping one's word'. Following the parallel of buildings with persons, in what sense can a building be said to keep its word or remain faithful to its promises? There is certainly a sense of expectation when a building is constructed, for example at the most basic level that it will provide shelter for the activities it is designed to house, or that it will be constructed within an agreed budget; these are examples of promises made on behalf of the building by those who commissioned it. A sense of promise is implicit in the catch-phrase 'fitness for purpose'; its claimed absence is often deployed to argue

for radical change or demolition. Of course, there is no guarantee that the expectations placed on the building are reasonable. For example, many owners mistakenly believe that a building 'promises' to survive in perpetuity without any basic maintenance; Morris's appeal for 'daily care' shows this is hardly a new problem.

When considering community buildings, one such commitment made by previous generations, whether explicitly or implicitly, is to constitute community; in this sense we can describe a building as setting up a world, in something of the same way that Heidegger ([1950] 2001: 39–45) describes the true work of art. We can make this claim in at least two respects. First, the construction of a communal building is almost never an end in itself; at a minimal level the cost in terms of effort and resources is always, at least to a substantial degree, justified on the basis of the community activities it is intended to accommodate. Second, there is the agency of buildings considered in Section 1.3 and encapsulated in Winston Churchill's dictum that 'We shape our buildings and afterwards our buildings shape us' (UK Parliament 1943). The first of these grounds relates to the fulfilment of functional requirements, the second to questions of identity. Ricoeur, too, describes a similar reciprocal relation: 'I try to say that by telling a story we construct the identity not only of the characters of the story but the character of the reader' (Reagan 1996: 112).

If indeed we are able to speak in terms of historic buildings 'keeping their word', then this has significant implications for their identity and thus for the key issue of how they should change. In interactions between people, it is precisely when circumstances change that one's ability to 'keep one's word' is tested, and one's character is shown; hence, as noted, a parent's commitment to provide for their child is expressed very differently at different stages of that child's life. If, as suggested, the role of conservation is primarily concerned with passing on the questions that constitute a building's identity, then we should expect that when the cultural situation changes (as it is bound to do while a building remains 'alive') this commitment to 'keeping one's word' may well demand significant change to that building.

We can see the history of this written into any multi-generational building. What should surprise us is not that buildings continue to need to change, but that anyone could think it sensible, as the preservationist argument maintains, that they should be prevented from doing so. To frustrate change in a building in the context outlined earlier is to do violence to it, compromising its identity and wresting it from the flow of its development that is an essential aspect of its nature. Clearly some structures, for example war memorials or the Völkerschlachtdenkmal discussed in Chapter 3, are intended to endure unaltered; to these Riegl ([1903] 1996)

attributed 'intentional commemorative-value', and they are indeed appropriately categorized as monuments. However, the exceptional status of such examples serves to highlight that once a building begins to 'live' as a result of initial episodes of change, preservation in perpetuity ceases to be part of its promise, if indeed it ever was.

Community and the fitness of narrativity

Where Ricoeur is principally interested in bridging the gap between time as experienced and time as recounted, David Carr in his *Time, Narrative, and History* (1986) draws out a second unifying aspect (implied by Ricoeur, but not his main focus) in which narrative brings together the individual and the communal. Carr is concerned with the pre-theoretical understanding of history, the ways in which we speak of the past in the context of everyday life, and it is this that lies behind his interest in the articulation of common narratives by groups. For Carr, this pre-reflective approach underlies the way the professional historian approaches their task, with clear applicability to the communal aspects of 'living heritage'. Indeed, it is this 'social dimension of narrative which is necessary for the full comprehension of history' (Carr 1986: 17).

Carr builds his case from individual small-scale experiences through extended actions to the full lives of individuals, attempting to demonstrate at each stage a narrative structure, and concluding at the level of groups, which in part are constituted by the narrative aspect of a community's traditions. For Carr, the narrative structure of human action means that historians who write in a narrative mode are reflecting the structure of events rather than imposing that structure onto them, although as has been pointed out historians may yet impose artificial structures on their material since the narratives of historical agents may not be their only, or even main, interest (Carroll 1988: 305).

It is Carr's insistence on the relation between narrative and the formation of community that is of greatest relevance to the argument of this book; for him, community identity is formed from events, actions and experiences spread across time. Hence, he can state that:

> the group's temporally persisting existence as a community, and as a social subject of experience and action, is not different from the story that is told about it; it too is constituted by a story of the community, of what it is and what it is doing, which is told, acted out, and received and accepted in a kind of self-reflective social narration.
>
> (Carr 1986: 149–150)

The congruence of the account of the past is as essential to the well-being of the community as to that of the individual. Since the past is readily manipulable, it is a sign of a healthy community that the facts of the past are vigorously debated, 'precisely because they are so important in the constitution of the present and the future' (1986: 172). In a buildings context, the conservation approvals process represents just such a vigorous debate over the facts of the past. It is one benefit of the Church of England's faculty system, outlined in the case study following Chapter 3, that its judgments leave a record of its major debates.

It is important to acknowledge that there are significant voices of dissent questioning the usefulness of narrative theory which demand attention. Typical of the claims made for narrative to which its detractors object is Charles Taylor's statement that, 'in order to have an identity, we need an orientation to the good' and that this 'has to be woven into my understanding of my life as an unfolding story'; further, in order to make sense of ourselves, for Taylor it is essential 'that we grasp our lives in a *narrative*' (1989: 47, emphasis original). The analytic philosopher Galen Strawson is one of the principal opponents of 'narrativism', and in his article 'Against Narrativity' (2004) helpfully differentiates between psychological and ethical forms of narrativity. Of these, the former is the thesis that life is commonly experienced in narrative form, which he regards as merely mistaken, while the latter, that narrativity is a requirement for a fulfilled life, he sees as positively harmful.

Peter Lamarque has expressed a number of concerns with the claims made for narrative in the context of literary aesthetics. He refers to the essential 'opacity of narrative' (Lamarque 2014) to suggest that, rather than narrative presenting a window through which a different world is glimpsed, nothing more is revealed than the specific story told. He engages with Alasdair MacIntyre (2014: 60–61), noting his introduction of narrative into ethics to counter the modern tendency to view actions atomistically, before criticizing him for overreaching in his argument by exploring the parallels between human lives and fictional narratives, which leads him to suggest we are 'co-authors' of the narratives of our lives (MacIntyre 1985: 213). For Lamarque, this is fraught with danger; this aestheticization:

> is another form of distortion, promoting quite the wrong kinds of explanations, finding meanings in mere coincidence, finding teleology where there is mere cause and elevating genre over brute fact.
>
> (Lamarque 2014: 30)

Lamarque and I have debated our differences in a jointly authored paper on the application of narrative to historic buildings (Lamarque & Walter

2019); see also the response from Saul Fisher, and our subsequent reply (Fisher forthcoming; Walter & Lamarque forthcoming).

Strawson notes (in pejorative terms) that many narrativists have a religious commitment: this is true of Ricoeur, Taylor, and MacIntyre, but not of Daniel Dennett, a noted atheist and secularist whom Strawson also attacks. Perhaps a more interesting correlation is between narrativity and the playfulness inherent in any creative endeavour and which, at least as argued by Johan Huizinga (1949), is essential to the generation of culture and the health of human society. Any designer can sense the playfulness present in the creation (and often in the subsequent alteration) of the historic buildings for which conservation professionals care. Similarly, a person's account of their own life is something that is constantly and perennially *in play* until the time of their death. In his earlier *Rule of Metaphor* (1977), Ricoeur argued for the fundamental fecundity of language, its playfulness and ability to generate new meaning, and saw that book and *Time and Narrative* as parts of a single extended project (1984: ix, 71). Gadamer (1986) also regarded play, along with symbol and festival, as a critical aspect of art and essential to the participation to which art invites us; more than merely describing the state of mind of the creative individual, for Gadamer play provides 'the clue to ontological explanation' ([1960] 1989: 101). The inclusion of a joke as an epigraph to this book is, in similar vein, intended to signal that the historic environment is too serious a matter not to be treated with a degree of playfulness.

5.3 The relevance of narrative for conservation

In contrast to Strawson's approach and in confirmation of Carr's 'simplicity argument', my professional experience working with community groups shows a striking readiness to discuss their building, and their own involvement with it, in terms of narrative. There is often a strong sense that the past remains in active dialogue with both the present and the future, particularly with some church communities. In part this may be related to an understanding of continuity with the past which attends a conscious identification with a tradition; this is in marked contrast to the sense of discontinuity from the past which Poulios (2014: 12) identifies as characteristic of conventional modern conservation. But what does the adoption of a narrative approach to conservation entail?

The central metaphor

Stephen Crites, in his essay 'The Narrative Quality of Experience', reflects on the role of storytelling in traditional folk cultures, suggesting that there is:

more to narrative form than meets the eye [...] even for a culture as fragmented, sophisticated, and anti-traditional as ours. [...] Such stories, and the symbolic worlds they project, are not like monuments that men behold, but like dwelling-places. People live in them. Yet even though they are not directly told, even though a culture seems rather to be the telling than the teller of these stories, their form seems to be narrative.

(Crites 1971: 295)

This image of narratives as 'dwelling-places' in which people live is richly evocative, and its validity and usefulness are not compromised by its possible inversion; that is, that the 'dwelling-places' around which the identities of communities are structured could helpfully be read as narratives. This therefore suggests that a historic building is best understood not in atomistic terms as comprising discrete 'gobbets' of significance – as the current methodology might be characterized – but as an ongoing community narrative.

Implicit in this metaphor are two related claims. The first is that a building is meaningful primarily for what it represents as a cultural whole, and only secondarily for its parts, however beautiful those individual parts may be. The second is that there is a directional relationship between whole and part. The current methodology works from part to whole, with significance presented as no more than the sum of the discrete values identified; yet no clue is offered as to how those individual parts are supposed to cohere into a comprehensive whole. Statutory consultees, particularly those concerned with a specific historic period, similarly tend to engage with a building on the basis of those parts that are of interest to them, with the composite historical whole relegated to secondary importance or neglected altogether. In the absence of an integrating framework – the mortar between the blocks as it were – it is difficult to see how a stable and historically literate account can possibly result.

One mode of viewing a building as a cultural whole would be to see it as poetry, the most concentrated form of linguistic expression. John Ruskin's evocative writing furnishes numerous examples of buildings described in the most poetic of language, and his direct influence is felt in the SPAB *Manifesto*, as noted in Chapter 1. More explicitly, in the 'Lamp of Memory' he states that 'there are but two strong conquerors of the forgetfulness of men, Poetry and Architecture; and the latter in some sort includes the former, and is mightier in its reality' ([1849] 1903: 224). But to see a building as poetry has significant implications for the way it should be treated. Poetry, as the most condensed literary form, is also the most resistant to paraphrase, since to change a poem is to alter its structure, which cannot but compromise its integrity. This question of paraphrasability – that is, the extent

to which the meaning of a literary work can survive its re-description in other words – is of significant interest to philosophers of literature (e.g. Beardsley 1958: 432–437), bringing with it a distinction between a general text which can indeed be re-expressed, and a work of literature which resists such re-description. A building viewed as poetry in this sense is indeed something which, as Morris warned, 'modern art cannot meddle with without destroying' (Morris [1877] 2017).

An alternative to Ruskin's understanding of poetry is Martin Heidegger's description of *poiesis* as the essence of art, that is, a making or bringing forth into being ([1950] 2001). In his essay 'Poetically Man Dwells', a reflection on a line from the poet Hölderlin, he states that 'poetic creation, which lets us dwell, is a kind of building' ([1954] 2001: 213). For Ruskin, the implication of the relation of architecture and poetry, distilled in aphorism 27, is that 'architecture is to be made historical and preserved as such'([1849] 1903: 225); for Heidegger, 'dwelling rests on the poetic', with dwelling understood as 'the basic character of human existence' ([1954] 2001: 212, 213), and therefore very much alive. The single image of architecture as poetry is therefore capable of interpretation in two very different ways, each with quite distinct consequences.

Furthermore, the Ruskinian 'building-as-poem' has two characteristics not shared by the sort of multi-generational community buildings which are a central concern of this book. First, poems are usually authored by a single person and, second, they are completed, usually by design or, as with Coleridge's *Kubla Khan* (1965), are left unfinished by accident. By contrast, a community historic building is more like a communally written narrative, with each person (generation) adding a line or a chapter. Following Chesterton's understanding of tradition as democracy extended through time, such a jointly authored, communal work can never be regarded as complete while the tradition remains alive. In something of the same way, Tim Ingold applies Davidson and Noble's (1993: 365) 'finished artefact fallacy' to buildings, suggesting that only once the builders move off site and hand it over does the serious work begin (Ingold 2013: 39, 48). Ingold has in mind the effort required to combat the effects of the elements, but the same applies *a fortiori* to the intergenerationally fluid requirements of living buildings. It is interesting to note that Ricoeur (in Dowling 2011: 113) mirrors Chesterton's understanding from almost a century earlier, with respect to the classics of philosophy: not only do they stand the test of time, but they form 'the space of a mysterious contemporaneity, in which what might be called a dialogue with the dead is nonetheless conducted by altogether living voices'.

Central to this metaphor of buildings as ongoing narratives is therefore the need to allow for *continuing* cultural production, or as noted with

respect to (cultural) landscapes, 'The decision that each generation [...] has to make, is what will happen next' (Fairclough 2002: 35). In discussing the benefits of working with old buildings, Stewart Brand touches on the same central metaphor: 'The building already has a story; all you have to do is add the interesting next chapter' (Brand 1994: 105). Following the logic of this metaphor, each generation has the opportunity (and perhaps the responsibility) to contribute to the ongoing narrative. But if the current 'chapter' is to represent a coherent addition to what in most cases is already a multi-faceted story, then a narrative approach demands that we understand the plot to date as well as we possibly can. What a narrative approach emphatically does not do, therefore, is to excuse us from a thorough engagement with the past. At the turn of the twenty-first century, there was much talk of 'informed conservation' (Clark 2001); while acknowledging its importance, the narrative approach goes beyond information and knowledge of the past to an active engagement with the tradition(s) that formed the narrative to date. That engagement is of primary importance in buildings that remain in use for the purpose for which they were built, but applies also for those for which an adaptive reuse has been found.

Benefits of the narrative model

Perhaps the key distinction of the proposed narrative approach is that, rather than relying on the apparatus of modernity, it works with the grain of tradition, traditionally understood. As explored in Chapter 4, tradition is more dynamic than static, as much concerned with the generation of new meanings as the preservation of old ones. It is essential, therefore, that any proposed framework for dealing with the objects of tradition includes a future dimension, as does narrative. Part of knowing what we should do at the present moment involves an acknowledgement that, whatever the 'chapter' we end up writing in this generation, future generations will wish to write their own and that this is an inevitable aspect of what it means to be a *living* building. If an intergenerational narrative is to be comprehensive and coherent, the author of each 'chapter' has a responsibility to leave 'plot lines' open for future generations. This requires a projection forward to imagine what a future generation of that community might perhaps need, to ensure where possible that the work currently undertaken does not prevent that future work. For example, where a building is extended it helps to think how it might be further extended, or indeed subdivided, and still add up to a coherent whole. This has much in common with the idea, developed from the 1960s onwards, of 'loose-fit architecture', which is typically argued on the basis of economics and sustainability, but also of ownership (Lifschutz 2017).

This recognition of the changing nature of needs may be good design practice but it remains unsupported by the current conservation methodology. Indeed, the doctrine of minimal intervention often works in the opposite direction, limiting approval to work for which a current need can be demonstrably proved; in this respect, contemporary conservation methodology is curiously atemporal, seemingly determined to look as little as possible into the future. Closely related to this, a narrative approach offers a framework for understanding living buildings as developing personalities, rather than as completed biographies.

It is a commonplace of conservation practice that buildings are better cared for if they remain in beneficial use. The *Venice Charter* states that 'The conservation of monuments is always facilitated by making use of them for some socially useful purpose' (ICOMOS 1964, Art. 5), although without allowing for any change to the building. The *Burra Charter* states that the use of a place should be retained where it is of cultural significance, and that 'A place should have a compatible use', defined as 'a use which respects the cultural significance of a place' (Australia ICOMOS 2013, Arts 7, 1.11). Historic England takes this further, recognizing that 'Keeping a significant place in use is likely to require continual adaptation and change', that 'the work of successive generations often contributes to their significance', and that those responsible for them 'should not be discouraged from adding further layers of potential future interest and value', again provided that heritage values are retained (Historic England 2008: 43). And in the United States, *The Secretary of the Interior's Standards for the Treatment of Historic Properties*, in its Rehabilitation Standards, 'acknowledge[s] the need to alter or add to a historic building to meet continuing or new uses while retaining the building's historic character' (Grimmer 2017: 2). But beyond these assertions, it is difficult to find any discussion of how the accommodation of beneficial use, particularly where it forms part of the significance of a building or place, can be managed in practice. Crucially, a narrative approach provides an account of change to historic buildings, and can distinguish this from harm, which the conventional methodology fails to do with any consistency. Indeed, this is congruent with the broader societal point of narrative as a means by which communities and individuals first negotiate change, and, second, account for continuity of identity and the formation of character through such change.

In making the specific link between buildings and narrative, Edward Hollis argues against the dominant assumption that architecture is about perfection, rejoicing instead in buildings whose 'beauty has been generated by their long and unpredictable lives' through successive acts of reinterpretation (Hollis 2010: 11–12). He explores a variety of parallels with other

creative fields such as literature and music, before focusing on the oral trad-ition as one alternative where the creative work and its performance are inseparable. This is indeed a good parallel, in that the development of stories within an oral tradition are iterative in something of the same way as is the development of a historic building. For Hollis, as we saw in Chapter 1, the repeated changes and shifting uses have served to perpetuate the lives of the historic buildings that he considers: change has been their *friend*. In many cases, the historic buildings we now enjoy have survived precisely *because* they have been allowed to flex and change. In the process they have become multi-authored hybrids, whose beauty lies in this very multiplicity of authorship; they are beautiful, at least in part, because of their history of change, because we can read them as narrative.

Another of the principal benefits of a narrative understanding of heri-tage is that it provides a theoretical grounding for the relation of a his-toric building, or part of a building, to its context. For example, a narrative understanding insists that the building cannot be understood without its community, whereas an aesthetic-historical approach is perfectly able to view the building, typically conceived of as an art object, in isolation. Hence Simon Jenkins is able to collect England's thousand best houses, its thou-sand best churches, or Britain's hundred best railway stations and so forth (Jenkins 2004, 2012, 2017). Such exercises, worthwhile as they may be in their own right, tell us little about the meaning of those buildings in the shifting local cultural landscapes within which each sits.

Attention to context, whether cultural or physical, is not a new idea in con-servation theory, practice or legislation, but it is a relatively recent one. True to its roots in antiquarianism, conservation initially focused solely on the individual treasured object/feature/building; Lionel Esher (1981: 72) simi-larly describes a general 'architectural myopia' in post-war Britain, noting how the amenity societies retained a focus on the particular. Welcome as the more recent concern with context undoubtedly is, it is usually restricted to consideration of the physical and visual setting – for example in England and Wales the Planning Act 1990 conceives of the protection of conserva-tion areas in terms of 'character or appearance'. As a result, when viewed from outside the conservation professions, it can seem at times that this broadening into context is used simply to adduce further reasons to oppose change, since other aspects of context beyond the physical and visual are rarely considered. In Chapter 4, cultural embeddedness was noted as one of Stein Olsen's four distinctive features of tradition. Since the proposed narrative approach is rooted in tradition, it enables the treasured building/object to be placed not only in its physical and visual context, but also in its broader ethical and cultural context.

The current values-based conservation orthodoxy attempts to address that context by extending the classes of values to be considered, most notably with the *Burra Charter*'s inclusion of social value from the outset in 1979, and widely adopted elsewhere as discussed in Chapter 3. Within the confines of that system, this is very welcome, and a values-based approach has the further benefit that it can be applied at a variety of scales, from an individual feature to a building to a townscape. Yet a values-based process is inherently atomistic, dividing the whole into smaller and smaller units or 'gobbets' of significance. Furthermore, the results of a values-based approach will always be open to the charge of relativity since it is an inescapably subjective exercise, always requiring the *attachment* of those values to objects by *individuals*, based on that individual's claimed authority. This makes it possible to ascribe high levels of value to almost anything, often employing the well-worn claim that the object in question is 'a very important early example of ...', a strategy that threatens to dissolve into self-parody. By contrast, the boundedness of tradition protects a narrative approach from at least some of this relativity, because of its intergenerational structure. A values-based system always requires someone (an expert) to determine in an act of interpretation which value claims are ranked above which other. The selection and ranking of values to arrive at significance is at every step an act of interpretation; this implicitly acknowledges the need for a hermeneutic approach without offering any guidance, structure or theoretical foundation for it. At the same time, the reliance on expert judgement undercuts the claims of greater public engagement that are made.

What narrative offers, by contrast, is a means of connecting the particular to the cultural whole. In a parallel move, where individuals engage in community, it also allows for the location of what is of worth to those individuals within the *communal* narrative, as, for example, when people show more concern for future generations of the community than for their own preferences. It goes without saying that there will be just as great a need for interpretation, but within the proposed approach this is openly acknowledged and is no longer the sole province of the expert. Instead, since narrative operates within the bounded fluidity of tradition, there is a sense of continuity against which to judge the propriety and credibility of that interpretation. As we saw in Chapter 4, part of the usefulness of tradition is that it provides an intergenerational framework to recognize what 'good' looks like, whether that be good workmanship, good interpretation, or, indeed, good change. For MacIntyre:

> Within a tradition the pursuit of goods extends through generations, sometimes through many generations. [...] Once again the narrative

phenomenon of embedding is crucial: the history of a practice in our time is generally and characteristically embedded in and made intelligible in terms of the larger and longer history of the tradition through which the practice in its present form was conveyed to us.

(MacIntyre 1985: 222)

This is a crucial distinction between the proposed narrative approach and other models that seek to address the deficiencies of the contemporary process using only the resources furnished by modernity and its later variants.

Because of its prominent use in ethics, and its facilitation of the link between part and whole, narrative offers great potential for re-evaluating the ethical and philosophical basis of conservation. In particular it offers modern conservation deliverance from the ahistoricism it inherited from its nineteenth-century roots, and in its place offers an understanding of history that for the first time would wholeheartedly engage with the common contemporary definition of conservation as the process of *managing* change, rather than deploying the processes of conservation to resist change. One could even dare to hope that, where appropriate, conservation professionals might come to rejoice in change as a sign that a historic building retains the vibrant glory of the balanced totality of its 'living heritage', and that its character and significance have thereby been strengthened.

Conclusion

This chapter has suggested that a narrative approach to conservation offers great promise as the foundation of an alternative methodology. Reviewing the assessment of the suitability of the narrative approach to conservation we can identify four principal benefits that address shortcomings in the current values-based approach:

- a narrative approach allows for fuller public participation which does not conceal executive control by the professional, yet without sacrificing everything to the whim of minimal democracy;
- by relating the part to the whole, it is hermeneutically literate, acknowledging the interpretative nature of conservation decision-making, and allowing us to enter a more meaningful dialogue with previous stages of our cultural tradition;
- in directly addressing issues of the development of character through time it provides a means of accounting for change, particularly in 'living' buildings; crucially this therefore prevents change necessarily being interpreted as harm;

- a narrative approach is thus able to provide the (hitherto missing) theoretical justification for much of the recent healthy innovation in conservation approaches, and directly to address the conditions for continuity of character.

Narrative follows the grain of tradition and offers a natural means of engaging with historic buildings as cultural wholes rather than merely as assemblages of parts. It also offers a defence against the relativism implicit within a values-based conservation. The proposed narrative approach is therefore able to overcome some of the limitations and potential abuses of the current methodology. It offers the potential to present heritage in a more accessible manner, resulting in greater public participation and, crucially, ownership in the broadest sense. And it recognizes that buildings themselves have agency, transforming them from their customary minimal status as a backdrop to human action to themselves being characters in the dramatic production that is culture. Narrative therefore offers an alternative and more serviceable theoretical framework for conservation in its next phase of development.

Note

1 The paper was delivered at a colloquium in 1969 in honour of Martin Heidegger's 80th birthday.

References

Augustine ([C5] 2006). *Confessions and Enchiridion*. (A.C. Outler, trans.). Louisville, KY: Westminster John Knox.

Australia ICOMOS (2013). *The Burra Charter: The Australia ICOMOS Charter for Places of Cultural Significance, 2013*. Burwood, Australia: Australia ICOMOS.

Banham, R. (1963). The Embalmed City. *New Statesman*, LXV (1674): 528–530.

Beardsley, M.C. (1958). *Aesthetics: Problems in the Philosophy of Criticism*. New York: Harcourt, Brace & World.

Brand, S. (1994). *How Buildings Learn: What Happens After They're Built*. New York and London: Viking.

Carr, D. (1986). *Time, Narrative, and History*. Bloomington: Indiana University Press.

Carr, D. (2008). Narrative Explanation and Its Malcontents. *History and Theory*, 47 (1): 19–30.

Carroll, N. (1988). Review of Time, Narrative, and History by David Carr. *History and Theory*, 27 (3): 297–306.

Clark, K. (2001). *Informed Conservation: Understanding Historic Buildings and Their Landscapes for Conservation*. London: English Heritage.

Coleridge, S.T. (1965). *Coleridge Poetry and Prose*. Oxford: Clarendon Press.

Crites, S. (1971). The Narrative Quality of Experience. *Journal of the American Academy of Religion*, (39): 291–311.

Davidson, I. & Noble, W. (1993). Tools and Language in Human Evolution. In: K.R. Gibson & T. Ingold (eds.), *Tools, Language and Cognition in Human Evolution*. Cambridge: Cambridge University Press. pp. 363–388.

Dowling, W.C. (2011). *Ricoeur on Time and Narrative: An Introduction to Temps et Récit*. Notre Dame, IN: University of Notre Dame Press.

Esher, L. (1981). *A Broken Wave: The Rebuilding of England 1940–1980*. London: Allen Lane.

Fairclough, G.J. (2002). Archaeologists and the European Landscape Convention. In: G.J. Fairclough & S. Rippon (eds.), *Europe's Cultural Landscape: Archaeologists and the Management of Change*. Brussels: Europae Archaeologiae Consilium. pp. 25–37.

Fisher, S. (forthcoming). Lifespans of Built Structures, Narrativity, and Conservation: Critical Note on Peter Lamarque and Nigel Walter's "The Application of Narrative to the Conservation of Historic Buildings". *Estetika: The European Journal of Aesthetics*, LVII/XIII (1).

Forster, E.M. (1910). *Howards End*. London: Edward Arnold.

Gadamer, H.-G. (1970). Concerning Empty and Ful-Filled Time. *Southern Journal of Philosophy*, 8 (4): 341–353.

Gadamer, H.-G. (1986). *The Relevance of the Beautiful and Other Essays*. (R. Bernasconi, ed., N. Walker, trans.). Cambridge: Cambridge University Press.

Gadamer, H.-G. ([1960] 1989). *Truth and Method*. (J. Weinsheimer & D.G. Marshall, trans.). 2nd rev. ed. London: Sheed and Ward.

Gilchrist, R. (2012). *Medieval Life: Archaeology and the Life Course*. Woodbridge: Boydell Press.

Grimmer, A.E. (2017). *The Secretary of the Interior's Standards for the Treatment of Historic Properties: With Guidelines for Preserving, Rehabilitating, Restoring & Reconstructing Historic Buildings*. Washington, DC: National Park Service.

Hardy, B. (1968). Towards a Poetics of Fiction: 3) An Approach through Narrative. *Novel: A Forum on Fiction*, 2 (1): 5–14.

Heidegger, M. ([1950] 2001). The Origin of the Work of Art. (A. Hofstadter, trans.). In: *Poetry, Language, Thought*. New York: HarperCollins. pp. 15–86.

Heidegger, M. ([1954] 2001). "… Poetically Man Dwells …" (A. Hofstadter, trans.). In: *Poetry, Language, Thought*. New York: HarperCollins. pp. 209–227.

Historic England (2008). *Conservation Principles: Policies and Guidance for the Sustainable Management of the Historic Environment*. London: English Heritage.

Hollis, E. (2010). *The Secret Lives of Buildings: From the Parthenon to the Vegas Strip in Thirteen Stories*. London: Portobello.

Huizinga, J. (1949). *Homo Ludens: A Study of the Play-Element in Culture*. London: Routledge & Kegan Paul.

ICOMOS (1964). *International Charter on the Conservation and Restoration of Monuments and Sites*. Paris: ICOMOS.

Ingold, T. (2013). *Making: Anthropology, Archaeology, Art and Architecture*. Abingdon and New York: Routledge.

Jenkins, M. (2013). *The View from the Street: Housing and Shopping in York during the Long Eighteenth Century*. York: University of York. PhD thesis.

Jenkins, S. (2004). *England's Thousand Best Houses*. London: Penguin.

Jenkins, S. (2012). *England's Thousand Best Churches*. London: Penguin.

Jenkins, S. (2017). *Britain's 100 Best Railway Stations*. London: Viking.

Kaplan, D.M. (2003). *Ricoeur's Critical Theory*. (B. Jenner, trans.). Albany: State University of New York Press.

Lamarque, P. (2014). *The Opacity of Narrative*. London: Rowman & Littlefield International.

Lamarque, P. & Walter, N. (2019). The Application of Narrative to the Conservation of Historic Buildings. *Estetika: The Central European Journal of Aesthetics*, LVI/XII (1): 5–27.

Lifschutz, A. (ed.) (2017). *Loose-Fit Architecture: Designing Buildings for Change*. Architectural Design Profile 249, 87 (5). Oxford: John Wiley & Sons.

Lucas, G. (2006). Historical Archaeology and Time. In: D. Hicks & M.C. Beaudry (eds.), *The Cambridge Companion to Historical Archaeology*. Cambridge: Cambridge University Press. pp. 34–47.

MacIntyre, A.C. (1985). *After Virtue: A Study in Moral Theory*. 3rd ed. London: Duckworth.

Mantel, H. (2017). *Reith Lectures 2017: Lecture 1: The Day Is for Living*. [Online]. Available at: http://downloads.bbc.co.uk/radio4/reith2017/reith_2017_hilary_mantel_lecture%201.pdf.

Mink, L.O. (1970). History and Fiction as Modes of Comprehension. *New Literary History*, 1 (3): 541–558.

Mink, L.O. (1972). Interpretation and Narrative Understanding. *Journal of Philosophy*, 69 (9): 735–737.

Morris, W. ([1877] 2017). *The Society for the Protection of Ancient Buildings Manifesto*. [Online]. Available at: www.spab.org.uk/about-us/spab-manifesto.

Newman, J.H. ([1845] 1909). *An Essay on the Development of Christian Doctrine*. London: Longmans, Green.

Olafson, F.A. (1979). *The Dialectic of Action: A Philosophical Interpretation of History and the Humanities*. Chicago and London: University of Chicago Press.

Poulios, I. (2014). *The Past in the Present: A Living Heritage Approach – Meteora, Greece*. London: Ubiquity Press.

Reagan, C.E. (1996). *Paul Ricoeur: His Life and His Work*. Chicago and London: University of Chicago Press.

Ricoeur, P. (1977). *The Rule of Metaphor: Multi-Disciplinary Studies of the Creation of Meaning in Language*. (R. Czerny, trans.). Toronto: University of Toronto Press.

Ricoeur, P. (1980). Narrative Time. *Critical Inquiry*, 7 (1): 169–190.

Ricoeur, P. (1984). *Time and Narrative, Vol. 1*. (K. McLaughlin & D. Pellauer, trans.). Chicago and London: University of Chicago Press.

Ricoeur, P. (1985). *Time and Narrative, Vol. 2*. (K. McLaughlin & D. Pellauer, trans.). Chicago and London: University of Chicago Press.

Ricoeur, P. (1988). *Time and Narrative, Vol. 3*. (K. Blamey & D. Pellauer, trans.). Chicago and London: University of Chicago Press.

Ricoeur, P. (1991). Narrative Identity. (D. Wood, trans.). In: D. Wood (ed.), *On Paul Ricoeur: Narrative and Interpretation*. London and New York: Routledge. pp. 188–199.

Ricoeur, P. (1992). *Oneself as Another*. (K. Blamey, trans.). Chicago and London: University of Chicago Press.

Riegl, A. ([1903] 1996). The Modern Cult of Monuments: Its Character and Its Origin. (K. Bruckner & K. Williams, trans.). In: N.S. Price, M.K. Talley, & A. Melucco Vaccaro (eds.), *Historical and Philosophical Issues in the Conservation of Cultural Heritage*. Los Angeles, CA: Getty Conservation Institute. pp. 69–83.

Rudd, A. (2009). In Defence of Narrative. *European Journal of Philosophy*, 17 (1): 60–75.

Ruskin, J. ([1849] 1903). The Seven Lamps of Architecture. In: E.T. Cook & A.D.O. Wedderburn (eds.), *The Works of John Ruskin*. London: George Allen.

Strawson, G. (2004). Against Narrativity. *Ratio*, 17 (4): 428–452.

Taylor, C. (1989). *Sources of the Self: The Making of the Modern Identity*. Cambridge, MA: Harvard University Press.

UK Parliament (1943). *HC Deb 28/10/1943 Vol 393 C403*. [Online]. Available at: http://hansard.millbanksystems.com/commons/1943/oct/28/house-of-commons-rebuilding.

Walter, N. & Lamarque, P. (forthcoming). Narrative and Conservation: A Response. *Estetika: the European Journal of Aesthetics*, LVII/XIII (1).

Application

The narrative approach to conservation

There are, however, many questions connected with the treatment of ancient buildings which are far more reasonably open to discussion, and I wish that some really judicious men [sic] would take these, fairly and dispassionately, under consideration.

George Gilbert Scott (1879)

At the end of the first chapter this book was described as circular in structure, starting from a practical question encountered in professional life, travelling in an arc through the current methodology and its associated theory, then considering an alternative body of theory, with the promise of returning to its practical application. This chapter therefore seeks to apply the proposed theoretical approach to twelve specific issues of historic or current concern to conservation practice, most of which featured in the foregoing discussion, grouped under three headings:

- the first group are questions of principle – explanatory competition (how competing narratives can be resolved), the relation of the cultural whole to the parts, continuity of character, and those buildings whose narratives seem to be complete;
- the second group relate to issues of everyday relevance to practitioners – significance, the doctrines of reversibility and expendability, and craftsmanship;
- the third group comprises 'meta-professional' or framing issues – the status of expertise, the status of non-professionals, difficult heritage, and the historical question of restoration, which provided the initial spur for the development of modern conservation.

This choice of 12 topics is not intended to be comprehensive, but instead to suggest the breadth of issues that can be rethought through a narrative-based understanding. The aim has not been to treat these in depth – most

deserve at least a chapter in their own right – but rather to provide a sketch to illustrate what the application of a narrative approach might look like, and the impact it would have on the activity of conservation professionals.

6.1 Questions of principle

Explanatory competition

Anyone can tell a story about a building, and any narrative approach immediately faces the question of how one is supposed to decide between competing accounts. Mirroring Thomas Hardy's 'incompatibles' (Hardy [1906] 1967), the *Nara+20* document recognizes 'that competing values and meanings of heritage may lead to seemingly irreconcilable conflicts' (Japan ICOMOS 2014: para. 4). Where those competing accounts share a similar epistemic approach, consensus might perhaps be achievable, but where those accounts represent a conflict of traditions, agreement is most unlikely. This latter case is a question of (epistemological) incommensurability – that is, the inability to assess the claims of one theory in terms of another, as, for example, in the incompatibility of Newtonian and Aristotelian physics. In heritage and conservation, such a condition of incommensurability applies where Western modernity meets Indigenous cultures, as discussed in Chapter 3, but also within the same culture where the claims of a narrative proposed by a community group have to be assessed against the competing narratives proposed by one or more statutory consultees.

This same issue, of course, afflicts the current values-based system – who is to say that your values take precedence over mine, or vice versa? The current system manages this question by sleight of hand, relying on one or more experts playing a largely unacknowledged editorial role and determining which values should prevail; in terms of public participation – one of the chief benefits claimed for a values-based system – this is highly problematic. Indeed the less than universal uptake of *Conservation Principles* (Historic England 2008) in England perhaps suggests unease with the implications of 'democratizing' heritage on the values-based model. Similar criticisms have been raised of the *Burra Charter* by Waterton et al. (2006), that it provides a show of public participation without altering the fundamental power relations implicit in heritage decision-making. This fundamentally questions the ability of the current methodology to deliver on its promise of public accountability.

This process of explanatory competition is one with which historians are familiar. It is unrealistic to demand that historical explanation be all-encompassing (philosophically speaking, *sufficient*); thus, historians almost

always argue not only *for* the benefits of their own account, but also *against* rival accounts. The aim for the historian when evaluating competing accounts, therefore, 'is not so much the production of truth but the writing of the best story that evidence and argument warrants' (Roberts 2001: 8). In Chapter 4, we have already touched on Alasdair MacIntyre's treatment of this very question of incommensurability. In the context of a discussion of the development of scientific theory, he notes that:

> The criterion of a successful theory is that it enables us to understand its predecessors in a newly intelligible way. It, at one and the same time, enables us to understand precisely why its predecessors have to be rejected or modified and also why, without and before its illumination, past theory could have remained credible. It introduces new standards for evaluating the past. It recasts the narrative which constitutes the continuous reconstruction of the scientific tradition.
>
> (MacIntyre 1977: 460)

This suggests three criteria when rival narratives compete. The first, and most obvious, is to judge which narrative is able to account for the full range of phenomena with the least contortion – that is, which rival is most *comprehensive*. On this measure, most narratives produced by the current conservation methodology are impoverished, lacking as they do an account of how buildings cohere through change, or of the role of local communities in the constitution of heritage. The second criterion is to step back from the individual case being argued, and to judge across the piece which rival is most *coherent*; here, again, conventional explanations fall short, lacking as they do a future dimension. The third and most demanding is to judge which rival can best explain the others *in their own terms*; this requires imagination, deftness, and a willingness to transgress disciplinary boundaries of which conservation discourse rarely seems capable.

This question of explanatory competition has two significant implications. The first is to reveal how unproductive it can be to advocate a particular course of action from a single-issue perspective such as a periodized brief, as, for example, do the majority of the amenity societies in the English system. Almost by definition, if one starts by privileging a single historic episode one is unlikely to deliver a balanced narrative; instead, conservation responses often argue for the retention of some medieval/Georgian/Victorian etc. feature which, it seems with increasing regularity, is judged to be of *exceptional* importance. Arguably, it is unrealistic, even improper, to expect anything else of such 'periodized' groups. But the implication of the narrative model is that such groups would much better fulfil their brief if their consultation

responses properly addressed at least the first criterion of comprehensiveness and the second of narrative coherence. A narrative approach focuses on why the particular feature is important *for the good of the cultural whole*, not just for the narrow interests of one or another favoured period.

The second implication is to expose the inability of the current methodology to evaluate the quality of new design. A narrative approach is as much interested in safeguarding the future as the past in an integrated and coherent temporal whole. This, as was suggested in Chapter 4, requires something like a premodern understanding of tradition. It is commonly observed that it is impossible to judge the importance of works of art or architecture created *de novo* until several generations have passed, and for this reason most systems of statutory protection have a minimum age – in many jurisdictions 30 years – before a building can be considered for inclusion. However, a narrative approach allows an early start to be made on this by locating creativity within a tradition, most pertinently when considering a new intervention in a historic building. By contrast, since it ignores the workings of tradition, the current significance methodology places contemporary creativity at a substantial disadvantage, impoverishing the heritage as a whole in the longer term.

The cultural whole

A narrative understanding is thus resolutely situational, that is, insisting that the part cannot be understood except in the context of the whole, and is all the while concerned with how that whole develops as the parts or chapters of the narrative unfold. A hermeneutic attitude, typical of a working tradition, prioritizes the cultural *questions* from whence it draws its life, rather than the cultural *answers* furnished by analyzing the artefact into pieces. Answers, of course, are safer, more collectible and more biddable, whereas questions are more 'mobile' and 'slippery', and prone to subversive activity such as the production of new meaning. A narrative approach strives to keep in view the cultural whole, in order to retain part and whole, question and answer, in play.

Any building is a highly complex answer to the series of overlapping questions that formed its 'brief', whether or not that brief may ever have been formally or coherently articulated. In the case of a multi-generational building such as a typical medieval English parish church, that set of questions has been elaborated through multiple generations. But if such buildings partake in an ongoing tradition, they additionally bear witness to the larger cultural question addressed in each generation. It is not, as the nineteenth century supposed, that their importance lies in themselves (as resolved

answers) at all, but rather in connecting us to the ongoing question(s) they seek to address. It is in this way, by pointing to the question(s), that historic buildings facilitate continuity. It is when their validity is seen to lie in their status as answers that they risk being cut adrift from their tradition and succumbing to a shadowy half-life as mere objects of veneration.

Following Gadamer, we should expect any form of historical understanding, and by extension decisions about change, to be dialogic, to have the form of a conversation. The implication of this is that we cannot go into this conversation with a fixed understanding of the outcome; that would not be a conversation, since

> the more genuine a conversation is, the less its conduct lies within the will of either partner. Thus a genuine conversation is never the one that we wanted to conduct.
>
> (Gadamer [1960] 1989: 383)

It is noted from the consideration of the *Duffield* judgment in Case study 2 (following Chapter 3) that the current process under the ecclesiastical exemption in England is inherently conversational, bringing together all stakeholders, including the public. This is a conversation in which none of the parties – not the parish, the Diocesan Advisory Committee, Historic England, the Church Buildings Council, the amenity societies nor the concerned public – has a veto. The process demands that this conversation takes place through thorough consultation, with the arguments heard, if necessary, in court. And ultimately it comes down to the chancellor, the judge of that court, to make their judgment on the basis of the balance of harm against public benefit.

Continuity of character

In the context of the preparatory workshop for the Nara Conference in 1994, David Lowenthal (1994: 40–41) used Plutarch's philosophical puzzle of the ship of Theseus (and Thomas Hobbes's modern variation on it) to highlight the tensions between object identity and material authenticity. Truthfulness of character – the conundrum of how people can retain the same character through the changes of life – is the analogue of this within moral philosophy. Character is also of central concern to conservation in the United Kingdom; for example Historic England's *Conservation Principles* makes frequent reference to 'character of place'. In England and Wales, conservation areas are designated under of the Planning Act 1990 (UK Government 1990: sn 69[1]) on the basis of a *character appraisal* of the

area, and declaring 'the desirability of conservation preserving or enhancing' that character (sn 72[1]). Similarly, the Act forbids the demolition or alteration of a listed building 'in any manner which would affect its character as a building of special architectural or historic interest' (sn 7). Interestingly, more recent statutory guidance for England and Wales in the form of the *National Planning Policy Framework* (Ministry of Housing, Communities and Local Government 2019) mentions character only in the sense of local area or landscape character of settlements or coastlines, not the character of buildings.

Stephen Crites compares narrative to music as 'the other cultural form capable of expressing coherence through time' (1971: 294). Working with community organizations one often discovers that such groups have a strong appreciation for their historic building and are determined to preserve its character through the process of change. Indeed, in articulating this, many show a more sophisticated understanding of the way their buildings have changed in the past than may be evident in the contributions of some conservation professionals. Perhaps this results from the fact that community groups will typically have reflected on the character of their building over years, if not decades, whereas professionals are often engaging with the building for the first time, and typically do so on the basis of a predetermined taxonomy of expert criteria. Following Ricoeur's distinction noted in Section 5.2, this suggests two contrasting approaches to continuity: one achieves a *continuity of sameness* through focusing on the fixity of form and material, and the other a *continuity of identity* through a greater degree of (bounded) fluidity. If the second approach is taken, then the question of how those bounds to fluidity are set becomes of primary importance; again following Gadamer, this boundedness is provided by the horizon of tradition. But, as noted in Chapter 1, Appiah (2016) suggests that we must ask the second more disruptive question whether such fluidity is not only typical of but also a *necessary* condition for this continuity of character; this would be the narrative view.

For historic buildings that are no longer used, the preservation of character is, rightly, substantially a question of the preservation of fabric; these we will consider in a moment. Missing from the orthodox methodology is a settled view of how character can endure through the processes of change that inevitably attend historic buildings that are still 'living'. As a result, the methodology remains focused on the fragility of physical fabric and on the minimization, not only of harm, but also of change. It is no surprise therefore that conservation practice usually resolves the tension illustrated by the ship of Theseus puzzle in favour of material authenticity. A narrative approach, based in a less backward-looking temporality, offers

an alternative theoretical grounding for the management of change, while sustaining identity and enriching character.

Completed narratives

There are, of course, some buildings whose narratives have stopped, in the sense that elective change is no longer necessary. One such class of buildings is the historic house museum, where the building itself forms part of the commemoration of a prominent individual, in which case it can be argued that the completed biography is an entirely appropriate narrative genre for describing the building. Monticello, a World Heritage site and the home that third US President Thomas Jefferson designed for himself near Charlottesville, Virginia, offers a good example (Figure 6.1). In such cases, the building is an adjunct to what is usually a reverential commemoration of the individual, and the building helps to ground and fix the place of that individual within a larger (often, as in this case, national) narrative. Just as the official narrative offers little scope for alternative and less honorific accounts, so the previous fluidity of the building has crystallized into a definitive form.

Figure 6.1 Monticello, Virginia: view from west (Photo: Martin Falbisoner – CC BY-SA 3.0)

Other buildings gain the status of a monument, thus leading to the closure of their narrative, after having enjoyed a life of varied change; one such is Independence Hall in Philadelphia (Figure 6.2), another World Heritage site and of the highest significance to US self-understanding. Originally the eighteenth-century colonial, then state, legislature, the building was built by stages and once 'complete' experienced several further episodes of change, including substantial alterations to its tower (Figure 6.3) and the removal and recreation of the wings. The building was the site of the signing of both the American Declaration of Independence and the US Constitution;[1] it is perhaps unsurprising that this building has come to be treated as a completed (and hallowed) monument, despite its history of change. Charlene Mires describes the building as a 'workshop for constructing and defending national identity', the more necessary for Americans as more time passes since

Figure 6.2 Independence Hall, Philadelphia: view from south (Public domain – CC0)

Figure 6.3 Independence Hall, Philadelphia: 'Back of the State House, Philadelphia' from *Birch's Views*, 1799 (Public Domain – PD-US)

their nation's founding (Mires 2002: xviii). Mires cites a 1959 Park Service study which describes the building's history as 'tremendously complicated', but adding that 'The concept of Independence Hall as a Shrine simplifies the interpretive problem' (Mires 2002: 231). This provides an overt acknow-ledgement of the relation between the sacralization of physical heritage and the editorial suppression of some aspects of the building's narrative – in this case, for example, as a place of protest for women's suffrage or civil rights – through simplification of its narrative.

However, these examples of apparently completed narratives are more the exception than the rule. Even in these cases, I would argue that a partial (backward-facing, biographical) narrative is helpful in understanding the history and contemporary salience of the building. Indeed, understanding that what is presented in/by these buildings is an account that has inevit-ably involved editorial selection and curation should alert us that other, less authorized stories could also have been told. As long as there remains a will-ingness to pay for their upkeep, these buildings can be expected to endure

in their current condition of stasis, at least until such time as the authorized narrative of the individual (and/or perhaps the nation) is rewritten, for example by political revolution. I would argue, therefore, that such buildings always retain the potential for future change through the reinvigoration of their narrative, even if their status and character is fixed for the time being. Rather than being completed narratives, perhaps we should rather see them as suspended until further notice, since even here there is the possibility of future development.

6.2 Questions of everyday practice

Significance

Despite protestations to the contrary, significance – so central to current conservation methodology – tends to be conceived of as more fixed than dynamic. In so far as it changes, it risks becoming inflationary and hyperbolic, with the danger that *everything* is classed as highly significant. But this is self-defeating, because the system must involve prioritization: if everything is important, then nothing is. Related to this is the secular tendency to treat the old/aesthetic as sacred, in the now well-trodden path from beauty to the beatification. Each of these aspects serves to undermine the current methodology and, potentially at least, is extremely harmful to heritage. MacIntyre's insistence, discussed in the previous chapter, that the meaning of the individual act/event/decision can only be understood if related to the narrative whole has three important consequences that help shape a more robust understanding of significance.

First, as repeatedly stated, a narrative approach underlines the importance of context. This of course is in line with modern conservation practice but, rather than being merely one additional aspect of significance to add to the pile, this 'narrative context' has the power to recalibrate everything else. A narrative approach suggests that the current understanding of significance as an assemblage of values is an inversion of what should be the priority of the cultural whole. This privileging of the cultural whole is consistent both with Eliot's understanding of tradition, and Gadamer's treatment of horizon, both discussed in Chapter 4.

Given that a lived narrative is by nature ongoing, a second consequence is that any such assessment of meaning must be provisional. Again, current practice recognizes this in principle, but only in the sense of an additive model of significance, which does not readily permit the re-evaluation of existing knowledge in light of the new. The implication of a narrative approach is that the importance of the Scott or Comper intervention in an

English church does not principally stem from the name (as it would in a 'Great Man' understanding of significance) but is always open to reappraisal on the basis of further and as yet unwritten chapters in the narrative. This is no different from the unfolding of a literary narrative, in which the hero may subsequently be revealed as the villain, or vice versa. Certainly this can be seen as 'unsettling', but the concern that it lays conservation open to rampant relativism is misplaced; given that a narrative understanding insists on the best possible understanding of the story to date, a wholesale re-evaluation of significance would be the exception rather than the rule. Furthermore, to be credible, such a change cannot be arbitrary; indeed the validity of such a reappraisal rests on it providing a *better* interpretation of the story to date, as touched on in the discussion of explanatory competition earlier. But it is an inescapable aspect of a *living* cultural tradition that such a re-evaluation must always be possible. In this sense, it is indeed the case that 'nothing is sacred' in terms of the way we account for the meaning of things, a conclusion that will be difficult for some professionals to countenance.

A third consequence is that, from a narrative point of view, the most interesting and valuable buildings are not the oldest, nor the least altered, nor those associated with the most interesting names. The most valuable are not even those with the most interesting narrative to date. Rather, they are those that combine the richest narrative to date with the most potential for future development of that narrative. If our aim is to create a system that safeguards the long-term health of the building as an intergenerational cultural whole, and to pass on to future generations a richer cultural legacy than we inherited, then the current understanding of significance with its inevitable bias towards the past is inadequate and unserviceable.

One particularly moving example of the indeterminate but non-arbitrary nature of significance, and the possibility of its enrichment in the narrative mode, is offered by All Saints' Church in Fleet, Hampshire. In 2015, this grade II* Victorian building was gutted in an arson attack which destroyed the roof and most of the fittings, leaving the brickwork walls and ceiling ribs intact (Figure 6.4). Extraordinarily, the altar survived, charred but retaining its finely carved detail (Figure 6.5). The building will be rebuilt and will live again. But having been so badly damaged, most of the altar's significance under a conventional conservation appraisal has been lost. However, while not denying the loss, a narrative approach sees that in its survival – in literally passing through the fire – the altar's meaning has also been *enriched*. Indeed, the narrativist claim is that, much as one would wish the fire never to have happened, the meaning borne by the altar in its current form and

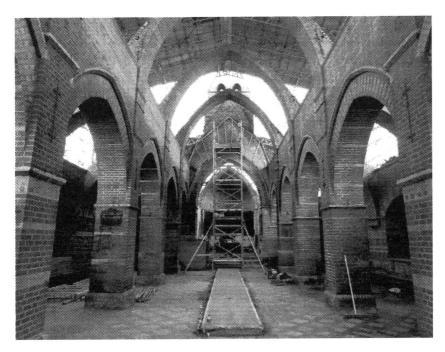

Figure 6.4 Church of All Saints, Fleet, Hampshire: general view of the gutted interior (2017)

Figure 6.5 Church of All Saints, Fleet, Hampshire: detail of altar (2017)

context is now *greater* than it was before, perhaps greater even than it would have been had it somehow survived the fire unscathed. The altar itself now embodies the trauma (importantly, to both building and community) of the fire, and its religious significance, to extend the metaphor, has been refined.

There is now the enticing possibility that the altar will be used as the focus of worship within the reconstructed church as a profound theological symbol of redemption and resurrection, speaking poetically both of destruction and of Christian hope. While that enhanced significance might be legible in outline from within a secular universalist conservation approach – not least because we all recognize loss and death – only by drawing on the resources of the host tradition can the abundance of meaning emerge. It is only those responsible for the building, if they are rooted in their tradition, who are able to uncover the latent riches of their particular narrative.

Reversibility

Reversibility is the conservation principle that, where possible, interventions should be designed to be subsequently removable leaving no indication of their having been there. The *Burra Charter* states that 'Reversible changes should be considered temporary. Non-reversible change should only be used as a last resort ...' (Australia ICOMOS 2013: note to Art. 15). The doctrine of reversibility first appears in the *Burra Charter* in the major 1999 revision in the context of change, remaining unaltered in the 2013 revision. Here, it is 'changes which reduce cultural significance' which should not only be reversible, but actually be reversed 'when circumstances permit' (Australia ICOMOS 2013: Art. 15.2). Presumably this constraint diminishes in impact if significance can be enhanced; but that is clearly not envisaged here. Historic England, meanwhile, is more cautious, speaking of 'the potential reversibility of changes' (2008: 46). Reversibility can be a good discipline for conservation practitioners, but it is always a question of degree, of leaving options for the future (Petzet 2009: 40). A narrative approach embraces reversibility in this pragmatic sense but views a doctrinaire reversibility with suspicion, principally because the latter is a denial of temporality.

As discussed, the irreversibility of change in the loss of historical material was one of the key objections in the nineteenth-century battle against restoration. Reversibility may be feasible in a literal sense, in that it is often possible to design an intervention in a historic building in such a way that it can be removed leaving little or no trace. It could be argued that reversibility suits a narrative approach, since a future generation can remove our contribution and return the narrative to the same point at which we intervened, and there will be times at which this will indeed be appropriate.

But if adopted as a universal principle, everything done hereafter remains provisional, and cannot therefore advance the narrative in the way that a traditionary understanding expects.

And what do we gain by putting the current contribution in parenthesis in this way? Is it not precisely the indelible traces of previous change that give a historic building such as a medieval church its interest? Reversibility is predicated on the same radical historical discontinuity espoused by William Morris, but even in Morris's own terms it cannot succeed, since any slavishly reversible intervention is change of a sort that still fails to 'leave history in the gap'. By deliberately not leaving one's mark, reversibility is a means of avoiding commitment, and there are few forms of cultural production in which avoidance of commitment is a virtue. Future generations will, I suggest, marvel at our timidity.

To return again to a literary example, a coherent novel cannot be written if all options are kept open; the fact that an author might confound the reader's expectations by subsequently reversing what was felt to be an earlier commitment merely underlines the need for such commitments. Perhaps it is truer to suggest that this avoidance of commitment is an indication that many modern interventions address functional needs without any feel for the cultural content of the building, or for the narrative that carries that cultural content. If a merely functional modern intervention floats detached from the building's narrative in this way, then perhaps its reversibility is both justifiable and desirable. But in the context of the cultural whole, such paucity of ambition is indefensible; reversibility is the direct product of modernity's belief in the discontinuity of history, making the absence of history 'left in the gap' an inevitability. In this light, reversibility can be viewed as an ahistorical failure to engage with the building and its ongoing development.

Clearly some changes should be regarded as provisional, since experimentation is also part of being 'living', in which case reversibility is appropriate. A common example of this in English parish churches is the removal of church furnishings under an archdeacon's licence for temporary minor reordering, a mechanism with no equivalent under secular legislation, which avoids the need for formal consultation but comes with strict criteria, including being time limited. In practice, however, most interventions to historic buildings are more permanent in nature and are intended to make some form of contribution to the narrative of the building. In these circumstances, reversibility, which often increases costs, is a convoluted means of making permanent change less unpalatable to those permission givers who lack the means of judging 'good' change from 'bad'; therein lies a fundamental dishonesty.

Expendability

Related to this is a third question of everyday practice concerning the loss of historic fabric. A narrative approach recognizes the need to look forwards as well as backwards and is concerned with the creation of heritage future as much as the management of heritage past. To look forwards means actively to nurture the conditions for contemporary creativity, very much including, where appropriate, change to existing historic buildings. Creativity is, and always has been, in part destructive, and certainly this was the way in which medieval builders, for example, seem to have worked. Because a narrative approach prioritizes community and the enhancement of 'social value' – that is, the breadth and depth of social connections with and within a historic building – it should be no surprise when at times it is necessary for elements of the old to make way for the new, to accommodate fresh creativity. As Rodney Harrison argues, heritage, like remembering, 'is an active process of cultivating and pruning', and that 'without closer attention to processes by which heritage might be deaccessioned or actively removed [...] we risk being overwhelmed by memory and, in the process, making all heritage worthless' (2013: 231).

One implication of a 'living heritage' that balances buildings and people is not only that a historic building should be used but more controversially it is not a disaster if its historic material is *used up*. As Keith Emerick suggests, drawing on Cornelius Holtorf's article 'Can less be more?' (Holtorf 2006):

> in using social value we have to accept that it can, and should, outrank evidential value where necessary. [...] Perhaps cultural heritage managers, as both legislators and interpreters, should accept that they are just one of a variety of stakeholders, take a deep breath and say 'this time we are going to record whatever, *and let it go*' and it may be found that the social value – the connections that develop about and around a place – are a more than equal exchange and are the qualities that give a place life, meanings and a future.
>
> (Emerick 2014: 221, emphasis added)

Interestingly, Emerick goes on to place narrative in the relationship between the communal and the material: 'quite simply we need to build the link between people, story and place and once that is understood and in place then solutions will be easier to find' (2014: 230). The stronger claim of the narrative approach is that the evident tension between the claims of material-based and communal-based heritage is unresolvable *except* in the context of narrative.

Emerick's experience is primarily of historic monuments, but his view that some should be left to 'die' gracefully is also applicable in principle to historic buildings, and particularly to parts of buildings, for example in the removal of a section of medieval wall to create a new doorway. There is often substantial opposition to alterations of this type, simply on the basis that it involves the loss of some medieval fabric. A narrative understanding sees that to preserve at any cost – in this case perhaps at the cost of the narrative coherence of the building as a whole – is foolhardy. This too is a question of context: like several other European countries, England has an abundance of medieval walling, where many other areas of the world do not.

The particular case of historic buildings purchased from the Old World and transported to the New World is an example of the creation of rarity value; but at the same time those transposed buildings become something else as, for example, in the case of the 1830s London Bridge, relocated in the 1960s to Lake Havasu City in the Arizona desert. In the process of transposition such buildings are detached from the original context which gave them birth and life; they may become a dead monument, perhaps literally a museum exhibit in an open-air museum such as St Fagans in South Wales or Skansen in Sweden, and for such a case the preservation of the existing fabric will rightly become the overriding concern. It is interesting to note that in the late nineteenth century the Society for the Protection of Ancient Buildings (SPAB) successfully campaigned against the sale and likely export of the Cloister of the Carmelites at Pont-l'Abbé-Finisterre, Brittany (Tschudi-Madsen 1976: 95–96), an early example of their campaigning beyond the confines of the United Kingdom.

It is also worth noting that alterations to historic fabric, precisely because they involve some disassembly, can deliver archaeological dividends that enrich the narrative in other ways. For example, at Wymondham Abbey (discussed in Chapter 3) the controversial reopening of an arch blocked as part of the feud between the parish and the monks resulted in the discovery in the jamb of the opening of a mason's incised, scaled design for a gable with window tracery (Freeland 2016: 11). This has enriched our understanding at both local and national levels and has made a significant contribution to the contemporary interpretation of the building.

Craftsmanship

Traditional craft skills are a staple of conservation practice for the obvious reason that without people to work with traditional materials in traditional ways it becomes impossible to maintain traditional buildings. Those skills are threatened by an increasingly mobile modernity, and there is rightly a

great deal of focus on keeping these skills alive and passing them on to future generations. Craft skills also fit firmly within the category of traditional knowledge which has become a central concern of intangible heritage: hence 'traditional craftsmanship' is one of five domains identified in the Convention for the Safeguarding of the Intangible Cultural Heritage (CSICH) (UNESCO 2003: Art. 2.2). It is notable that Frank Hassard focuses on the craftsmanship aspect of intangible heritage, arguing that intangible heritage is sustained by 'the pre-industrial, historically transcendent craft-based perspective' (Hassard 2009: 282) and on that basis claims Ruskin and Morris as prototypical for the intangible heritage cause.

A central concern for Morris was the revival of craft skills, which he saw not only as indispensable to the creation of objects of beauty and true utility, but also as an essential aspect of human fulfilment. Morris distinguished craftsmen – 'makers of things by their own free will' – from workmen, who to their employers are merely 'a part of the machinery of the workshop or the factory', and intriguingly describing the latter as 'without any metaphor at all' (Morris [1915] 2012: 88–89). As touched on in Chapter 2, it was because medieval churches were to Morris the product of freely given labour that he was motivated to establish SPAB to oppose their restoration. In this, as in much else, Morris was building on Ruskin, who was sickened by the excesses of industrial production and its social costs and who saw in craftsmanship a means of reintegrating material practices within a healthier society.

Trevor Marchand, in a review of traditional building practices in Mali and Yemen, suggests a more fundamental role for craft skills:

> The contemporary traditional builder, through his apprenticeship, is inculcated with the technical and social knowledge necessary for innovatively responding to change while simultaneously reproducing a discourse of locality, continuity, and tradition. In short, it is this expertise that sustains a sense of place.
>
> (Marchand 2003: 155)

He adds that Western conservation processes can themselves incapacitate traditional craftsmen and communities, resulting in the loss of their heritage. On this view, craft skills are therefore more than just a resource; they also represent a fundamental challenge to the epistemological foundations of modern conservation. Craftsmanship challenges the assumption, deep-rooted within conservation, that if we get the process right then all else will follow. It does this because, as Tim Ingold and others have argued, making is a form of knowing; craftsmanship represents a knowing with our hands.

It is an example of what Michael Polanyi, recognizing 'the fact that *we can know more than we can tell*' (Polanyi 2009: 4, emphasis original), referred to as the 'tacit dimension' of knowledge, which is personal and local, and to be contrasted with the public and replicable 'explicit knowledge' of modern science.

In his book *The Craftsman*, Richard Sennett helpfully distinguishes between two forms of expertise, the sociable and the antisocial (Sennett 2009: 246–252); what he terms 'well-crafted' institutions favour the former and are characterized by good practices:

> The well-crafted organization will focus on whole human beings in time, it will encourage mentoring, and it will demand standards framed in the language that any person in the organization might understand.
>
> (Sennett 2009: 249)

We might paraphrase Sennett by adding that social expertise in conservation would similarly focus on whole buildings in time – that is, advancing an account of multi-phase buildings as coherent wholes developing through time, rather than as dismembered assemblages of parts where no further change is anticipated. Following Sennett, therefore, for all its interest in craftsmanship, conservation is in urgent need of itself being re-crafted. Because craftsmanship is always placed somewhere specific, it challenges the claims to universality which are the stock-in-trade of conservation. Because craftsmanship has an understanding of tradition at its centre, it offers a means by which conservation might engage with the non-modern understanding of tradition explored in Chapter 4. Rather than follow Ruskin in treating craft as primarily concerned with individual workmanship – though of course it is that – it will be by treating the whole process of conservation *as a craft* that we might perhaps address the democratic deficit outlined in Chapter 3.

6.3 Questions of meta-practice

'Who needs experts?'

As discussed in Chapter 3, the role of the expert is currently a contested one (Schofield 2014); as we know, this is an issue not only for heritage, but also within a wider political context. Within conservation, a narrative understanding has substantial implications for the role of the expert, and this will be a cause of concern for some professionals. If a professional's role is understood to include the right to determine outcomes, that is, to act as a gatekeeper in the decision-making process, then we should expect a

catastrophic loss of authority. In this, Sennett's distinction above is helpful; it is only those whose expertise is held 'antisocially' who need be concerned. The argument from a narrative viewpoint is that this realignment offers a welcome corrective.

Ricoeur (1991: 26) suggested that 'the sense or the significance of a narrative stems from the intersection of the world of the text and the world of the reader'. In a built-heritage context, that suggests that the meaning of a building comes from the interplay between the 'text' of the building and its 'readers', foremost among them the community which formed the building in the first place and which in turn it continues to form. Until recently it was deemed sufficient for the expert to be concerned only with 'the world of the text'; now we find ourselves at a crossroads, thrust into precisely that busy 'intersection'. Poulios (2015: 174) judges conservation professionals to be faced with just such a choice, between a reinforcement of their current role and seeking a new and more challenging one that is less conventionally authoritative but more supportive, and in the process redefining the purpose of conservation. His comments are made specifically in the context of the *Nara+20* document and an understanding of living heritage that is continually created. In the same journal issue, Aylin Orbaşli (2015) sees in *Nara+20* an implicit diminishing of the role of the conservation expert because of its emphasis on wider stakeholder involvement.

Common to both a virtue ethics approach and Gadamer's understanding of application as integral to understanding is the Aristotelian notion, from Book VI of the *Nicomachean Ethics*, of *phronesis* (practical wisdom, in Latin *prudentia*). Under a narrative approach, expert knowledge cannot exist in isolation but must be rooted in practice, and application is understood to be essential to understanding. Kinsella and Pitman (2012) consider *phronesis* as a means of exploring a non-instrumentalized form of professional knowledge in education and related fields; a parallel investigation, combining the respective expertise of professionals, craftsmen and core communities to create a professionalism of practical experience, would be transformative for conservation. The role of the professional is an essential aspect of modernity and, once we draw on the resources of premodernity, we can expect this to be renegotiated. The point is not that excellent examples of professionalism of the sort described do not already exist in conservation, but once again that this good practice lacks the support of an adequate theoretical foundation, to significant effect.

A narrative approach does not dispense with the expert's knowledge and experience; arguably they become more central than ever. However, in the narrative model, that knowledge must be placed in a wider context: there is loss in the giving up of absolutes, and gain in increased relatedness,

accessibility and application, or, in Latour's terms, less purity and more hybridity (Latour 1993). The United Kingdom has a decentralized system for the care of historic buildings: maintenance and upkeep is the responsibility of the building's owners, with the State's role limited to providing the legislative framework and some grant funding; this, of course, is in contrast to many other jurisdictions. One example in the United Kingdom of an enduring localism is that for many centuries minor work to rural church buildings was carried out by surplus farm labour out of season, but in more recent times, particularly after the widespread and detrimental application of cement mortar, this is generally discouraged. As a result, many conservation professionals (including architects) deter church communities from undertaking minor repairs. The narrative view, and my own practice as a church architect, is to encourage those communities to resume this traditional practice; it is much preferable for churches to talk to their professional advisor to agree whether they can address an issue themselves, with guidance as appropriate. Not only does this de-professionalize some items of work, it means that the building is better maintained and, crucially, it helps restore to the local community a sense of ownership through active engagement. The recent 'Maintenance Cooperatives' project and the earlier 'Faith in Maintenance' developed by SPAB offer successful examples of working in this same spirit.

This adjustment to a different form of professionalism may make substantial demands of both conservation professionals and communities alike in reassessing the role of expert knowledge and experience. The expert must be willing to play by the new rules and learn to work through facilitation instead of diktat; but, once again, this is an extension of current best practice. Hence Siân Jones describes the 'collaborative co-production' appropriate for addressing social value:

> the attribution of expertise, whilst still important, is de-centred and distributed, with professionals and community participants being recognized for their different kinds of knowledge and skilled practice.
>
> (Jones 2017: 28)

Under the narrative approach, the expert still has authority, but this must be earned (as true authority always is) rather than imposed; and it will stem not from rank but from their contribution to cohering, informing and enriching the community's narrative. As well as holding knowledge, the expert becomes an enabler, a shift that demands substantial cultural change for all involved. Once again, this denotes Sennett's 'social' form of expertise, as against the 'antisocial'.

While Schofield's concern is with the role of the expert in heritage, there is an overlapping but non-identical set of issues in the creation of new work. The implication of a narrative approach for architects, as for any designer, will be to move from focusing on individual authorship to facilitating community. This echoes the concerns of the community architecture movement of the 1980s, whose impact is still felt in the community planning methodology (Wates 1987, 2014). This has application not only in the present, but because narrative accommodates future change, this will include anticipating, indeed enabling, future change to one's own creations. How readily this is accepted will depend on the architect's self-understanding: if they see their design work as a memorial securing their reputation in perpetuity, then subsequent change diminishes that legacy and necessarily equates to harm. But if architects can see themselves as facilitating the creation and development of community within a narrative approach, then for a future generation to obstruct well-managed change on the basis of the architect's celebrity or skill would be a travesty of authorial intention.

People power

If conservation is to remain effective in its care of the historic environment, it will need to embrace meaningful public participation. The fear shared by many heritage professionals that public participation entails a descent into relativism is equally applicable under a narrative approach. Here narrative's fundamentally communal nature is a significant asset. Communal narrative is an expression of grass roots democracy, and therefore lacks the democratic deficit that afflicts conventional expert-focused processes. On a traditionary understanding, this democratic characteristic extends beyond the present to give a voice to past iterations of a community; as noted above, G.K. Chesterton (1908: 82–83) described tradition as 'democracy extended through time. [...] It is the democracy of the dead.'

This is not democracy understood as individual expressions of opinion aggregated into the choice of the majority; rather, it concerns the constitution of community. This is as much of a challenge for postmodernity as for modernity, since both prioritize the individual over the communal. In building terms, narrative certainly provides a means to articulate 'my story', for example through my involvement with a building, whether private or public; such a form of narrative provides a powerful means of experiencing the past, affording a framework for individual engagement with the historic environment on the basis of personal biography. But of greater interest is the claim of an essentially communal aspect to narrative (Ricoeur 1980; Carr 1986). Beyond our concerns as individuals, a narrative framework provides a structure within which to discover 'our story' – that is, the narrative of the

community. It is not suggested that discovering that shared narrative will be easy in an age of individualism, but at least narrative, rightly understood, provides a framework within which such discussions can take place.

Finally, and perhaps most obviously, narrative has the great virtue of being a well-understood genre, so much so that we rarely consider all of the multiple narratives with which we engage in the course of our day-to-day lives. Whether or not one argues that narrative is fundamental to our humanity, that we are 'hard-wired' for it, it is enough for the present purpose to observe that narrative *works*: as the cliché goes, 'everyone loves a good story'. My own interest in narrative stems from discovering in the course of architectural practice that talking in narrative terms enables many non-professionals to engage with the historic building they use, and for which they are responsible, in a new way and perhaps for the first time. This engagement is far greater than when the discussion is restricted to the dissection of a form of significance assembled from discrete values. And this applies across a broader demographic, since a narrative approach is as much concerned with embracing the future as it is with honouring the past. In this way, heritage becomes something of greater relevance to younger people, a typically under-represented group in terms of heritage engagement.

Difficult heritage

How might a narrative approach help us address the particular challenges of 'difficult heritage', the term coined by Sharon Macdonald to describe heritage that is 'contested and awkward for public reconciliation with a positive, self-affirming contemporary identity' (Macdonald 2009: 1). Macdonald's book of that name considers the legacy of Nazi heritage in Nuremberg, Germany, and the contrasting ways in which the city's recent past has been acknowledged or disowned. Nuremberg had been of great importance within the Holy Roman Empire, and as part of their co-option of history the National Socialists designated it one of five Führerstädte; here, vast annual party rallies were held in the newly constructed parade grounds on the outskirts of the city. The Congress Hall, part of this enormous site, is the largest surviving building of the Nazi era; it was designed as a horseshoe-shaped masonry perimeter – its façade overtly referencing the Roman Colosseum – which was to enclose a huge central hall, whose roof was never constructed. What should one do with such a building – vast and undoubtedly important but also of dubious origin and purpose?

The site, of such importance to the Nazi Party, presented a seemingly intractable problem for post-war German identity. One obvious response was demolition, as proposed in 1963 by the Association of German Architects on the grounds of a moral responsibility to sacrifice 'this represen-tation of a crazed dictatorship' (Macdonald 2009: 73); this proposal was

never implemented. The site was listed in the mid-1970s, and over the years a number of alternative uses were accommodated, including storage for towed away cars, rehearsal rooms and a recording studio for the Nuremberg Symphony Orchestra, and an open-air concert hall in the courtyard of the southern wing. In 1987 a more substantial proposal was made for conversion into a shopping and leisure centre, against which Michael Petzet, then chief conservator of the Bavarian Conservation Department argued strongly, suggesting that the building should instead be left unused as a *Mahnmal* or warning sign (as opposed to a *Denkmal* – monument) to the 'gigantomania' of National Socialism (Macdonald 2009: 95).

A new use has now been added to the building, with the creation in the north wing of the Dokumentationszentrum, including its permanent 'Fascination and Terror' exhibition and education space for the study of Nazism (Museen der Stadt Nürnberg 2019). The scheme, by Austrian architect Günther Domenig, opened in 2001 and provides an example of a building repurposed through a bold architectural insertion, reinventing it and radically changing its identity while incorporating and extending the previous narrative. The most visible symbol of this new narrative is the rooftop extension housing the Education Forum which cantilevers over the corner entrance (Figure 6.6); a 'stake' in the form of the entrance stair

Figure 6.6 Dokumentationszentrum, Nuremberg: external view of entrance

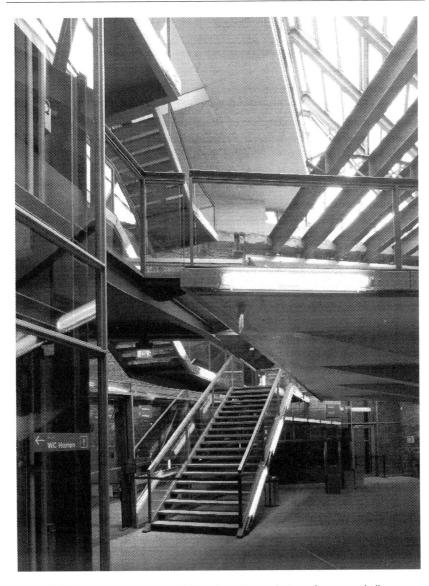

Figure 6.7 Dokumentationszentrum, Nuremberg: internal view of entrance hall

and canopy pierces the northern corner and passes all the way through the building to the vast courtyard to the rear (Figures 6.7 and 6.8).

In narrative terms, Domenig's intervention treats the original building as a canvas against which a new and different story is told, one with redemptive intent. Much is made in architectural terms of the juxtaposition of new and old, most obviously by exploiting contrasts of geometry and materials. One might say that the former narrative – quite literally of world domination – is

Figure 6.8 Dokumentationszentrum, Nuremberg: the 'stake' emerging into the inner courtyard

challenged and subverted in a way that enables this undeniably important but still painful part of German history to be incorporated into a contemporary understanding. It is an excellent example of the palimpsest, an overwriting of the original with a new story that nevertheless makes comprehensive use of the original material. As Mélanie van der Hoorn (2002) notes in a thoughtful architectural review of the building, Domenig's scheme opens the building up, transforming it itself into part of the exhibition; this is a similar result to that achieved in very different circumstances by Carlo Scarpa in the Castelvecchio (case study, Chapter 2).

Given its sheer size and particular form, the Congress Hall provides scope, perhaps uniquely, for a number of further reinterpretations – of the sort that we can expect to follow in future generations – to coexist side by side; such a series of alterations themselves might compose a museologically

rich developmental cultural story. But this is only possible because of the scale and redundancy of the original building; this therefore would be the exception that proves the rule that each chapter in the narrative of a historic building is more normally interwoven with previous chapters.

Restoration

As outlined in Chapter 2, it was opposition to the nineteenth-century restoration of historic churches that led William Morris and others to establish the Society for the Protection of Ancient Buildings, which was foundational for the development of modern conservation both within the United Kingdom and beyond. A narrative understanding would follow Ruskin and Morris in their condemnation of the excesses of nineteenth-century restoration; but it would do so on different grounds, and at the same time allow a more positive assessment of other work of the period.

A narrative understanding does not take exception to the fact that a historic building is changed; the issue is how well the changes align with the grain of the narrative to date. The concern for the narrativist is that in being restored, the building is 'restoried' – that is, too much of the narrative to date is ignored, overwritten by a new and potentially unrelated story. As discussed in Chapter 2, restoration was problematic because of two distinct sets of practices – the first was the re-tooling of old stonework to conceal the effects of the passage of time, and the second was the imposition of the deep-seated principle of *l'unité de style*, the 'correction' of the building into a single style. The result of both is that previous chapters are effaced and wilfully overwritten, losing the subtleties of layering, the eccentricities of character. In extremis we are asked not just to suspend our disbelief, but to enter a world of make-believe, as when the full-blooded folk tale is 'Disneyfied' into the sanitized fairy story. The crime associated with restoration is thus not directly to do with change as such, but with a 'dumbing down', a thinning out of character, a dressing up in historical garb and the loss of whole chapters of the story to date. The crime of restoration is not change, but revisionism.

It is instructive at this juncture to compare William Morris with Max Dvořák, in particular the latter's *Conservation Catechism*, now 100 years old (Dvořák [1916] 2012). As Miele (2005: 57) demonstrates, Morris's approach was ideological and utopian; he saw historic buildings as testaments to what unalienated human labour could achieve. Dvořák was equally opposed to restoration, which he described as 'stylistic dogmatism' ([1916] 2012: 393), not because he wished to use historic buildings for ideological ends, but

because he saw their complex layering and juxtapositions – such as the Baroque altar in the Gothic church – as essential to their character:

> Churches or other buildings, streets and squares which have gradually attained their artistic character and have retained it over the course of time, a character consisting of different stylistic elements – such things can be compared to beings with souls. But they lose all life and attraction and become boring pattern-book examples when the violence of stylistic unification is visited upon them.
>
> (Dvořák [1916] 2012: 395)

While not explicitly concerned with the creation of new work in historic settings, Dvořák's approach is much more compatible with living buildings and a narrative-based concern with future heritage. It should also be noted in passing that this *Conservation Catechism* was principally addressed to the educated public, rather than to a professional audience, another indication of the suitability of this approach for engaging with non-expert audiences.

6.4 Compatibility with tradition

As a preliminary stage in the earlier exploration of tradition, the beginning of Chapter 4 considered four aspects of tradition that for Stein Olsen (2016: 158–160) serve to distinguish it from the more modern notion of a canon of cultural works: first, that it is concerned with practices and with continuity; second, that it is often marked by anonymous and collective cultural production; third, that it is developmental; and, finally, that it is culturally embedded. This chapter concludes by returning to those distinctions in light of the discussion of the preceding questions of conservation practice, in order to reflect again on the relation of tradition to a narrative approach to conservation.

An obvious, first observation is that the care of historic buildings constitutes a complex series of practices; in this sense conservation from its outset has been intensely *practical*, something which helps distinguish it from the earlier antiquarianism from which it developed. The first of Olsen's four points is that tradition and practice are closely aligned, a conjunction which, together with narrative, we have seen was highlighted by MacIntyre (1985). From this one would expect to find a ready fit between the concerns of conservation and a narrative- and tradition-based approach at the level of its practices; many of the examples of conservation issues touched on above demonstrate that compatibility in principle.

Olsen's second point is that 'tradition has continuity'; it was added, in the context of historic buildings, that this continuity is intergenerational, resulting in a richer landscape of reference. The second and third issues in the first section of this chapter explicitly address questions of continuity, in terms of the continuity of character and the relation of the cultural whole to its parts. This intergenerational continuity is essential for recognizing good practice, thus addressing the key concern that, if living buildings are to be allowed to change, then on what grounds are conservation professionals and others to distinguish good change from bad.

The third of Olsen's points is that tradition is often marked by anonymous and collective cultural production, which featured heavily in the third group of 'meta-professional' issues discussed earlier concerning the status of expertise and the place accorded to non-professionals. The related notion that tradition is developmental is reflected in the second section, particularly in the questions of reversibility and expendability, but also in the tacit knowledge that is foundational for craftsmanship.

Olsen's final point relating to the cultural embeddedness of tradition is relevant across the board for the historic environment, and in two senses. First, topographically, a building is necessarily rooted to a specific site and location, something increasingly well understood by heritage professionals. Second, in a more general sense, a cultural situatedness runs through the entirety of this section, though the repeated evidence of working with community groups is that this is often neglected within the current methodology. The case study with which this chapter concludes addresses this aspect of cultural embeddedness and illustrates how the culture of conservation might change if it were to take the status of living buildings seriously.

Note

1 In 1915, it was also the site of the formation of the League to Enforce Peace, a forerunner of the United Nations.

References

Appiah, K.A. (2016). *Reith Lectures 2016: Lecture 1: Creed.* [Online]. Available at: http://downloads.bbc.co.uk/radio4/transcripts/2016_reith1_Appiah_Mistaken_Identies_Creed.pdf.

Australia ICOMOS (2013). *The Burra Charter: The Australia ICOMOS Charter for Places of Cultural Significance, 2013.* Burwood, Australia: Australia ICOMOS.

Carr, D. (1986). *Time, Narrative, and History.* Bloomington: Indiana University Press.

Chesterton, G.K. (1908). *Orthodoxy.* New York: Dodd, Mead & Co.

Crites, S. (1971). The Narrative Quality of Experience. *Journal of the American Academy of Religion*, (39): 291–311.

Dvořák, M. ([1916] 2012). The Conservation Catechism. (J. Blower, trans.). In: J. Blower *The Monument Question in Late Habsburg Austria: A Critical Introduction to Max Dvořák's Denkmalpflege*. Edinburgh: University of Edinburgh. PhD thesis. pp. 380–451.

Emerick, K. (2014). *Conserving and Managing Ancient Monuments: Heritage, Democracy, and Inclusion*. Woodbridge: Boydell Press.

Freeland, H. (2016). The President's Award – Re-Ordering and Extensions. *Journal of the Ecclesiastical Architects' and Surveyors' Association* (Winter 2016): 8–11.

Gadamer, H.-G. ([1960] 1989). *Truth and Method*. (J. Weinsheimer & D.G. Marshall, trans.). 2nd rev. ed. London: Sheed and Ward.

Hardy, T. ([1906] 1967). Memories of Church Restoration. In: H. Orel (ed.), *Thomas Hardy's Personal Writings. Prefaces, Literary Opinions, Reminiscences*. London and Melbourne: Macmillan. pp. 203–218.

Harrison, R. (2013). *Heritage: Critical Approaches*. Abingdon and New York: Routledge.

Hassard, F. (2009). Intangible Heritage in the United Kingdom: The Dark Side of Enlightenment? In: L. Smith & N. Akagawa (eds.), *Intangible Heritage*. Abingdon and New York: Routledge. pp. 270–288.

Historic England (2008). *Conservation Principles: Policies and Guidance for the Sustainable Management of the Historic Environment*. London: English Heritage.

Holtorf, C. (2006). Can Less Be More? Heritage in the Age of Terrorism. *Public Archaeology*, 5 (2): 101–109.

Hoorn, M. van der (2002). Injection in a Nazi Ruin: The Party Rally Grounds Documentation Centre at Nuremberg. *Archis: Magazine for Architecture, the City and Visual Culture*, 3: 108–115.

Japan ICOMOS (2014). *Nara + 20: On Heritage Practices, Cultural Values, and the Concept of Authenticity*. [Online]. Available at: www.japan-icomos.org/pdf/nara20_final_eng.pdf.

Jones, S. (2017). Wrestling with the Social Value of Heritage: Problems, Dilemmas and Opportunities. *Journal of Community Archaeology & Heritage*, 4 (1): 21–37.

Kinsella, E.A. & Pitman, A. (eds.) (2012). *Phronesis as Professional Knowledge: Practical Wisdom in the Professions*. Rotterdam: Sense Publishers.

Latour, B. (1993). *We Have Never Been Modern*. (C. Porter, trans.). Cambridge, MA: Harvard University Press.

Lowenthal, D. (1994). Criteria of Authenticity. In: K.E. Larsen & N. Marstein (eds.) *Conference on Authenticity in Relation to the World Heritage Convention – Preparatory Workshop*. Oslo: Tapir Forlag. pp. 35–64.

Macdonald, S. (2009). *Difficult Heritage: Negotiating the Nazi Past in Nuremberg and Beyond*. Abingdon and New York: Routledge.

MacIntyre, A.C. (1977). Epistemological Crises, Dramatic Narrative and the Philosophy of Science. *The Monist*, 60 (4): 453–472.

MacIntyre, A.C. (1985). *After Virtue: A Study in Moral Theory*. 3rd ed. London: Duckworth.

Marchand, T.H.J. (2003). Process over Product: Case Studies of Traditional Building Practices in Djenné, Mali, and San'a', Yemen. In: J.M. Teutonico & F.G. Matero

(eds.), *Managing Change: Sustainable Approaches to the Conservation of the Built Environment*. Los Angeles, CA: Getty Conservation Institute. pp. 137–159.

Miele, C. (2005). Morris and Conservation. In: C. Miele (ed.), *From William Morris: Building Conservation and the Arts and Crafts Cult of Authenticity, 1877–1939*. New Haven, CT, and London: Yale University Press. pp. 30–65.

Ministry of Housing, Communities and Local Government (2019). *National Planning Policy Framework*. [Online]. Available at: https://assets.publishing.service.gov.uk/government/uploads/system/uploads/attachment_data/file/810197/NPPF_Feb_2019_revised.pdf.

Mires, C. (2002). *Independence Hall in American Memory*. Philadelphia: University of Pennsylvania Press.

Morris, W. ([1915] 2012). Signs of Change. In: M. Morris (ed.), *The Collected Works of William Morris, Volume 23, Signs of Changes: Lectures on Socialism: With Introductions by His Daughter May Morris*. Cambridge: Cambridge University Press. pp. 1–140.

Museen der Stadt Nürnberg (2019). *Documentation Center Nazi Party Rally Grounds*. [Online]. Available at: https://museums.nuernberg.de/documentation-center/.

Olsen, S.H. (2016). Canon and Tradition. In: N. Carroll & J. Gibson (eds.), *The Routledge Companion to Philosophy of Literature*. Abingdon and New York: Routledge. pp. 147–160.

Orbaşli, A. (2015). Nara+20: A Theory and Practice Perspective. *Heritage & Society*, 8 (2): 178–188.

Petzet, M. (2009). *International Principles of Preservation*. 20. Berlin: Hendrik Bäßler Verlag.

Polanyi, M. (2009). *The Tacit Dimension*. Chicago and London: University of Chicago Press.

Poulios, I. (2015). Gazing at the 'Blue Ocean,' and Tapping into the Mental Models of Conservation: Reflections on the Nara+20 Document. *Heritage & Society*, 8: 158–177.

Ricoeur, P. (1980). Narrative Time. *Critical Inquiry*, 7 (1): 169–190.

Ricoeur, P. (1991). Life in Quest of Narrative. In: D. Wood (ed.), *On Paul Ricoeur: Narrative and Interpretation*. London and New York: Routledge. pp. 20–33.

Roberts, G. (2001). Introduction: The History and Narrative Debate, 1960–2000. In: G. Roberts (ed.), *The History and Narrative Reader*. Abingdon and New York: Routledge. pp. 1–21.

Schofield, A.J. (ed.) (2014). *Who Needs Experts?: Counter-Mapping Cultural Heritage*. Farnham: Ashgate.

Scott, G.G. (1879). *Personal and Professional Recollections*. (G. Gilbert Scott, ed.). London: Sampson Low, Marston, Searle, & Rivington.

Sennett, R. (2009). *The Craftsman*. London: Penguin.

Tschudi-Madsen, S. (1976). *Restoration and Anti-Restoration: A Study in English Restoration Philosophy*. Oslo: Universitetsforlaget.

UK Government (1990). *Planning (Listed Buildings and Conservation Areas) Act 1990*. [Online]. Available at: www.legislation.gov.uk/ukpga/1990/9/data.pdf.

UNESCO (2003). *Convention for the Safeguarding of the Intangible Cultural Heritage*. [Online]. Available at: https://ich.unesco.org/en/convention.

Waterton, E., Smith, L. & Campbell, G. (2006). The Utility of Discourse Analysis to Heritage Studies: The Burra Charter and Social Inclusion. *International Journal of Heritage Studies*, 12 (4): 339–355.

Wates, N. (1987). *Community Architecture: How People Are Creating Their Own Environment*. London and New York: Penguin.

Wates, N. (2014). *The Community Planning Handbook: How People Can Shape Their Cities, Towns and Villages in Any Part of the World*. Abingdon and New York: Routledge.

Case Study: The SCARAB Manifesto

No doubt, Sir, – there is a whole chapter wanting here – and a chasm of
ten pages made in the book by it [...] but, on the contrary, the book is
more perfect and complete by wanting the chapter, than having it.

<div align="right">Laurence Sterne (1761)</div>

Context

The SCARAB Manifesto that follows extends the narrative approach
argued for in this book into polemical form. It is explicitly intended to com-
plement Morris's *Manifesto* for the Society for the Protection of Ancient
Buildings (SPAB) (Morris [1877] 2017), adopting a comparably polem-
ical approach; homage is paid to Morris, and the connection between the
two underlined, in the adaptation of Morris's prefatory wording. This new
manifesto is a thought experiment exploring the implications of putting
'Continuity and Renewal' in place of 'Preservation' in conservation dis-
course: what might a manifesto for The Society for the *Continuity and
Renewal* of Ancient Buildings look like? The text is available on a dedicated
website (Figure 6.9).[1]

As Chris Miele (2005a, 2005b) demonstrates, there is a substantial
ideology underlying Morris's work, including the SPAB *Manifesto*. The tit-
ling of the SPAB document as a 'manifesto' marks it out as the product
of an artistic sensibility, 'the stock-in-trade of the self-styled avant garde'
(Miele 2005b: 32). For Morris, the revival of craft skills was of far more
than utilitarian value to the survival of historic buildings; rather it was cen-
tral to his utopian cultural vision. For him, historic buildings embodied an
understanding of the relation between labour, art, and society distinct from
that of the nineteenth century, and thereby pointed the way to a better future.
Central to this craft understanding is the exercise of artistic judgement, and
it is part of the SPAB *Manifesto*'s enduring legacy that, for better or worse,

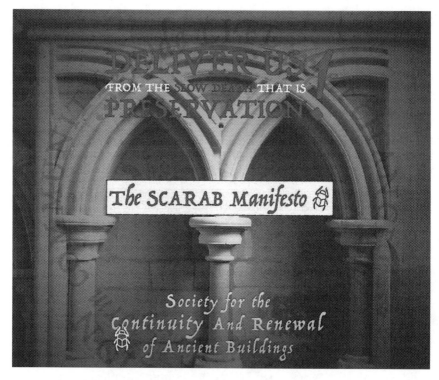

Figure 6.9 SCARAB Manifesto: web version

it has helped cement in place a predominantly art historical approach to historic buildings.

The relative invisibility of the 'other Conservation Movement' that Miele (2005a: 13) identifies with George Godwin can perhaps be explained by the lack of a comparable manifesto as a rallying point and touchstone, indeed a credo, for those who followed. Morris's skilful choice of vocabulary is integral to the persuasiveness of its argument. The fact that his *Manifesto* has endured is due not least to his clever use of the genre of polemic. Any polemic is by definition an act of aggression,[2] and therefore presents an implicit invitation to resistance; Morris's is no exception. Indeed, it could be argued that the tragedy of the SPAB *Manifesto* is that it has never been responded to in similar vein. It is precisely because Morris's original is so well written that it has retained its currency and lends itself to this form of engagement. To respond in kind is to take Morris and his ideas seriously, and seems an appropriate means of challenging what, in the light of the theoretical frame provided by Chapters 4 and 5, is the error of Morris's central claim, that tradition is dead. The SCARAB Manifesto opposes preservation,

arguing for a middle ground between no change and uncontrolled change; it provides a means of cladding this middle ground in equivalent polemical clothing.

The new Manifesto is therefore substantially congruent with the aims of SPAB, which remains one of the most valued organizations working for the benefit of the historic environment. While clearly intended to be playful, the new Manifesto is not parody but dialogue, playfulness of a serious kind in the best Gadamerian sense. In its complementarity it is both subaltern and subversive at one and the same time, and in can itself be seen as an illustration of the working of a tradition in robust good health.

The text of the *Manifesto*

Preamble

A society coming before the public with such a name must needs explain its purpose. This, then, is the explanation we offer ...

- once a font of community vitality, the life is being squeezed from our ancient buildings;
- conservation without cultural continuity threatens those buildings with a death called preservation;
- living traditions demand change; conservation ignores this at its peril.

Ancient buildings exude LIFE

SCARAB sees ancient buildings as alive. Just as it is never appropriate to 'preserve' a still living person, so we should not seek to preserve a living building, but rather to sustain it in good health. Some historic structures should indeed be preserved as is; such works of art are monuments that are no longer living and are the exception that proves the rule.

Unlike monuments, living buildings have an ongoing usefulness and purpose; the unthinking restriction of that utility is the biggest threat such buildings face.

Most living buildings have been authored by their communities across many generations; most have a purpose that points beyond themselves. With few exceptions, they are terminally incomplete, always as much about process and journey as about product and destination.

Living buildings cannot be reduced solely to art history or archaeology; they are living expressions of heritage that are nurtured by the continuity of past, present, and future. A conservation based on cultural discontinuity will suppress their life, and that of the communities that use them.

Buildings of any kind have agency; they are actors in the unfolding drama of human culture. Conservation can help an ancient building to exude life or, through preservation, to exclude life. To exude or exclude: that is the question.

Ancient buildings expect CHANGE

History is the study of change through time and is narrative in structure. A genuinely historic building is also narrative in structure, and thus as much future facing as past facing.

A building valued only for its past ceases to be historic; removed from the flow of history, its life drains away and it becomes a monument. To remain historic, ancient buildings can, should, and indeed must, be allowed to change.

Of course, not all change is good. For conservation to be credible it must address a fatal omission by developing a means of judging good change from bad. Change itself should not be feared as a threat but welcomed as evidence of life.

Ancient buildings provide a model; many have changed in every generation. Change is in their nature and has given them their character. It is their lifeblood, a lifeline that binds them to their community. Who would wish to obstruct it?

SCARAB sees ancient buildings as ICONs – Intergenerational, Communal, and Ongoing Narratives. Each generation writes a chapter in the communal story; in writing ours, we have a duty to enrich the plot and move it forward, while allowing space for future generations to write their chapters.

A narrative approach opposes the privileging of one particular historic period over any other. Old is not necessarily more important than new. What is essential is to safeguard character, continuity, and the coherence of the whole. We should expect change to be subtractive as well as additive; otherwise, over time, any building will choke and die.

The alternative, to stop the narrative through the sclerosis of preservation, dishonours the past and dispossesses the future; this ahistoricism is the death of conservation, and of culture.

Ancient buildings embody TRADITION

SCARAB views ancient buildings as objects of tradition. A tradition in good health is constantly changing, but its fluidity is bounded. Tradition has little place for individual genius, but great respect for creativity in community.

Continuity of tradition should not be confused with keeping things the same; that is the task of preservation, not conservation. A continuity of sameness fixates on answers; continuity of tradition is concerned with questions, specifically with maintaining and developing the questions that sustain a culture. It is the role of tradition to keep those cultural questions alive. This can only be achieved by a radical tradition of dynamism, and not by modernity's pseudo-tradition of stasis in the service of political conservatism.

A conservation of answers literally 'has no future'. Only a conservation of the question is able to reconcile the claims of past, present, and future. This 'balanced heritage' allows for creativity, making space for the uninvited guest, and for the young alongside the old.

It is not possible to deal well with the objects of tradition without a comparable premodern understanding of tradition. The new wine of modernity threatens to destroy the old wineskin of a living building because it does not understand the subversive vitality of dynamic tradition.

Ancient buildings form COMMUNITY

Of critical importance to the health of ancient buildings is their relationship with the local communities which created them, and which they continue to co-create. The relationship is reciprocal, the feeling mutual.

Culture starts with the most local forms of community and works from the bottom up. Culture 'dwells', is always from somewhere. Living buildings make this dwelling manifest; they are owned by their community and are convivial.

By contrast, high culture is by instinct 'contravivial.' It defines a canon, invests in a collection, and then defends against change through preservation. Dealing in universals, it controls from above, marginalizing the local and communal.

The resulting democratic deficit is not resolved by introducing intangible as distinct from tangible forms of heritage, which offer no account for the 'co-dwelling' of people and buildings. Adding the communal to a significance of discrete values cannot resurrect the life of a heritage once it has been embalmed; preservation by any other name would smell as sick.

SCARAB stands for the continuity and renewal of living buildings. It promotes a balanced heritage of past, present, and future that integrates the communal with the aesthetic and historical. It favours localism over nationalism, continuity over separation, movement over stasis and celebration over the 'contravivial'.

Notes

1 www.scarabsoc.org.uk.
2 The Greek root of 'polemic' is *polemos*, 'war'.

References

Miele, C. (2005a). Conservation and the Enemies of Progress? In: C. Miele (ed.), *From William Morris: Building Conservation and the Arts and Crafts Cult of Authenticity, 1877–1939*. New Haven, CT, and London: Yale University Press. pp. 1–29.

Miele, C. (2005b). Morris and Conservation. In: C. Miele (ed.), *From William Morris: Building Conservation and the Arts and Crafts Cult of Authenticity, 1877–1939*. New Haven, CT, and London: Yale University Press. pp. 30–65.

Morris, W. ([1877] 2017). *The Society for the Protection of Ancient Buildings Manifesto*. [Online]. Available at: www.spab.org.uk/about-us/spab-manifesto.

Sterne, L. (1761). *The Life and Opinions of Tristram Shandy, Gentleman*. London: R & J Dodsley.

Conclusion

Conservation 'as if people mattered'

... those who are vainly striving to stem the progress of the world are as careless of the past as they are fearful of the future. In short, history [...] is now teaching us worthily, and making us feel that the past is not dead, but is living in us, and will be alive in the future which we are now helping to make.

William Morris (1893)

The central problem examined in this book is the question of change to historic buildings. The project has grown directly from my professional experience with medieval church buildings and their core communities, and an unease at the often poor quality of outcomes for those community groups and (by extension) for the buildings themselves. I am convinced that something important is being missed; as discussed, responsibility for that omission may not lie with conservation *per se*, but with the much larger project of modernity of which it forms an integral part. By contrast, for the premodern world the boundedness of tradition acted as the guarantor of a broader cultural continuity and a means of judging what sort of change is desirable. By bringing conservation into dialogue with premodernity, this book has aimed to address the current lack of a coherent conservation philosophy for living buildings and to offer a viable theoretical foundation based on virtue ethics. My hope is that this will open up a broader discussion that will develop further.

Conservation futures

From its origins in the antiquarian movement, conservation has predominantly approached old buildings as aesthetic and/or historical objects, strongly influenced by romanticism's nostalgia for the past (reacting to Enlightenment faith in progress) and the birth of aesthetics. In this spirit, the SPAB *Manifesto* drew attention to the excesses of an instrumentalized and

industrialized approach to historic buildings (Morris [1877] 2017). Morris's achievement was to articulate this in polemical form of enduring power, such that the aesthetic-historical approach remains the touchstone for contemporary practice; thus, as in the United Kingdom, the categories of architectural and historic interest typically remain the sole criteria for the listing of historic buildings, and central to their statutory protection thereafter. These criteria are helpful for the 'keeping' side of Donald Insall's duality, but more problematic for the 'making' side, argued here to be essential both to their nature and future (Insall 2008: 93); thus, while the aesthetic-historical approach remains foundational for conservation, it cannot adequately describe the complexity of living historic buildings. The interests of the local and communal are supposed, within a values-based methodology, to be safeguarded by social value, but this only reaches as far as describing the meaning of the historic environment for *contemporary* communities (Jones 2017). It is only by broadening the temporal definition of community, which can be achieved through engagement with the dialogical orientation of tradition, that the democratic relativity of social value can be addressed; this is the aim of the proposed narrative approach.

Conservation now faces a series of difficult challenges that result from its pattern of development. The lack of historical depth means that old buildings are increasingly seen as sacred by virtue of their age, even though this was almost never the original intention behind their creation (with the partial exception of the deliberate monument). This 'sacredness' easily leads conservation professionals to conclude that less change is better, and no change at all is ideal. There is further confusion over what sort of change is envisaged – merely change resulting from time and the work of the elements, or elective change in which the users of the building seek to whatever extent to reshape it to their developing needs. This confusion often causes conservation professionals to oppose change to buildings that may have already changed multiple times through their history, and whose character and very survival are the result of that process of development. Critical approaches to heritage have raised legitimate concerns about ownership and power relations; from a user's perspective the aesthetic-historical approach can look very much like the theft of the building from the community. If heritage is understood as found in the nexus (literally the binding together) between the historic building and the people associated with it, this will result in the destruction of heritage in the very attempt to save it.

Conservation thus stands at something of a crossroads. Unless it regains a sense of legitimacy by rethinking its relation to local communities and to the culture as a whole, it risks becoming increasingly marginalized; being the voice of conscience is of little benefit if that voice is ignored by

the culture at large. A second possibility is that conservation will collapse under the weight of the expansion of heritage: in many jurisdictions it is already judged unaffordable for the State to provide the principal means of protecting heritage, and it is likely that the much vaunted values structure will (ironically) collapse back into the pre-nineteenth-century understanding of value in solely economic terms. Neither of these possibilities is remotely healthy for the historic environment. A third, more optimistic possibility is that conservation will succeed in claiming the cultural centre ground, embracing the positive opportunity to engage anew with local needs and communities. Conservation professionals could then position themselves as experts in responsible change, guardians of narrative, and thus the obvious place to turn not only in order to understand the community's collective story, but to enable the creative co-production of its next chapter.

As discussed in Chapter 3, the argument of this book shares many of the same criticisms of contemporary heritage structures and practice as raised by Rodney Harrison (2013), and reaches similar conclusions, but it does so on the basis of a more fundamental (and non-modern) engagement with tradition; this is seen as essential for making heritage dialogical not only in a social, but also in a historical sense. If conservation were fully to embrace the implications of living buildings and move to a 'morphogenetic' understanding of the material world as essentially fluid (Ingold 2013), then heritage assets would no longer be 'irreplaceable', as the current system claims, and their physical fabric would be characterized more by resilience (cf. Jones & Mean 2010) than by fragility.

History in the gap

The SPAB *Manifesto*, which has been discussed at various points through the book, represents an approach to historic buildings that reifies the past, believing that in the modern age the historical should be treated as a static and disconnected representation rather than part of a dynamic process in which we continue to participate. This reflects modernity's pursuit of certainty and the abhorrence of paradox from Descartes onwards; regrettably, as Lorraine Daston suggests in discussing the eloquence of physical things, it is 'when the paradox becomes prosaic [that] things that talk subside into speechlessness' (2004: 24). The ability to entertain paradox stands out as a particular contribution of the premodern approach, in contrast to the contemporary tendency to reduce the richer categories of traditional meaning to the tradable certainties of 'significance'. This book offers a response to Morris's challenge, laid down at the foundation of SPAB but subsequently neglected, to explore what 'leaving history in the gap' – that is, adopting a

hermeneutically literate approach to altering the physical remains of the past – might mean in an age that has lost its understanding of tradition.

It was noted in Chapter 5 how Hilary Mantel (2017: 4) playfully uses metaphors of dance, birth, performance, and journey to evoke the past not as something inert but as living and active, as premodernity allows. This sense of playfulness is far closer to the understanding of history that a conservation of living buildings requires and, coming from the pen of a novelist, indicates the relevance of narrative to this understanding. When describing historic buildings for non-professional audiences, I have often found such metaphors, particularly those of dance and journey, compellingly useful. In a different context, Ingold draws on Deleuze and Guattari's insistence that 'matter-flow can only *be followed*' (1987: 409, emphasis original), noting that 'practitioners who follow the flow are, in effect, itinerants, wayfarers' (Ingold 2013: 25). What neither Mantel nor Ingold touch on is that through tradition the past can remain accessible in dialogue; the dance continues, in our case the dance between the living building and the core community that 'owns' and cares for it.

This acknowledgement of continuity, of dialogue across history, characterizes the hermeneutic, as opposed to the aesthetic-historical, position. L.P. Hartley's resonant phrase 'The past is a foreign country: they do things differently there', the opening lines of his novel *The Go-Between* (Hartley [1953] 1997), was adopted by David Lowenthal as the title for his seminal book (Lowenthal 1985), which marked the birth of heritage studies as a discipline. The phrase can be seen as applying as much to the postmodern approach to the historical past as to the modern, exemplified by Morris; for both, the past is discontinuous with the present, resulting from what Hans-Georg Gadamer terms a romantic as opposed to a classical hermeneutic (Chapter 4). From this difference of hermeneutics flow many of the difficulties faced by modern conservation, such as the marginalizing of communal interests, the conflation of change with harm, and the sacralization of the past. The non-modern rejoinder to Lowenthal (and Morris) might perhaps be: 'The past is familial: we discuss our differences'.

This book argues that the medievals offer conservation a lifeline and an escape from the inherent contradictions of a process unable to question the modernity of its inherited assumptions. In Chapter 4, the treatment of historic buildings as the retained relics of the past illustrated the operation – as much for Morris as for Le Corbusier – of the romantic hermeneutic. While the Victorians, the Georgians, and others could describe themselves in terms of the respective labels they now wear, the medievals could not have known that modernity would (pejoratively) label their time the 'Middle Ages' – that is, the interval or void between antiquity and modernity. As far

as the medievals were concerned they were simply living in continuity with antiquity, in Gadamer's terms with a classical hermeneutic, and by definition were the last era to do so in a wholeheartedly premodern way.

While there is much to like in premodernity, this is not a call for a simple return to an idealized medieval past (as offered by Pugin), nor future (as offered by Morris). Following Latour's sketch, we must take all the help we can get, utilizing also the resources of modernity and even postmodernity, acknowledging that there remains a fundamental underlying continuity between these three. To do otherwise would be to follow modernity in proposing yet another revolutionary break with the past. Latour favoured what he terms the 'nonmodern', and in his last chapter is prescriptive of what from the moderns, premoderns, and postmoderns should respectively be retained and what rejected (Latour 1993: 138–145). While we might question some aspects of this cultural map, Latour's approach has nevertheless proved highly productive for this study. At the outset of Latour's investigation and at the centre of his map stand the awkward, heretical, shape-shifting hybrids. Similarly, the architectural hybrid that is the living building occasioned this investigation and has served as our companion throughout. She now stands at its centre, not on a pedestal in historicized isolation as the modernities of Morris or Le Corbusier would place her, but as the life and soul of the cultural party. As a hybrid *par excellence*, discontinuity has never been her nature and so, following Latour, she can justifiably claim never to have been modern.

Returning to the tripartite ethical structure outlined in Chapter 1, this argument follows the grain of tradition and seeks for the first time to establish a virtue ethics approach to conservation; it therefore should not only be judged on its own merits but also against its rival ethical approaches. Of these, the 'universal' covers the official development of modern conservation from its inception until the later twentieth century; under the label of a 'subversive' conservation ethics we can gather Critical Heritage Studies and, arguably, the *Burra Charter*, which promote intangibility and communal/social value respectively. However, if change is to be managed, *someone* needs to make decisions: while a universal approach is at least honestly prescriptive – 'let the expert decide' – none of the subversive approaches adequately addresses the question of whose values should prevail. Regardless of how much late-modern, subversive forms of heritage might critique the modern, universal variety, they nevertheless retain much in common and are equally ill-suited to address the needs of living buildings.

This book contends that the difficulties inherent in modern conservation remain irreconcilable without looking beyond the confines of modernity (broadly defined) and employing a classical hermeneutic to renew

our dialogue with the past. If character is to play a role in conservation, and if change is acknowledged as not all bad, then the conservation ethics that should ultimately prevail is that which best addresses the issues of continuity of character and the discernment of good change from bad, and which offers the most compelling account of living buildings for the communities that animate them. The argument of this book is that an understanding of tradition is indispensable if we are to 'leave history in the gap'. And as has been suggested throughout this concluding chapter, in principle this has application to buildings of all eras and types: all historic buildings are, in some sense, living, not least since they all have some level of community association and use, whether local, national, or international (Poulios 2011: 146).

Hybridity and the via media

Following Latour, this book calls for a recalibration of conservation away from the particularly modern concern with the purities of authorship, style, or period to a valuing of the heterodox, the hybrid and the composite. In the past those purities have combined with an aesthetic-historical understanding to toxic effect, blighting the life of historic buildings and stifling contemporary creativity since, as already noted, 'the moderns cannot imagine so much as exists' (Thoreau [1860] 1906: 155). One manifestation of this peculiarly modern rigidity, the preservation sensibility, remains active and is not infrequently encountered amongst conservation professionals at local, national, and international levels. Rigid systems, whether physical or theoretical, are also fragile and risk sudden failure, in this case at potentially great cost to the built heritage. As has been argued throughout, this rigidity results in part from conservation's lack of engagement with its theoretical foundation; more positively, it is not difficult to imagine how transformative such an engagement could be.

The current process does, of course, already allow for a degree of change, but the privileging of authorship, style and period over the balanced holism of 'living heritage' serves to marginalize the community, confining it to 'the play corner' while the grown-ups get on with their important aesthetic-historical business. The narrative approach proposed here goes beyond the understanding that change (suitably circumscribed) can be good; rather, change is *essential* to the flourishing – indeed the very survival – of the historic buildings in our care. Change is wholly distinct from harm, and more change may well be *less* harmful to the cultural whole and therefore for the 'historic environment' than minimized change. And so we return to Newman's epigraph with which Chapter 1 started: 'to live is to change, and to be perfect is to have changed often' (Newman [1845] 1909: 40).

Where Newman places no bounds on change, Caroline Walker Bynum's understanding of premodern materiality and metamorphosis explicitly uses narrative to frame a more nuanced view: 'Without [real change] there is no story; nothing happens. [...] And yet there is no story if there is only change' (Bynum 2001: 177). Narrative, on this account, constrains change, because it demands continuity; it is this fundamentally premodern understanding of a middle way between the positions of 'no change' and 'all change' which underpins the overall argument of this book.

This book represents an appeal to overcome the false dichotomies of past and future, of living and dead, through a renewal of the non-modern understanding of continuity. This is not another postmodern turn; within the premodern frame, postmodernity is merely a late variation of modernity, pursuing the same fragmented and discontinuous view of culture, and the same privileging of the individual over the communal. Some of its particular characteristics are to be welcomed, not least its playfulness, but others, such as its instinctive relativism, rejected. In its place this book argues for a mediatory approach. I hope to have demonstrated that such an approach is productive in offering means of addressing the contradictions inherent in modern conservation. As Thoreau implies, to challenge the impoverished scope of what modernity can imagine we do not need to embrace the full extent of premodern credulity. There is a middle way, and within the realm of conservation practice that middle way is at times discernible in some of the best, historically literate change to old buildings. What is lacking is the coherent body of theory to support that good practice; it is the ambition of this book to initiate the debate that will produce that theoretical infrastructure.

In Aristotelian ethics, the term *via media* refers to the middle way of moderation between extremes; its use to describe the self-understanding of the Anglican Church's attempt to reconcile the Catholic and Reformed wings of Western Christendom stems from the Oxford Movement with which Newman was so closely associated.[1] The *via media* is not a question of compromise as typically understood – a grudging settlement at the lowest common denominator. This, rather, is dialogue, and one from which all parties can emerge enriched. The *via media* is a stage on which our drama can unfold, a 'broad church' on the Anglican model, Thomas Sharp's middle way, the hermeneutic place for Gadamer's genuine conversation and the resulting fusion of horizons in which we discover both who we are and our direction of travel. That is what is at stake in heritage in general, and community-owned historic buildings in particular. For that mediating role between the excesses of 'no change' and 'all change', the word 'compromise' is wholly inadequate. Perhaps we should use the alternative word

'conservation'; but conservation can only fulfil that role if it furnishes itself with a theoretical foundation substantially different from the aesthetic-historical one under which it has laboured to date. A conservation embracing the premodern understanding of materiality and hybridity from which medieval buildings were formed would transform the care of buildings of all ages and types, celebrating change as a sign of their vitality. To borrow E.F. Schumacher's phrase, this is conservation 'as if people mattered' – conservation, that is, reimagined as the preservation and enhancement not of a physical object but of the questions that make us collectively what we are.

Note

1 In the event, for Newman that middle way proved unsustainable, as he and a number of other 'Tractarians' converted to Roman Catholicism; nevertheless, the phrase has endured, describing the Church of England's unique position and its ambition to reconcile division.

References

Bynum, C.W. (2001). *Metamorphosis and Identity*. New York: Zone Books.

Daston, L. (2004). Introduction: Speechless. In: L. Daston (ed.), *Things That Talk: Object Lessons from Art and Science*. London and New York: Zone Books. pp. 9–24.

Deleuze, G. & Guattari, F. (1987). *A Thousand Plateaus: Capitalism and Schizophrenia*. (B. Massumi, trans.). Minneapolis: University of Minnesota Press.

Harrison, R. (2013). *Heritage: Critical Approaches*. Abingdon and New York: Routledge.

Hartley, L.P. ([1953] 1997). *The Go-Between*. London: Penguin.

Ingold, T. (2013). *Making: Anthropology, Archaeology, Art and Architecture*. Abingdon and New York: Routledge.

Insall, D.W. (2008). *Living Buildings: Architectural Conservation: Philosophy, Principles and Practice*. Mulgrave, Victoria: Images.

Jones, S. (2017). Wrestling with the Social Value of Heritage: Problems, Dilemmas and Opportunities. *Journal of Community Archaeology & Heritage*, 4 (1): 21–37.

Jones, S. & Mean, M. (2010). *Resilient Places: Character and Community in Everyday Heritage*. London: Demos.

Latour, B. (1993). *We Have Never Been Modern*. (C. Porter, trans.). Cambridge, MA: Harvard University Press.

Lowenthal, D. (1985). *The Past Is a Foreign Country*. Cambridge and New York: Cambridge University Press.

Mantel, H. (2017). *Reith Lectures 2017: Lecture 1: The Day Is for Living*. [Online]. Available at: http://downloads.bbc.co.uk/radio4/reith2017/reith_2017_hilary_mantel_lecture%201.pdf.

Morris, W. (1893). Preface. In: R. Steele (ed.), *Medieval Lore: An Epitome of the Science, Geography, Animal and Plant Folk-Lore and Myth of the Middle*

Age: Being Classified Gleanings from the Encyclopedia of Bartholomew Anglicus on the Properties of Things. London: Elliot Stock. pp. v–viii.

Morris, W. ([1877] 2017). *The Society for the Protection of Ancient Buildings Manifesto*. [Online]. Available at: www.spab.org.uk/about-us/spab-manifesto.

Newman, J.H. ([1845] 1909). *An Essay on the Development of Christian Doctrine*. London: Longmans, Green.

Poulios, I. (2011). Is Every Heritage Site a 'Living' One? Linking Conservation to Communities' Association with Sites. *The Historic Environment*, 2 (2): 144–156.

Thoreau, H.D. ([1860] 1906). *Journal*. XIII. Boston, MA, and New York: Houghton Mifflin.

Index

Printed in the United States
by Baker & Taylor Publisher Services